DRAW IT WITH YOUR EYES CLOSED:

Draw it with your eyes closed: the art of the art assignment

EDITED BY
PAPER MONUMENT

PAPER MONUMENT

Take an eighteen-by-twenty-four-inch paper and make a drawing using nothing but your car.

In my freshman year at Bennington College, I took a set design class with Tony Carruthers: a mad, charismatic Scotsman, multimedia artist, and legendary teacher. He asked us to design a set based on L. Ron Hubbard's *Dianetics: The Modern Science of Mental Heath*. Tony had a brilliant way of cajoling us to open up our little high-school brains ("Who cares about the fucking actors? They're just props!") and embrace the absurdity of the task at hand. My maquette was negligible—a red-hot volcano surrounded by a ring of jutting cardboard and tin foil flats (think *Metropolis*)—but the experience of studying with a larger-than-life true believer was indelible. I wasn't stuck in Oregon anymore. This was what REAL ART felt like.

As I see it, there are three ways to approach teaching art.

1. THE CHEERLEADER
For better or worse (OK, worse) this is the model I most adhere to.

I'm from the "if you don't have anything nice to say, don't say it" school. It serves no one's needs but I can't help it. Codepenents make the worst teachers.

A good teacher probably needs to believe that one thing is better than another, but I have difficulty with the idea of objective differences in quality. My critique sessions tend to resemble confidence-building exercises. Oprah giving hugs. You go, girl!

I make a better cheerleader than coach.

2. THE ROLE MODEL
This one I don't do. I couldn't, even if I tried. It comes from reading too many "famous artist" biographies. It's nurtured by bitter old faculty members who would rather be in their studios working, and it inevitably leads to creepy teachers sleeping with students. Really, it does no one any good at all.

3. THE DIALOGUE FACILITATOR
This is probably the best way to approach teaching art, and if I can shut up long enough I'm not so bad at it. On a good day, I'm fairly adept at fostering dialogue and getting students to talk. I can go on at great length, citing points of reference, texts to read, and artists to look at. I can dissect the meaning of a work of art from any number of perspectives. Freud, Marx, even the French Guys—I can cite them all and bring multiple meanings to the slightest mark or material. And sometimes, just sometimes, I can even believe what I'm saying.

Of course all of this is made much easier if I'm teaching in a room with a projector and a high-speed Internet connection. There's really no reference that can't be made more interesting or conversation enhanced with a good Google search. Sure, this can result in a good hour of class time being spent watching kittens play piano, but really, is that so wrong?

In my experience, assignments are sort of like folk songs, or certain kinds of jokes. They're retold and adapted from generation to generation of teachers, tinkered with, misheard, brought up to date. Even when I think I've come up with something new, it always ends up being a version of something else.

In comedy—as opposed to casual joke-telling—there are various mechanisms in place to deal with the issue of *stolen* jokes. Was a joke stolen outright, inappropriately adapted, or merely the coincidence of thematic overlap? One can imagine a jury of comics sitting in a dark club, parsing the language of a joke and determining whether or not an infraction had been committed. When Robin Williams, an infamous pilferer of other comedians' material, was called out, he would just pay off the offended comic. The popular and unfunny Dane Cook famously accused another comic of stealing his "essence." And though we may imagine certain artists and art professors making the same claim, in teaching art there are no expectations of intellectual property rights. If there were, how would these be enforced?

I often teach beginning drawing and a favorite assignment is ostensibly from the Bauhaus, though I've looked and never found it published in any of the books about the school. Maybe it was passed through Josef Albers to the Yale crowd of the 1960s and 70s. The painter Peter Charlap passed it to me and I haven't changed it a bit. In any event, it never fails and I often use it to start the semester. It immediately teaches the students something about change, time, erasure, composition, and drawing as an event. And the drawings produced by the students are beautiful, which always helps morale. There are two versions:

ERASURE WITH LINE
(*Read out loud to class, waiting for students to complete each step before going on to the next one.*)
I'm going to give you a set of instructions to follow.
These instructions are intentionally cryptic.
You can't ask any questions.
You must reason your way through the problem.
Using line only, draw one simple geometric shape, such as a square, triangle or circle.
Without overlapping or intersecting, draw a different shape.
Now, draw another.

Choose your favorite.
Make the other 2 like your favorite.
Enlarge one of the shapes.
Reduce one of them.
Make one shape touch one edge of the page.
Make the other two touch two different sides.
Without moving the shapes from the sides,
 make each touch the other two.
Introduce a new shape that's different.
Keeping the original 3 shapes in the same places,
 make them like the new shape.
Make one shape larger than all the others.
Make one 50% smaller than the largest shape.
Make one of the 2 remaining shapes touch
 2 sides of the page.
Discuss.

ERASURE WITH TONE

Use 18 × 24 inch paper and vine charcoal.
On a new sheet of paper and using no line,
 draw a white circle.
On the same sheet, and using no line,
 draw a black circle.
Draw a gray circle.
Move one circle so that it is touching the edge
 of the page.
Make one circle 50% larger than all the others.
Add another shape of your choice, any value.
Take a new sheet of paper.
Copy the negative shapes only.
Fold the sheet into 4 quadrants.
Make the shapes different values.
Repeat one quadrant into another.
Discuss.

The first art assignment I ever received, on my first day at the School of the Art Institute of Chicago, in 1997, was the most humbling and powerful one I've ever experienced. After introducing our 2-D Foundations class to the work of Giorgio Morandi by way of a full color monograph, Matthew Girson instructed us to pick up an assortment of generic bottles, vessels, and brushes—but no paint or surfaces—and led us on a walk out of the classroom into the morning heat. Upon arriving at a stretch of newly made asphalt near Buckingham Fountain, we were asked to set up a Morandiesque arrangement using the bottles. Girson told us to "paint" what we saw onto the absorbent surface of the black asphalt, using our brushes and water from a drinking fountain. This was surprisingly effective. Using these austere means, we were able to make recognizable, nuanced images. We became conscious of the sun as an integral element in the existence of the image: it would never sit still, because it was evaporating before our eyes. We had to detach from the object, having no means to preserve our labor. What could have been a mere novelty became something else when we were instructed to continue our paintings for the rest of class: five more hours. Even though we ended the day empty-handed, I felt energized by the beauty of an immaterial experience.

MOLLY SMITH
FIRST SCULPTURE ASSIGNMENT

Laminate eight one-inch-thick by eight-inch-square wood planks together to make a cube.
Make six cuts with the band saw to make new pieces.
Reassemble these pieces together to make a sculpture.

This was assigned to me at the beginning of a 3-D art class at the University of Georgia during my freshman year. These simple instructions produced surprising results. Each student in the class followed these steps, yet managed to express their individuality in striking ways. No two sculptures looked alike.

Mine is on the shelf in my studio now, and visitors often respond to it. It still feels relevant and its methodology continues to influence my studio practice. When I teach, I give assignments similar to this one. I try to recreate for my students the same experience I had with this sculpture, and continue to have each day in my studio: the possibility for the same materials to generate a singular and unique experience each time they are used.

DAVID ROBBINS

Shoot and edit a TV commercial promoting something that you like. It might be a product, a place, a person, a virtue or a quality. The commercial's length should be no shorter than fifteen seconds and no longer than one minute.

The assignment is meant to encourage a use of video that isn't critical or deconstructive. Students are asked to identify what they're in favor of, to reveal it publicly, and to package their attraction using a format—the TV commercial—that typically has been disdained and, consequently, unexplored by the artistic imagination.

The second part of the assignment asks a question about information control. If you like a product that you pay for and use, do you have the right to make an advertisement that supports that product? Why or why not? Be prepared to debate the question in class.

I had a drawing teacher—Drew Beattie—who started each semester by handing his students a packet full of 100 sheets of printer paper and five Sharpie markers. We had about three weeks to make a drawing on each of those 100 sheets of paper, and we couldn't throw any away, or add any, or use any other materials. It forced me to stop self-editing so mercilessly. Some of those 100 drawings that I thought were abysmal at first are now some of my favorites.

ADDITIVE COLOR
Using language, edit and colorize a Wikipedia entry about a place or object. Think of it like a black-and-white entity to which you are adding words to allow the viewer to perceive it as a colorized space.

THE SHADOW
Make a sculpture that includes a light as a part of the sculpture. Have that light cast a shadow that speaks metaphorically about the sculpture.

THE PHOTOGRAPHED OBJECT
Make and photograph a sculpture with the idea that the sculpture will never be seen outside of the photograph.

THE TOOL
Make a tool to work on a problem that is currently unknown.

MADE OR FOUND
Make an object where the viewer will question what you made and what was found.

THE WHOLE
Make a sculpture/installation where everything needed to make it is included.

THE PART
Make a sculpture where what is shown points to something that we cannot see.

MARY WALLING BLACKBURN GLOSSARY: THE ART SCHOOL CRITIQUE AND ITS EMOTIONAL TERRITORIES (COURSING BETWEEN STUDENTS AND TEACHERS) (PROMISES, POSSIBILITIES, AND DEVASTATIONS)

Aggression, overt; sublimated; menstrual; cocksure
Aimlessness, decried; lauded
Ambition, raw and distorted
Ambivalence, toward the object; toward the ephemeral
Anal Stage
Anticipation, of your moment
Anxiety, runs through
Attention, free-floating
Belief: as masked; as mocked; as envied
Betrayal: by the teacher; by peers; of self
Boredom, as atmosphere vs. material
Claustrophobia, as combated by recusing oneself to the restroom
Compliance: to the will of the mob/class; to the will of personal manias
Composure, please
Compulsion, repetition
Concern; for object, for self; no
Confessions: awkward; unmediated; unintegrated
Construction of obstacles, make it bigger
Control, magical; defensive
Cure, possible
Desire, for total affirmation (all-loving mother); for repair (art as trade)
Destruction: of line of flight
Ego, as intermediary surface; critique channeled through
Embarrassment
Experience, fantasy of
False Self
Fathers, as model for the power structure within the classroom
Feelings
Future, is in their critics' hands
Genius as bogeyman in the classroom; guilt that one is not genius
Humiliation as bogeyman
Improvisation, as bust or boon
Infant: solitude of; sucking and relation to breast
Jokes, as salve. See also Laughter
Kissing, as a way to imagine the relation between object and viewer

Knowing, unknowing/not knowing
Love, as foreign to the critique process; the possibility of L. in critique
Mourning, of student as obstruction to receiving critique
Narcissism, of teacher; of student.
Nourishment, without food
Objects: of fear; sexual; of knowledge; of love and hate; disregard and destruction of; of worry; good; transformational; absence of
Observation, as ideal
Orality, as privileged
Pain, of non-reaction
Paranoia, of swiped idea
Privacy, undone
Protest, to critique as bad etiquette
Recognition, of some kind of beauty
Repetition, compulsion (rewarded)
Resistance, paramount
Ruthlessness, fetishized
Storytelling, as perceived digression
Saudade, as obstruction to perception of the work
Trust: illusory; performed; pursued; touched upon
Unhappiness, as mirage (in relation to production)
Unpleasure, as mirage (in relation to production)
Use: of instincts; of symptoms; of worries; of objects; of language
Wish(es): to be understood; punishment for; desire and; for obstacles
Yes; a critique based on
Yet; as apology for work to come

SLOW DANCE
The psychological bracken of artistic uncertainty, coltish egos, and market forces creates a critique structure that can be so useless that undignified, weird, and goofy alternates are no longer beyond the pale. In devising a number of alternate critique methods this fall, our class arrived at one strategy focused on the slow dance.

Instructions:
The art student subject to the critique will

Arrange a half-circle of chairs.
Eschew the overhead bank of lights for a single studio lamp.
Stand quietly in the middle of the floor and wait for the others to arrive and settle.

Turn music on.
Beckon to another seated student.
Enfold the student in a swaying embrace called the
 slow dance.
Make sure they are very close and they are looking at
 your eyes.
Realize this is intimate but not sexual.
Hold this dance for twenty seconds.
Let the invited student know, nonverbally,
 to return to their chair.
Wait for that student to be seated.
Entreat another student to come and dance.
Repeat the above sequence.
Repeat.
Repeat.
Repeat.
Another, and another, until you, the art student
 who is about to have a critique of work, has slowly
 danced with every member of the class.

KEVIN ZUCKER
SEEMINGLY INNOCUOUS ASSIGNMENTS THAT WILL LEAD TO IMPROBABLE CALAMITIES: CAUTIONARY NOTES FOR TEACHERS, UNFORTUNATELY BASED ON PERSONAL* EXPERIENCE

MAKE SOMETHING UGLY
Some twisted genius will stumble upon the ultimate solution to this art school chestnut: when it's their turn to be critiqued they'll just stand up and destroy the work of one of their classmates. An administrative shitstorm will ensue.

MAKE A WORK ON PAPER THAT IS EITHER EMBARRASSING OR SERVES A CONFESSIONAL PURPOSE
This assignment turns out to be appropriate only for grad students, who, unlike undergrads, can generally be trusted not to pin you against the crit wall and try to make out with you. Not that you'd be that comfortable getting publicly molested by any of your students, but it bears noting that the student who does this will inevitably be of the gender you're appreciably less into making out with. Still beet-red fifteen minutes later, you will have to find some way to address the "work" in a group critique where nobody can stop laughing. Since the assignment was given in a works on paper class, you, at a total loss, will first ask how paper was in any way involved—to which the student will point out that the wall against which the performance took place was made of Homasote, technically a paper product.

"THE FIVE OBSTRUCTIONS"
Each member of the class is asked to bring in a successful work they've made previously. They then watch Lars von Trier's *The Five Obstructions* as a group. After this screening each student has to sit silently and transcribe as their classmates shout out possible ways to "obstruct" that student's previously successful works (as von Trier does to Jørgen Leth in the movie). Finally, they take the lists they've transcribed back to their studios and have two weeks to produce five obstructed remakes of their original, based on five of the suggestions.

As above, you can give this to grad students. In the hands of BFA students, however, someone will find a way to reinterpret a champagne-colored abstraction as a performance in which they funnel

an entire bottle of champagne in a matter of seconds and then immediately puke it back up into a garbage can. (You will have to explain to your department head that it happened too quickly for you to intervene.) Years later, when you email this former student to see if he can remember what assignment he did this in response to, his helpful answer will end with the line, "it was intended as a foil to the Saab painting."

BRING IN A SONG YOU'RE EMBARRASSED YOU LIKE/BRING IN IMAGES OF PAST WORK YOU'RE NOW EMBARRASSED BY

Here the opposite proves to be true: whatever marginal credibility you have as an authority figure with undergrads will prevent them from staging a revolt in response to this first-day-of-class, getting-to-know-you assignment. Grad students, on the other hand (especially if you're not too much older than some of them), will demand that you participate, creating a situation where you're all sitting around listening to an unforgivable Gin Blossoms song you taped off the radio in eighth grade while watching a slideshow of the weird-shaped canvas/wall drawing show you did with the Belgian gallery you haven't heard from since. Squeezing your eyes shut hard as the song comes to its lame conclusion, you will wonder how anyone in the group of MFA students you're supposed to work closely with for the next two years will ever take anything you say seriously.

INDEXICAL DRAWING ("INDEX" IN THE SENSE OF PIERCE'S SEMIOTICS: A SIGN WHOSE SIGNIFIER AND SIGNIFIED HAVE A REAL AND OFTEN PHYSICAL RELATIONSHIP TO ONE ANOTHER PRIOR TO INTERPRETATION. LIKE, YOU MIGHT EXPLAIN WHEN INTRODUCING THE ASSIGNMENT, SMOKE COMING OUT OF THE WINDOW OF A BURNING HOUSE, LIPSTICK ON A WINE GLASS, OR THE CAGE / RAUSCHENBERG TIRE-TRACK PRINT MADE BY A MOVING CAR)

You should have known better than to give this assignment again after the time when a student with an obscure skin condition that makes even light scratches stand out in welts had a friend trace something across the surface of her back with a fingernail, and the whole class looked on while the words GRAD SCHOOL slowly appeared in raised skin surrounded by angry red marks.

This time, nobody will admit to pinning the skidmarked undies to the wall. Thankfully they will disappear after the first break, sparing you and the class the indignity of having to critique them. Still, fuck.

DÉTOURNEMENT

Don't forget how easy it is for them to find images of your work on the internet.

GO ON A FIELD TRIP TO DIA BEACON

The trip itself will be pleasant and uneventful. However, the following day, officials from the charter bus company will call your department head and allege that student behavior on the return drive involved alcohol consumption, the formation of an impromptu mobile drum circle, and verbal abuse of the driver. While these allegations will be persuasively denied by both the teaching assistant chaperoning the bus (who's older and probably more responsible than you are) and the forty or so 22-year-old students present, you will nonetheless be censured for not being on the bus in emails that will be copied to a large part of the school's faculty and administration.

ANYTHING RELATED TO VIENNESE ACTIONISM

Do not mention it, in any class, ever. If a student brings it up, give them a patronizing laugh and "patiently" explain that the whole thing is an urban legend. Even if for some reason you have to admit that the movement actually happened, don't allow any license for studio work to be made in response to it. This should probably be self-evident, but if you haven't been teaching for that long you might forget exactly what 19-year-olds are capable of, and naively think it would be good for them to know what something genuinely shocking might look like. Years later, never quite the same, you will still be haunted by the things you saw that semester.

GIVE A PRESENTATION ON AN ARTIST OF YOUR CHOOSING

Someone will pick Richard Prince, and focus on his early work. The student will do a good job, but when the dean comes in midway through the presentation to sit in on your class as part of the review process for pre-tenure faculty, there will be a very large image of Prince's *Spiritual America* projected on the screen at the front of the room. Some of the students may find the reflex bad joke you make about your "history of

child pornography seminar" amusing, but the person responsible for determining whether your contract gets renewed will not.

BRING FOOD TO CLASS

Someone will decide that everyone in the class would like to unknowingly eat pot muffins at 8 AM on a Tuesday. You will have to wander around for the next four hours with a bunch of tripping students, trying to explain to those unfamiliar with the experience that "yes, it's way more intense than smoking it" and "this will only last a couple of hours" and "no, there's nothing wrong with your heart, just stop holding your breath."

One particularly innocent student, someone you suspect has never so much as taken a drag off a cigarette, will actually start doing the "dude, have you ever really looked at your hands?" thing that nobody ever does except in movies about hallucinogens made by people who have never taken hallucinogens. When you, concerned, ask how she's feeling, she will pause for a long time before slowly looking up from her outstretched palms and thoughtfully replying, "I feel very … focused."

Figuring if you just handle this yourself you're going to get fired for it, you will bring your entire class, stoned and giggling, to your department head. She will have no choice but to call the school's public safety office, which will then apparently have no choice but to call the local police, who will threaten to charge the baker of the muffins with nine counts of felony poisoning. While you would be happy to see her get in some kind of trouble on the principle that everyone should have the right to decide themselves what drugs they want to do and when, the prospect of her having to do hard time seems a bit extreme and everyone involved is relieved when nobody shows up to arrest her.

Later that afternoon you will have to endure a lengthy meeting with someone from the college's "risk management" office. This official's job description, enthusiasm for discharging his duties, and Men's Wearhouse suit will all combine to make you bottomlessly sad. For the next hour he will run through the whole Aristotelian taxonomy of logical fallacies as he tries to shoulder you with responsibility for the situation in a transparent effort to minimize the school's exposure to litigious parents. After he finally gives up and goes away, you will fall asleep in an uncomfortable chair in your office. When you wake up hours later, sweating, in the middle of the night, you will have missed your train back to New York.

** The first one happened not to me but to someone I know. The rest are firsthand. Any resemblance to actual people, places, or events at the school at which I am presently employed and hope to pass tenure review soon is purely coincidental.*

*The best or most memorable art assignment
you ever got:*

1995.

5th grade.

10 years old.

My art teacher roamed the classroom observing our drawings of people. He advised me to add a neck to my drawing of a person, grabbed my pencil, and elevated the head of my figure. Fireworks went off and I had my first artistic epiphany. Yes, a neck can make one look fantastic.

As a young English art student in the 60s I was painting what I thought to be ambitious pop paintings based on photographs of the American Civil War. While I was working on a large portrait of Stonewall Jackson a comment was passed that I just didn't know how to paint heads and that I should go across the road to the museum and look at the Rembrandt portrait. The comment smarted and so I went to look and stayed for three weeks, painting from the Rembrandt. It was the one and only true painting lesson I ever received whilst in art school. You couldn't just copy the appearance of the painting—you had to go through following the way you thought the painting was made from your observation of it, which brought you to terms with the range of feelings imbued into the painting of the portrait. From the slow modeling of form, to the flourish of costume, to the final skeins of glazes and scumbles, you could feel the tempo of the painting's making and how it was built. You could just sense the slow emergence of presence, of a form emerging in space and something very human taking place through the palpable use of the light—the act of seeing with paint.

In the fall of 1999, it seemed that all of the freshman students from the smallest towns dotting the South and Midwest ended up in Russell Ferguson's foundations class at the Kansas City Art Institute. Most of us had gone to tiny public high schools in places that didn't offer much in the way of culture. I, along with several of my classmates that year, was from a small town in Kentucky, where Versailles is pronounced like something you attach to your boat, and Antigone sounds like a cleaning product. I grew up thinking that all artists went through a period when they made drawings and paintings of lighthouses or sunsets, whether they lived in New England or not. I didn't know what to think of this mostly brilliant yet eccentric professor.

Russell Ferguson's teaching philosophy centered on giving nearly impossible, often confusing assignments, and then critiquing them through references to various artists, movies, books, both well-known and obscure. He often seemed unaware that his references would be lost on his audience. A casual reference to the name of a former student held the same weight as a citation from *Who's Afraid of Virginia Woolf?*: both held the same weight for him, and he imagined that we were equally familiar with them. Growing up where I had, most of these references were lost on me, but in the rare moments where I picked up on one, I was overjoyed—as if I were part of some secret society.

Russell's assignments that semester ran the gamut. One day we were instructed to make a watertight vessel large enough for a person, using only sticks and twine. I remember tightly weaving hundreds of tiny twigs into a large basket form held together with jute, wondering how it was ever going to hold water; a friend of mine took the assignment more figuratively, making a sort of drawing in space with his sticks. Another day we were each given a large twenty-four by thirty-six inch sheet of paper and a litho-crayon and instructed to fill the entire page without making any marks.

The lack of clear direction sometimes led to amazing innovation. Other times, it produced utter chaos. There was the day we were each to design and then build a proscenium arch stretching across the room without using any glue or tape—only folded paper. One student, in a late-night art school "epiphany," covered the entire classroom with calligraphic ink-brushed scrolls of butcher paper and then, if this wasn't enough, proceeded to raid the bathrooms for toilet paper, to layer her poems in a sea of white. In the morning, wading through this bed of crackling paper covering everything, another student rushed to a corner of the room, dramatically exclaiming, "Oh my god, where is my paper bridge? It was beautiful!"

Russell got annoyed if we asked too many questions about a particular assignment's parameters. One day late in the semester he grew tired of our questions and complaints and decided to pantomime all of our nightly assignments. On most evenings, a group of the more hardworking and dedicated students returned to the classroom after dinner, to try to figure out how to fulfill—or even understand—the aim of the project.

I remember looking with envy at the other foundation classes' work. There were life-sized sculptural self-portraits made out of bamboo skewers and hot glue, carefully rendered large-scale drawings of piles of bricks, and monumental portraits in the style of Chuck Close. It seemed like these classes, unlike ours, were populated by students from art-magnet high schools: they were familiar with contemporary artists, materials, and techniques. They knew, for example, how to correctly pronounce Titian (not "Titan," as I thought, since he painted Greek gods like the ones in *Clash of the Titans*—a movie I'd watched in my high school course on Greek mythology).

Compared to these students, our class's projects at first seemed meaningless and anticlimactic. It was only later that I realized how much I had learned. Much like Daniel LaRusso in *The Karate Kid,* only after the class had ended did I become conscious of the myriad skills I had developed through these often obscure and seemingly pointless exercises. I think some of us also wondered if our names could one day enter the lexicon of Russell's obscure references. I don't suppose I made a huge impression on Russell Ferguson that semester, but I like to imagine that, years after I graduated, some student presented her paper arch, or stick vessel, and Russell smiled wistfully, saying, "You've made a Rachel Frank"—leaving the bewildered student to wonder, "Rachel Frank—who's she?"

SEAN DOWNEY
WELCOME TO THE RAG BALL

Lester Goldman taught a drawing course at the Kansas City Art Institute called "Welcome to the Rag Ball." The entirety of the course structure, subject, and, to some extent, material production, revolved around a towering bale of thrift-store clothing placed in the center of the classroom. Tautly compacted by wire, this purchased-by-the-pound compression of random apparel was early on (and ceremoniously) snipped open. What started as a massive fabric monolith exploded into a landscape of clothing, color, pattern, and topography that became the motif, metaphor, and matter of the class. In the weeks that followed the "opening" ceremony, the mountain of clothing overtook the room—as did the peculiar thrift-store "clean" smell that seems designed to mask garments' potentially dubious history.

This was technically a drawing class, however nearly all forms of exploration were encouraged. An excerpt from the course syllabus reads like a passage from Hakim Bey's *T.A.Z.* (another formative influence for many KCAI students in the mid-90s):

A Rag Ball—a political fiasco, the masses at their most unruly, mobile moulds with sexualized pretensions, a potential explosion of indigenous hues, surplus use-value, abundant material in the service of erotic fantasy disguised by religious ecstasy, a funky cacophonic and dissonant collision bound for transport.

German-English slippage
Lumpen Ball <Rag Ball> a spherical object or dance consisting of rags. Lumpenproletariat or the ragged masses. Lumpen Sammler <Ragpicker or collector> Lumpen Nacht or the Nite of Rags. Lumpenwald or Rag Forest. Nacktlumpen or Naked Rags. Lumpen as phonetic reminder of lump allows rags to be humanized, conceptually always seeming to be in a state of loss relative to that which they once contained.

An impromptu performance can be the moment when the Lumpenball explodes as the steel hoops that bind it are broken. Dress up begins and all play a new role, "fool for a day." A random identity that has no meaning other than its impulsive goofiness.

As the semester progressed, the material laws of art-school entropy took their course and what began as mountains and valleys of clothing dwindled. All wearable articles were eventually scavenged, and much of the rest became painting rags or components of archetypal art-school "investigations," derivative of Jessica Stockholder, Mike Kelley, Robert Rauschenberg, Paul McCarthy, etc. It was essentially dumpster-diving invited into the classroom and domesticated; and as rummage was not only a way of life but also an aesthetic foundation for many of us, it gave one the feeling that a new standard of excessiveness in this realm was being sanctioned.

We did draw constantly in class—we also collaged, built ephemeral still lifes and sculptures, stuffed clothes to make figural stand-ins à la Hans Bellmer, and occasionally would have models posing in the piles or putting on articles of clothing. I don't remember any of the student work made in the class, which in retrospect makes perfect sense: the "process over product" mantra of our artistic education was here perfectly embodied as curricular regimen. However, though all "products" of the class have vanished from my memory, I do remember the sort of semester-long epiphany that took place: the *eureka!* of chaotic space, abundant color, and material malleability; a fresh set of criteria for relocating the boundaries between everyday utility and artistic utility; and the inheritance of a new, excessive model for energetic, serious play.

The first assignment in my college sculpture fundamentals class was to carve, in foam, something extremely personal. I was a third-year history major. I chose the Alamo. I was not from Texas. A scaled-down relief of the front exterior of the building was the result. It took about two weeks. I knew I would not be a historian afterwards. Thanks, Keith.

When I got to the Yale MFA program in 1997 I met a man on the street one night outside a pub. We had an argument right away about his beloved Liverpool Football Club and how my Manchester United Football Club was going to crush his cheap pub-team in the Premier League standings that year. He called me "Chocky" before he rode off on his bicycle. Later I learned that he was named Paul Elliman and was teaching a graphic design class about reading the weather. I enrolled in his class and definitely misunderstood the first assignment. He showed us Turner's cloud-study paintings and I remember seeing some pictures of a tree up in Eagle Rock Park that he photographed every month for a year. I presented a tormented drawing I made of NATO warplanes bombing Belgrade, Serbia because, I recall, the U.S. Air Force was rumored to have deployed some kind of cloud-making/anti-radar technology. When I brought the drawing to class, no one said a word. The next week Paul asked me to meet him for a bowl of soup. He more or less told me that I shouldn't come to his class anymore. Instead we were going to meet every week after class at Atticus bookstore and eat the same half-cup of soup and half-sandwich for the remainder of the semester. Mainly during these lunches he complained to me about his students and I mainly listened, which was a great idea. The whole thing taught me that I shouldn't confuse my interest in design with the design profession, because as an artist I can go anywhere and do anything and never ever ever have to discuss typography at a dance party.

HARRY ROSEMAN
ASSIGNMENT ON ASSIGNMENTS

At the start of every year I give my new students the following exercise.

Bring in four reproductions of artworks:
1. A work that you like and think is good.
2. A work that you don't like and don't think is good.
3. A work that you like, but suspect might not be good.
4. A work that you don't like but have to admit is good.

Explain your choices.

This is not a studio assignment and it doesn't result in visual work, but it starts the year off with a context for discussion. It allows the students to begin taking stock of their ideas about art.

—

In a Sculpture II class in the fall of 2010, I directed students to make a sculpture (though there was wiggle room in this assignment as to their definition of sculpture) that operated simultaneously as part and as whole, an incomplete thing and a complete thing. The work could be representational or abstract.

In giving assignments I usually set a preliminary due date for ideas, drawings, and models. During this first phase, students feel out the parameters and possible meanings of the assignment—test the waters, in other words. Often, within the first round of ideas, responses are straightforward or literal: they "solve" the problem of the assignment, but not in the most interesting way. For example, one student suggested that a heart is both a part and a whole. This answer seemed reasonable: even though the heart is a working part of the body, it is its own thing, and can be thought of as an entity—certainly more so than an arm in relationship to the body. But in discussion, the class agreed that the heart was a rather straightforward solution to the assignment, and didn't add enough to the concepts of whole and part.

Starting from idea of the part and whole, the ten students in the class discussed the assignment, moved sideways, circled back, and eventually came up with a range of expansive solutions. Some were very hard to figure out how to implement—thoughts without physical substance—at least to begin with. The same student who came up with the heart moved on to issues of truth: how does one attain the complete truth? Isn't truth always partial, always incomplete—yet often presented as the complete truth, the whole truth (as in the phrase, "the whole truth and nothing but the truth")? For her work she built a simplified witness box, where the participant would sit, be sworn in and answer very specific questions about his or her movements and experiences, the accuracy of which would be pretty hard to assess.

Another student's solution was to pull up, with some editing, key words associated with war photography searches in the Magnum photo archives; these texts were printed as photographs and installed on a wall as an exhibition. A third mined memory and dream, and built an installation where the parts of a dream most vivid as wholes were depicted in high contrast—the more vague aspects were represented in white. Yet another created an installation in different rooms of an apartment: an extremely cold room, a room that smoke seeped into, a room where an alarm was going off; all were meant to add up to a whole experience of anxiety.

I often think that an assignment works when the students tell me things about it that I hadn't recognized. When this happens, I know that the assignment is broad enough, and it teaches me as well as the students.

—

Some time ago my wife, the painter Catherine Murphy, gave a short drawing course at the graduate school of art at Yale University. The course was scheduled for four sessions. The four classes started with the following statement that Catherine gave out to the students:

The subject of this seminar is subject.
How does subject differ from content?
Is subject something that we are responsible for?
If so, can we be responsible for what time does to subject?
Is subject what the viewer perceives or what we intend?
Can formal concerns become subject or is that a conceit?

Does abstraction have subject or is it the realist's burden?

Is it a burden or a gift?

The class was centered on observational drawing. Each week there was a setup to work from. For the first session, it consisted of a table with a tablecloth and place settings, and two chairs. For the second session, a nude model was seated at the table. For the third, the place settings and chairs were removed and the model lay flat on her back on the table. For the final session of the class, the table was removed and the model lay on the floor, completely wrapped in the tablecloth.

A few things struck me about this assignment. The first, of course, was the examination of subject and meaning. The second was that many painters who work from life often have a passive relationship with their subject—not in terms of the choices they make and their points of focus, but in their understanding of how much or little control they can have over it. The assignment was a way to show students that perceptual painting could exist in the mind as a concept—in relationship to ideas about realism and observation—and that one could have both in varying degrees as needed.

SHIRLEY IRONS

In a second-year painting class at SVA, I distributed two short stories by Lydia Davis: "Television" and "Gaslight." Since they are each one page or less, they're pretty impossible to summarize here, but I asked that the students read them and try to make a painting that combined some of the attention to detail, clarity, neurosis, humor, or whatever else they got from one or both. Almost all did their best and strangest work. When I enthused about Davis's writing, saying that she was our Samuel Beckett, they looked blank. "Beckett? You know, *Waiting for Godot?*" The gaps are amazing.

I was frustrated by a class that seemed to be making work that was just too easy. Too many conceptual one-liners, too many lightweight "political statements" devoid of any ambiguity, too much autopilot minimalism. No risk, no complexity, no real personal investment.

My assignment was: make a piece that is guaranteed to make the viewer say "WTF?!?"

Not every response was a masterpiece, but at least students stopped relying on their default can't-fail strategies. "WTF?!?" is actually a much humbler goal than changing the world or manifesting mystical truth. To aim low was liberating. For some students, the pleasure they experienced in completing the assignment served as a reminder that making art does not always have to rely on strenuous efforts toward a precisely predetermined goal. Instead, sometimes the process can be only a playful exploration, destination unknown. Feedback to this assignment was strongly positive. Several students reported they felt that WTF-ness was exactly what had been missing from their work.

Years ago, when I was teaching at one of the fine community colleges in our area, one that was known for its stellar art department, I gave an assignment to my painting students to do a self-portrait showing an individual trait. A student whom we shall call "BJ" came up with a realistic, well-painted work showing him performing fellatio on himself. This was certainly outside the school's established standards of propriety, but I had taught my students to be true to their feelings and encouraged complete freedom of expression. In the ensuing critique, I praised the uniqueness of the work and talked about the sort of reaction that it could bring. At the same time, I reiterated something I had said before: that artists should treat negative criticism as water off a duck's back.

At the end of a semester, we were to install a student show. BJ showed up brandishing his work proudly. I told him the school would have to give permission to show something like this. I relinquished my responsibility by seeing the new president and presenting her with the problem. To my relief, she came up with what seemed to be a good compromise. We would show the painting, but it would hang in an out-of-the-way spot, away from the other works. I found such a place—a dark corner, in which BJ's self-portrait would be relatively concealed.

At the opening, I was relieved that, indeed, our president's hunch had been correct, and nothing much was made of BJ's painting. However, arriving at work a couple of days later, I was shocked and alarmed to see a bevy of reporters and photographers besieging the art building. I must admit I was relieved to learn that they were not there to investigate our student art exhibition but rather because our vice president had been arrested on pornography charges unrelated to BJ's portrait, or our show. But what if they saw the painting? This would certainly exacerbate the issue and make trouble for the school.

Again, I ran to the president. I had learned that it was better to be a coward than risk one's job. She very calmly told me to tell BJ about the recent developments, and how it would be good to take down his work. But then, knowing the character of the artist, she added that if he refused to take it down, we should just hope nothing would ensue. Things could not get much worse.

BJ, of course, refused. He brought up the French Salon and how some artists had to escape to the *Salon des Refusés* when deprived of their intellectual freedom. I left the painting up, and nothing happened. Years have gone by, and I have since moved to a different position as professor of art at a nearby university. BJ is now the chairman of the art department of another community college, in the same district as the one in which his controversial painting had been shown.

TOMMY WHITE
TWO MODEL ERECTIONS

I was an undergraduate at the Hartford Art School in the early 90s, and I studied with the late realist painter Stephen Brown. I had a lot of respect for Stephen, and am grateful for all that he taught me, but I often found that his figure painting classes tended to drag on as I struggled to stay focused. There were exceptions, like when the young model from a neighboring university would show up. I remember that she was a volleyball player, tall, in shape, with long, dark-blond hair. After the usual succession of models, who seemed to range from the uncanny to the otherworldly, having someone show up who was similar in age—and who I was attracted to—was not only exciting; it was what I thought I needed to make a great painting. Sadly this was never the case, and I was never able to turn her beauty, or my lust, into art.

Then one day a tall, thin, youngish man came to pose for us. The class was fairly typical through lunch (first drawing, then thin layers of paint, breaks and cigarettes every half-hour) until, early in the afternoon, much to everyone's surprise, the model's dick became erect. Stephen, my classmates, and I were stunned and silent. The erection was many things: shocking, funny, and threatening. I felt prudish, especially for an art school student. I don't remember all the feelings I had toward that erection, though I'm sure they ran the gamut. What I do remember is that I was uncomfortable and that I made my best painting of the semester that day.

Recently I was teaching a figure-painting course in which I felt that many of the students were suffering a malaise similar to my own as a young figure painter. Week to week I tried to inspire and motivate them, to pretty mundane results. Then one day an average-height, rotund, exceptionally hairy middle-aged man showed up to model. The day was dragging on, as most had. But as I walked from one easel to the next, critiquing each painting, suddenly a light glinted off something in the room and reflected back into the corner of my eye. I turned to see a touch of preejaculate on the tip of the model's now-erect cock. Here it was again: a hard dick in figure-painting class. I said nothing and looked curiously to the students. Nothing. Had half of them even noticed? I let them work and let the model fester for another five minutes, then called for a break. The model,

obviously embarrassed, quickly left the room. At first I was frustrated with him but as I surveyed the room, looking at all the paintings and at all of the students, I felt that perhaps his erection was the most inspired thing all day.

ALFREDO GISHOLT
CLANDESTINE DRAWING

When I was in school in Mexico City there was this drawing class that met every Tuesday night in the basement of the Academy. You heard of it through friends; it was never mentioned officially. We started at eight, but the end time wasn't set—sometimes we left at ten-thirty, other times we kept going until two in the morning, drinking sake and tea as we drew. There were always three models—either two guysand a girl or two girls and a guy. Two of them were constant, and we understood that they were a couple, but we could also sense that everyone they brought in had also been their intimate. In fact, that was the point. They wouldn't start right away, but as the evening progressed the models would move in various ways toward intercourse. Some nights they would start by rubbing one another, other nights it was quicker, and sometimes they'd end up having sex three or four times, resting in between in various poses on the pared-down stage. The only thing we couldn't do at any point was stop drawing. That was the single rule. That moved it away from pornography, but toward what? Each night, we left with a roll of drawings that weren't ordinary, that much is certain. I went regularly from about October until May, and then one evening neither the models nor the teacher showed up, and that was apparently the end.

According to Rosalind Krauss, Frank Stella once told the art historian Michael Fried that he admired the "genius" of Ted Williams, the only modern baseball player to hit over .400 for an entire season. Stella's analysis was that Williams *saw* so fast that he could actually see the stitches of a ninety mile-per-hour fastball as it crossed the plate before he hit it out of the park.[1] The degree to which elite athletes can see, interpret, and act simultaneously, without a fraction of a second spent thinking about what is happening, often separates the greats from the rest—remember Michael Phelps's gold medal finish in the butterfly in the 2008 Olympics?

It's easy to imagine great artists "performing" at this level. For one, I think of Rauschenberg making combines: totally immersed in the performance of work, as if the artwork, a mere record of his focus and intensity, were making itself. Whenever I've taught drawing or painting, I've had discussions about this with students. It seems to me that most students (and artists) would benefit enormously from learning to free themselves of extraneous thoughts and impulses in the studio and just *do*. One can't teach genius or greatness. But can a training regimen be designed to teach artists how to turn off their minds in the studio and become one with their process?

Hoyt L. Sherman thought so. Sherman was an art professor at Ohio State University in the 1940s. He was also Roy Lichtenstein's advisor at OSU, and his ideas about perception and "visual unity" in picture making influenced Lichtenstein's thinking for fifty years.[2]

In his recent book, *Hall of Mirrors: Roy Lichtenstein and the Face of Painting in the 1960s*, Graham Bader writes that Sherman believed "successful contemporary artists had to learn to work as had Poussin, Rembrandt, and Cézanne before them: to pursue unity in seeing, unity in the process of seeing-and-drawing, unity in the total creative act."[3]

For Sherman, "unity in the total creative act" could only be achieved by training the faculties of perception to work as one with the body, thereby eliminating "cultural interference."[4] "Seeing must be developed as an aggressive act," he wrote in his 1947 book *Drawing by Seeing*.[5] To this end, he developed an experimental drawing curriculum called the "flash lab." The following is a description of the program, as quoted from Bader's book:

The flash lab [was] a seventy-foot-long structure on the OSU campus specially converted for his teaching. The facility was so named because the instruction that took place there was built around the "flashing" of images with a tachistoscope (originally for a fraction of a second, progressively longer as the course continued) on a large screen at the front of the light-sealed structure. After each image was shown, students were asked to draw, in absolute darkness, the figure they had seen. Beginning with simple abstract configurations, these flashed images grew increasingly complex over the course of each class session and the six-week program itself, eventually including old-master drawings and three-dimensional constructions assembled by Sherman and his assistants (among them Lichtenstein himself). As outlined in *Drawing by Seeing*, a rigidly organized curriculum was necessary to guarantee the success of the flash lab course: classes met five times each week for a total of six weeks; each class began with a ten-minute "warm-up" period during which music was played and students would "sing, whistle, or beat time" in the pitch-black room; exact arrangements for the positioning of the projection screen and student drawing tables were preset and altered slowly over the course of the program; and, most important, there was to be "no talk about drawing, about great artists, about the history of art," or about any other subjects which tend to establish verbalisms instead of drawing reactions.

Sherman's flash lab was to operate as a well-oiled machine for producing efficient and unified vision, a space free from both corrupting "verbalisms" and disharmonious optical intrusions alike. The flip side of this distrust of any form of intellectualization was a foregrounding of the role of the body in producing successful works of art. The music at the start of each flash lab session, for instance (which continued for the full thirty-five minutes of class time at the start of the program and was slowly phased out as the course progressed), served to establish "rhythm" and "keep the body attuned to its full possibility of movement." And the very centerpiece of flash lab instruction—the split between the "flash" of vision and the tactile act of drawing in darkness—was to focus attention on these

distinct sensual "channels" so that their integration could be achieved by course's end.

By the conclusion of the six-week class, the distinction between drawing and seeing was to have been abolished—both in the program of instruction itself (for the tableaux to be represented would finally be shown as the students drew them, rather than flashed beforehand) and in the perceptual and compositional habits of individual students (as successful flash lab participants, so the plan went, would by then be converting "visual relations and reactions into kinesthetic and tactile relations and reactions," and thus producing images of exemplary vitality and pictorial organization). The body, in fact, can be seen as the central term of Sherman's flash lab program: for students who completed the curriculum, seeing was to become an act of "reaching out and seizing" an object or scene, and composition itself a "kinesthetic expression of the whole body" liberated from cultural interference.[6]

As for the athlete/artist analogy, Sherman himself claimed that his "finest" flash lab student was actually the OSU football team's quarterback.[7] Roy R. Behrens, who studied under several of the original flash lab students, writes that the team was on a losing streak when Sherman decided to get involved:

[Says Sherman,] "I explained to the team that attention to the field of 'solids' or players and 'voids' or openings is the most effective way to play football well."

Then he unveiled his latest invention, a "flash helmet," consisting of a modified football helmet with a cord attached to a hinged visor-like shutter. By pulling the cord while standing behind the passer, Sherman could limit the view of the field to split second flashes—just as he had in the flash lab. The passer would see the receiver during that fraction of a second, then throw while the shutter was actually closed. By that method, the passer would not be allotted the time to focus on nonessential details, but rather on figure-ground patterns or visual gestalts. There was a dramatic improvement that year in [the] football team.[8]

Were there other successes? Behrens writes about another student who was inducted into military service:

During the student's physical, he was asked to read the letters from an eye chart. "The student took one look at the chart," Sherman remembered, "turned his back, and read accurately the rows of letters down to the 20-18 central acuity range. The poor sergeant was baffled. The student had developed eidetic imagery."[9]

Behrens adds:

No one knows the true extent to which Sherman's teaching methods were actually successful …. But back then, the players, the press and the public believed (if only for a season) that the flash lab was largely responsible for the dramatic reversal of fortune for the Ohio State University football team.[10]

A Google search turns up no evidence that anyone is currently teaching perceptual unity using Sherman's techniques of drawing in the dark, even though the original textbook is available on Amazon and a laptop and digital projector would do the trick in no time. The room that housed the original Flash Lab remains a functioning classroom at OSU and I was told by a friend and faculty member that remnants of the set-up can still be seen, albeit in bits and pieces.

1. Krauss, Rosalind E., "The Story of the Eye." New Literary History, Vol. 21, No. 2 (winter 1990), p.283.
2. Bader, Graham, Hall of Mirrors: Roy Lichtenstein and the Face of Painting in the 1960s. (Cambridge, MA: MIT Press, 2010), p.2–3. Bader also acknowledges studies of Hoyt Sherman in Bonnie Clearwater's 2001 catalog Roy Lichtenstein: Inside/Outside and Michael Lobel's 2002 book Image Duplicator: Roy Lichtenstein and the Emergence of Pop Art.
3. Ibid., p.3
4. Ibid., p.6
5. Sherman, Hoyt. L. Drawing by Seeing: A New Development in the Teaching of the Visual Arts through the Training of Perception. (New York: Hinds, Hayden & Eldredge, Inc., 1947) p.9.
6. Ibid., pp.5–6. Bader's quotations are from Sherman's Drawing by Seeing.
7. Behrens, Roy R. "Drawing in the Dark: Hoyt Sherman and the Flash Lab at Ohio State University." http://www.bobolinkbooks.com/Ames/DrawingInDark.html, p.3. Initially published in Print magazine (September–October 1992), pp.96–101.
8. Ibid.
9. Ibid.
10. Ibid.

SPORTS ASSIGNMENT

Rate a sport along several axes, such as:
— Play time
— Number of players required
— Equipment required
— Size of play area
— Size of ball(s), if any
— Amount of endurance required to play well
— Etc.

Then, modify the sport by changing one of the ratings. Basketball examples include:
— Play with a tennis ball instead.
— Play eight-on-eight instead of five-on-five, and use two balls, one of which is worth an extra point.
— Play low-endurance basketball: players pick their starting location on the court, and then cannot move for the whole game.

NO MATERIALS GAME ASSIGNMENT

Create a game that can be played without any materials, like you might play in the car or on a hike. The game should be playable with two players, and take less than fifteen minutes to play one round. You may specify where and when the game is played (anywhere, only at night, on the beach, etc.).

DICE GAME ASSIGNMENT

Make a game that uses dice. Play-test the game and observe the results. Based on your analysis, modify the original rules. Repeat this process at least five times.

In 1974, I took a year off from college. I was living alone, for the first time, in New York and working during the day as a bicycle messenger. In the evening, I took anatomy at the Art Students League with Robert Hale. I think the class met three or four times a week. We drew from the model. One evening each week, Hale would give an anatomy lesson that focused on one part of the body. He had a very distinctive way of lecturing, which included drawing with charcoal affixed to a long stick. I remember enjoying these demonstrations, the way he spoke, accompanied by those effortless sketches. After every presentation, Hale would make himself available to critique our work. There were always a small number of students lined up to show him their drawings, but I wasn't one of them. The other students were more skilled. They were on a different level.

One evening, after a couple of months, I decided that, for better or worse, my time had come. After waiting patiently, I presented my sketchpad. Hale turned the pages and said that what he saw was "elementary." Then he asked to see what else I had, so I showed him some sketches I had done in college. One was of several quickly drawn contour line figures that overlapped each other, creating an abstract rhythm. It had probably taken me all of several minutes to make. "Oh, I like this," he said. "I can put this in the student show." The idea of exhibiting a work that wasn't made in his class was deflating. And it was also the first time I had shown anything in public. I wondered what Hale saw in the wavy, intersecting pencil lines and what his rationale was for including this sketch in his student show of expertly drawn figures.

When people ask me about teachers that I've gotten something from, I always go back to Hale, but until now I've never thought about the reason. It wasn't what I learned about artistic anatomy. Maybe it was the way he performed his lectures. They felt masterful, which was an experience I never had before. To see him begin with something as complicated as the human body and then take it apart with his simple but elegant language of lines, planes, and masses, felt all-encompassing, as though you could apply the principles to anything and it would make sense. But Hale also made sure that part of his talk always

included useful bits of practical information. He would give us tips on how to shade volumes, how to use imaginary light sources, and so on.

But then there was that drawing in the student show. It didn't matter that I hadn't mastered the figure. Hale saw something in my sketch that was moving in a different direction, towards abstraction. Instead of merely exposing my limitations as a figurative artist, he gave me another way to look at what I had done. It was a moment of encouragement, something to keep me going, even though at the time I had no idea where my work was going to lead me.

The best assignment of which I've heard recently was created by an artist whose work I do not particularly admire. It was this: the class pooled their money and purchased a piano. Then they smashed it to bits. Over the course of the six-week workshop, the class was then to reassemble the piano. Why is this such a great assignment? It neatly bypasses the ego-based obstacles of individual expression and authorship through a collective project of useless labor. I am quite jealous of this assignment. Maybe I will steal it. After all, I have been told more than once by colleagues that "there is only one syllabus." But I am reluctant to give up what I perceive as the originality of my own particular teaching method. And this is a highly proscriptive assignment. It is an anecdote in and of itself, and I worry that it would disrupt the emergence of further anecdotal material (one of the greatest joys I take in teaching art is the stories that come out of it), which often comes not from busying students with little jobs to perform, but from forcing them to do less and less. Sometimes even nothing at all. This has proved an interesting strategy in my current post at a liberal arts university. In this environment (as opposed to the art school environment that I am used to) students are invariably preoccupied with their grades. I find this preoccupation annoying and myopic. This led to some interesting conflicts.

In my former post at an art school, I found that my students generally scoffed at assignments. They considered themselves artists rather than students and they expected me to meet them on their own terms, which I was happy to do. After all, I prefer a critical conversation in which there is a measure of reciprocity. But in my current job I often find myself working with econ and poly-sci majors who see nothing wrong with telling me that they are taking the class in order to raise their GPA. These students often complain to me that I am not giving them clear enough guidelines in my assignments. To this I often respond with a mock belligerence: "I am not your father! Do what you want!" This of course makes it nearly impossible for them to "do what they want," so long as they see me as any kind of authority. Of course, I am extremely uncomfortable with any kind of authority conferred upon me from outside, and this is my way of introducing the reciprocity. I *must* assume the role of authority in this situation. And so

I assume this role by rejecting it, and handing it back to these poor souls drowning in obedience. Now it is their turn to "assume the role"—that of an artist and independent thinker. I admit that it is a bit of a crash course, but I feel it is necessary in order to prevent myself from becoming a "cult leader"-type professor with a pack of slavering clones at my heels. To be honest, the results are mixed. Here are a couple recent stories:

My advanced sculpture class consists of four students, all majors in art, all in their final year, and thus (superficially) committed to the vocation. One of the students seemed a bit depressive and listless, and this led me to mark her as the one with the greatest potential. I am sure I saw a bit of myself in her. In the beginning of the semester, she received the keys to her studio, a damp basement room next to the wood shop with no windows. She occupied it by dragging in some trash from the street outside, most notably an old armoire made from cheap materials. I would go into her studio periodically and attempt to stage discussions with her, deliberately ignoring the lack of visible work. But she found it difficult to let this go herself. She constantly returned to the fact that she had made very little work, despite my repeated statements that this was not my concern. She begged me for an assignment, and finally I capitulated by giving her a ridiculous one (although no more ridiculous than average), which she promptly ignored. Interestingly, she often displayed great enthusiasm for the work of her peers, assisting them in their projects, and so on. I took this as a good sign too. Occasionally, her studio would contain some aborted attempts at "traditional" sculpture, little half-formed models made out of clay and such. Finally it was the end of the semester, and time for the exhibition of students' work. She seemed at odds as to what she should include. This seemed like the proper time for a push. I asked her if she intended to include the old armoire, by far the largest object in her studio. She was taken aback at this.

"Are you serious?"

"You have been staring at it for the entire semester. If it is not art by now, it will never be."

"Hmmm. Then I should also include this," she said, gesturing at a broken full length mirror.

Together we assembled a box of what we judged to be the more interesting items in her studio and loaded everything in the truck heading up to the exhibition space. Once there, she assembled various provisional structures out of them, including a particularly interesting piece made of a broken table with found photographs affixed to it with Vaseline. Her work far outshone most of the work in the exhibition, dealing in a level of material and conceptual sophistication far beyond that of most of her peers. I watched her holding court before an audience of attendees at the opening, explaining her work to them. Later she confided in me with a sense of barely concealed glee, "I just did my first art-bullshitting speech!"

I considered this a victory on both our parts.

The second story concerns another student in the same class. Over the course of the semester my opinion of this student changed considerably. At first I considered her to be a rich spoiled brat with little or nothing interesting to say. I had no qualms about sharing this opinion with her; for instance I once told her that I found her floor-length mink coat repulsive and her attitude regarding her place in society crude and bourgeois. This turned out to be the correct way to approach her, as she quickly picked up the ball of antagonism and tossed it back to me, and eventually we developed the sort of contentious student/teacher relationship from which, in my experience, great advances are made. She had made a series of pieces meant to be hung on the wall. They were quite elegant, and showed an economy of means that I thought must have been quite difficult for someone who wore a coat like that. They consisted of squares of untreated plywood with eye-hooks screwed into it and a few pieces of thread stretched taut across the surface. However, because my class was designated "sculpture" and had only four students, we were allotted only a very small amount of wall space. Most of the vertical real estate in the exhibition space was given over to the painters whose number greatly eclipsed our own. I think there were eighteen of them. I gave the small amount of wall space to one of the other students whose work I thought it more important to be displayed that way. This generated a lot of protest from the subject in question. So I endeavored to satisfy her by proposing some alternative methods of display. Finally we settled on some black aluminum tripods set up easel-fashion. This looked really good. Unfortunately, there were only two of these. We would have to figure something else out for the third work. The student refused to discuss

this with me, insisting that it was my problem since I had not reserved wall space for her. I decided that something radical was called for here. I suggested that we make the final piece in the series a collaborative piece between her and myself. She agreed. I found a large cardboard garbage bin with TRASH stenciled on it in big red letters. I screwed through the surface of her piece and attached it to the bin. Then I said it was time for us to sign the piece. I told her to go first and I would follow her lead. Again she refused, and said she didn't care how it was signed. I warned her that if she allowed me to be in charge of the signature that I would sign the piece exactly as I pleased. She gestured for me to go ahead, and so I promptly scrawled my name in large letters across the center of the picture. Her mouth fell open. I handed her the pencil. She ran over to the piece and wrote "is a jackass" underneath my name, and then signed her own. Hmmmm. There was one final step during which I knew I might regain the upper hand. This was the title of the work that would be read on the checklist (I managed to talk the students out of wall labels, an idea to which they were oddly attached). For each piece we listed the artist, the title, and the materials. I did not feel like measuring the pieces and so dimensions were not included. Our collaboration was listed thus:

> Justin Lieberman and Jodie Rae Rosenberg
> *Meisterschüler*
> trash bin and student artwork

The best or most memorable art assignment you ever got:

The most memorable assignment for me was from my first semester foundations program at RISD, in 3-D design class. I like it because it presages reality-show style-making contests, and because I can still use it as an "in my day" example when I want to bust on my students for not working hard enough. It is memorable because, as an anecdote, it also illustrates an early example of my turning failure into comedy, my competitive nature, and my obsession with eggs and food.

Because it was RISD, and the faculty were training fine artists along with designers and architects, we had a lot of *problems*. In this class, we had already competitively built bridges from corrugated cardboard, a contest in which my design disappointingly fell about in the middle of both aesthetics and engineering. For one of our last assignments, given over the Thanksgiving break, the professor (sadly I've forgotten his name), gave us an engineering problem. He gave us the following supplies:

> 1 8 × 8 in. square of corrugated cardboard
> 1 paper napkin
> 1 length of string, approx. 18 in.
> 1 bag of oyster crackers
> 1 length of gummed brown packing tape, approx. 8 in.
> and some rough square-stock sticks

With these, we each had to design a structure that could protect an egg—which had to be removable and fully visible—from a fall of three stories. After my poor showing with the bridge project, I immediately knew I would never solve the problem, and so I sacrificed function completely and built a chicken (or turkey) with three cross-form slots for eggs on the bottom. When we got to the roof of the building, I threw the oyster crackers off the side for feed, and let the sculpture (and eggs) follow after. The end. I got an A minus.

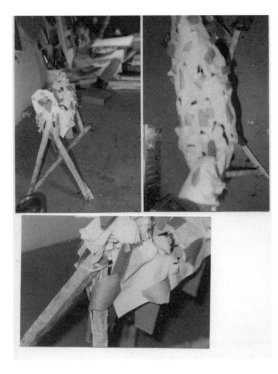

PAINTING IN THE MEDIUM OF FOOD

Guest Assignment for Lauren O'Neill-Butler's Graduate Painting Seminar, "Meaning in the Medium of Painting"
Due May 14, 2010

You could say making a print is like preparing a pizza. You start with a white sheet of paper— that is, the "dough"—to which you add layers of images: cheese, mushrooms, sausage bits, tomato paste, immersed in overprinted inks. In the end, the "pizza" is "editioned"—that is, sliced and distributed for consumption.
—Claes Oldenburg, as told to Richard Axsom in 1996

Tell me what you eat, and I will tell you who you are.
—Jean Anthelme Brillat-Savarin

Ferran Adrià had been invited as an artist, as a thinker in the realm of materials, or better yet, as the interface between the material and the immaterial.
—Roger Buergel, on inviting chef Ferran Adrià to participate in Documenta 12

Your assignment is to present a culinary recipe that encapsulates your concept/theory of painting. The recipe need not be your own, it can be appropriated, but it should be an analogue for your working method or guiding principle.

The recipe should be presented on a 4 × 6 inch card, in an edition of 10, to be shared with the other members of the class and with Sara and Lauren.

The most successful or useful one you yourself have given:

OK, so this was neither the most successful nor useful assignment, but I like it because it keeps the theme of food going. I also always like using ridiculous metaphors while teaching. For example, I adjust Claes Oldenburg's pizza analogy in the assignment below and meld it with the famous Jasper Johns quote ("Do something, do something to that, and then do something to that"), and—the short version—tell students that a pizza with carmelized onions is better than one with raw onions. Recently I had all of my students thinking I was truly crazy when I likened mentally and physically regrouping in the studio—in this case asking them to clean up the studio in the middle of working—to how a tennis player always returns to the middle with a split-step between shots.

The students who participated in this assignment came up with some really good solutions, and we had an instant artists' book.

The best one you ever heard about:

I like a lot of my friends' assignments, and a lot of assignments from various foundations teachers at RISD still hover in the back of my mind, but the most recent thing I heard about an artist in the classroom was an artist teaching a drawing class at a "Jewish-sponsored" university telling some students, who were perhaps slacking, *"Arbeit macht frei."* This killed me, because, even though I follow rules of appropriateness in the classroom—no touching, contraband, or political speech—I can appreciate

the sacrifice of decorum, proper behavior, and professionalism, in service of a really good joke. It's not really an assignment, and it was a fucked up thing to say to a young person, but it suggests a ballsy and enviable fearlessness that is somehow encouraging in this era of customer-service academia. And if it were on a TV show, I would laugh.

DEMETRIUS OLIVER

One of the more memorable assignments I had as a student occurred while I was a freshman in a foundation course. I can't recall the name of the teacher, but the class was 3-D design, and this particular fall day the class was held in a forest far away from campus. The assignment was simply to make something with the materials available at hand within a couple of hours. As I recall, the sculpture I made was kind of generic, but the experience of that event would take years for me to absorb. The simplicity of the assignment belied the challenge of making art with limited resources. It also demonstrated that art could be completed within the time frame of a gust of wind, if the mind is concentrated and the imagination charged.

FIONA GARDNER
KEN HORII'S CARDBOARD CHAIR
ASSIGNMENT

When asked about my experience as a student at the Rhode Island School of Design, I always wind up talking about the cardboard chair assignment in Ken Horii's 3-D design class during my freshman year. Students were asked to design a cardboard chair using 48 × 80 inch sheets of corrugated cardboard, glue, packing tape, and a utility knife. The chair had to hold the student's weight for the duration of a six-hour critique. Over the years Ken made the assignment even more challenging by not allowing students to use glue or tape, and going so far as requiring the chair to be portable, fitting into a box no larger than 12 × 18 × 24.

The assignment was fairly straightforward. Ken first spent a class demonstrating different building techniques with cardboard. We were shown the best way to laminate sheets of cardboard together, how to best cut the cardboard with a utility knife, as well as how to join cardboard using paper-packing tape. Ken stressed that the strength of the cardboard is maintained by folding: the fewer cuts you make, the more weight your design will hold.

My design was a stretch, as far as my actual building skills were concerned. But after four all-nighters in the studio, I had a large triangular block shape that rested on one of its shorter ends, with a seat that sank into the longest of the three sides. It was somewhat reminiscent of a mid-century modernist egg chair. Despite being an unwieldy object, barely able to fit through the studio doors, my chair was extremely comfortable and easily held my weight. This was demonstrated when it came time for my critique—sleep deprivation got the better of me, and I was caught fast asleep in my chair.

I don't remember Ken talking to my class about the cardboard chair in terms of "form follows function" or other design principles. These ideas were inherent in the assignment, and they have had a great deal of influence on how I approach being a photographer. In the fifteen years since I took Ken's class, I have often wondered what his thoughts were on the cardboard chair. What did he intend for his students to take away from the project? I recently had a chance to meet up with him and chat about his memorable assignment.

FIONA GARDNER: When I was in your class, you had just started teaching at RISD.

KEN HORII: Yeah, I got to RISD in 1993. I did a version of the project when I was at Syracuse University. I really focused on it when I got to RISD, mostly because I found a source for the cardboard: the RISD store stocks 48 × 80 inch sheets. I don't know why they order that size, perhaps it's a standard size that box companies use. I just went with the size they have. Your class was allowed to use brown paper tape and glue. For a couple of years I made no glue and tape an extra credit option. Eventually I moved away from that and didn't allow tape or glue.

FG: Where did the project originate?

KH: When I was an undergrad at Cooper Union, we did a structural project with cardboard in a 3-D class and I really just fell in love with working with cardboard. When I was at Syracuse there was a faculty member who did this chair project using wood. For a while I did this project where I gave students a certain amount of two-by-fours, and they had to use this limited material to design a chair.

When I came to RISD I just put the two things together. It's a combination of a project I had as an undergraduate and an assignment I gave that was inspired by another faculty member. What I didn't like about doing it in wood was that there was so much use of the shop that would be necessary to do it, cutting and forming. I really wanted it to be something that students could do with minimal training, directly. Without shop training, without a

band saw. I liked the idea that all you needed was a mat knife and a T-square.

Eventually getting rid of tape and glue, and evolving all these different versions of it over the years, I think two or three years into it I had a whole group of students that made these amazing chairs. They complained that they couldn't take them home for Christmas. They were flying here and there and a couple of them were Korean students that were flying home to Korea and they wanted to be able to take their chairs with them. So that gave me the idea to make the chair have to be portable. Portability came with the idea that it would have to be a certain dimension, and so the dimension I have worked with for a long time is either a domestic or international plane's overhead compartment size. In the airport they have these ridged boxes—you put your suitcase in to test whether it meets the regulation. The international one is really severe: 9 × 22 × 14 inches. I also gave a slightly less difficult domestic overhead compartment size of 12 × 16 × 24 inches. I liked that because it didn't compromise the structure as much, and more students were able to do it well, so I stuck with that for a while.

So that became a kind of extra credit: can you build a chair, no glue, no tape, and have it collapse down to fit in that space? Then the other thing that came into it was recycled cardboard; it couldn't be any larger than the 48 × 80 inch sheets they stocked at the RISD store, so you were working with the same amount of material. It also had to be, obviously, commercial cardboard—in other words, cartons or boxes that had graphics on them, and you had to integrate the graphics into the design of the chair, so there was recognition of the recycled cardboard as part of the design. There have been all these different permutations.

I tried mandating that it have arms, and a back rest, and then the reverse—no arms, no back rest. At one point I tried taking it into the realm of sculpture and not defining it as a chair. Saying that it had to be a form you could sit on. That really became ridiculous. Everyone wanted a chair, and they made forms that looked like chairs and functioned like chairs. So then I just went back to calling it a chair. Then I did a table option, including a table that was done from folding a single sheet of cardboard. A student that was really well versed in origami came in with a chair folded from a single sheet of cardboard. It didn't really work that well, but I liked the idea.

I decided to give that as a challenge: you had to fold a 48 × 80 inch sheet of cardboard, with arm rests, back rests, that was portable and fit a certain dimension—and you had to be able to demonstrate it a number of times and hold a certain amount of weight. When I started doing the desk, I asked students to fold an adult-sized chair out of a single sheet of cardboard with a writing desk that had to be able to hold an 8 ½ × 11-inch sheet of paper flat. You had to be able to write on the desk while you sat in the chair. All of this had to collapse into a portable dimension. One girl realized that all you needed was one leg, like a monopod; you could sit on it and your two legs made a tripod. So she made this cardboard chair that was basically just a four-sided pyramid, and the desk was a larger one that leaned on her knees. You will see a picture of it in the images I gave you.

FG: It seemed like the project really morphed and became more and more challenging.

KH: Yeah, I think so. The other thing that I have been challenged by is that as more and more classes have done the project, students would go and post their chairs, and students now can go and see them. So I have to constantly change the project. From fall to spring I always change the project, so the spring students don't have an upper hand from seeing what the fall students did. The parameters are always a little bit different. The other thing I have been doing is now there is a 180-pound weight test, which is me sitting on all the chairs with a bag of sand to make up the 180 pounds. So we test them all, too, with an objective weight test.

FG: So one thing I have thought about over the years is that it embodied the larger philosophy of a RISD education, this idea of form and function being integrated, no matter what you are making. I think the cardboard chair was all about that: you had these very strict limitations, and you were making this very utilitarian object. The way students chose to solve the problem ended up saying so much about who they were and what their weaknesses and strengths were. For example I remember particularly admiring my classmate Kirsten's chair, which was entirely designed around interlocking triangles. It was an incredibly simple solution to the assignment as well as being aesthetically pleasing. She ended up going into architecture, and I thought it was interesting how you saw those qualities in the chair she constructed.

KH: I don't remember—back then, did I lecture about form and function as a modernist idea in your class?

FG: No, you didn't present that in a formal way to my class.

KH: In later classes, I really began to focus on that as an introduction to the chair. Really talking about that as a dichotomy, two ways of thinking about it. It's about meeting a structural engineering test at the same time. I would go all the way to saying that this is an argument for something that is beautiful in form, addressing aesthetics. How do you negotiate making an aesthetic statement, as far as form is concerned, at the same time as dealing with the potential that the design will compromise the engineering of it? That negotiation is what is so important. It opens up two very big realms:

when design is working best, it's inseparable from function. I also make this connection also with natural forms—structure and form in nature and why there is a simultaneity to them; you can't really separate the two. When we see nature and appreciate its form, we are simultaneously looking at structure. I didn't do much with the nature lab back then, but with recent classes I have started to work with the nature lab and have students look at natural forms as a starting point for design.

FG: That's interesting; I don't remember you going much into aesthetics with my class. You gave the parameters of the project, and talked about the tensile strength of cardboard, and demonstrated different techniques for working with cardboard using glue, tape, the T-square, and the mat knife. I think those ideas about form and function are built into the assignment, and even though you didn't directly address them, I came away with those concepts from working on the project. I don't remember any of my freshman foundation teachers at RISD talking about form and function that way, but I feel like it was demonstrated in so many of my assignments freshman year. In our freshman survey art-history course, when we got to the Bauhaus and our professor started talking about form and function, everyone started laughing. It was this ah-ha! moment where we all realized that these were principles that ran through the assignments we had been working on in our studio classes all year.

KH: It's really interesting to hear how you digested that experience, and that you came away from it thinking about these questions of form and function. Your year I did four assignments: a wire shoe, a vase carved out of a poured plaster block, the cardboard chair, and a form that expands to be four times its original size. I'd like to teach a class where the only assignment for the entire semester is the cardboard chair. I think these basic design principles of transforming something 2-D into 3-D, with aesthetics and engineering interconnected, is what the cardboard chair assignment is about. Students can really spend a whole semester working on these concepts, designing a cardboard chair.

DRAW IT WITH YOUR EYES CLOSED

1. Imitate Baldessari in actions and speech. Video.

2. Make up an art game. Structure a set of rules with which to play.
 A physical game is not necessary; more important are the rules and
 their structure. Do we in life operate by rules? Does all art?
 OR ART RULES, LIKE TENANT RULES. OR ART VIOLATIONS.

3. How can we prevent art boredom?

4. Write a list of art lies, un-truths that might be truthful if
 we really thought about them. However consider this: Art truths
 that we have often are boring in their correctness.

5. How can plants be used in art. Problem becomes how can we really
 get people to look freshly at plants as if they've never noticed
 them before. A few possibilities: 1. Arrange them alphabetically
 like books on a shelf; 2. Plant them like popsicle trees (as in
 child art) perpendicular to line of hill; 3. Include object among
 plants that is camouflaged; *(4) COLOR A PALM TREE PINK.*
 (5) PHOTO FOUND GROWING ARRANGEMENTS (6) OR A MOVIE ON HOW *PLANT A PLANT*

6. How can gallery use be subverted, as in land art? Exchange locations
 with another business? Photo gallery sq. ft. for sq. ft. and paste
 up in another space? One way glass in front of gallery?

8. Give police artist verbal description of Baldessari and have him
 do drawing. Perhaps everyone in class do verbal description.

9. Describe a neutral object completely with film and tape or video.
 Do it until you have fully transfered all its qualities to the
 medium. Perhaps better a class project in that more insights
 would be availabee. *STEAL ITS QUALITIES.*

10. Create art from our procedures of learning. How does an infant
 learn? How do we continue to learn. How do we learn speech?
 To count? To know danger? Investigate Montessori methods, books
 on learning and perception.

11. Do a tape recording of raw sounds and edit into a composition.

12. Make up a list of sound as art projects. (see sample).

13. How can a gallery space be used rather than put art objects into
 it?

14. Two man film project. Each shoots up an amount of film. Ea.
 edits the others fim. A film collage problem. Important that
 the footage be "found".

15. Given: The availability of an airplane or helicopter for a
 short time use, i.e., an hour. What would you do?

16. Given: $1. What art can you do for that amount?

17. Cooking art. Invent recipes. They are organizations of parts,
 aren't they?

18. Subvert real systems. I.e., dial a number that records messages while the person is out and dial another number that gives recored messages. Put the two phones together. Put a sign that says <u>slow</u> in the middle of a street. Get it?

19. What art can arise from magic and myth. Or just a magic trick on vidieo.

20. A sensory deprivation piece. A sensory overload piece.

21. Ecological guerilla art.

22. Disguise yourself as another object--a tree maybe. Or becoming a tree. A big bird? *OR ANOTHER PERSON. BUY MAKE-UP.*

23. What are the minute differences in things that are supposed to be the same. And vice versa. If you took 36 photos of a lawn, would they all be the same? Or of 36 sections of the same lawn? Or of a wall? Or 36 identical? nails (either, figner or kind you hammer).

24. Film loops or slides of all the objects one stares at in a given interval when in an arbitrarily chosen room. Or recorded on a tape recorder as one's eyes locks on them.

25. 36 slides from start to finish of simple motion like picking your nose, scatching your ass, and so on.

26. Slides of #24-projected in correct places in another (bare) room.

27. Wet and dry. I.e., how does wet gravel in a parking lot look next to another dry area. Perhaps as atual situation, where something would be constantly wetted.

28. Recreate sculpturally with other materials in a magic realist approach any 12" sq. area of earth land,. Perhaps better yet to keep your own aesth. out of it, would be to have another choose it for you.

29. Have some take a photo portrait of you just before you go into a store to steal something. Have your portrait taken immediately aafter the act. Photo the object stolen.

30. Design and have printed your calling card.

31. Steal the trash from Pres. Corrigan's wastebasket and make a collage of it.

32. Have yorrself photographed in act of insulting a person. Do Repeatit each time insulting a new person.

33. Pay homage to a movie star, rock musician, etc. in form of a pilgrimage visit.. Photograph is required of the two of you with a personalized signed greeting by the culture hero. Or it could be to a famous person's grave. In this case a photo of you at the grave. Person's name on the gravestone should be visible. No signature necessary.

34. Defenestrate objects. Photo them in mid-air.

35. What kind of art can be done with real animals?

36. Record all sensations, thoughts, for ½ hr. on tape recorder.

37. What kind of works can be done literally under the earth.

38. Liquid works.

39. Chemical works.

40.. Biological works.

41. Photograph landscape in color. Make 8x10 color print. Make
some color changes. Color landscape to match retouched photo.
Color landscape to match photo. Rephoto.

42. Class make up list for scavenger hunt. Exhibit works at end
of day.

43. Forgeries. Ea. in class tries to forge my signature on a check
by looking at an original. Or forgeries of forgeries of forgeries,
etc.

44. Take any sentence of text to 6 signpainters to be lettered in
letters of same style and height. Study differences.

45. Punishment. Write "I will not make any more art"
"I will not make any more boring art"
" I will make good art"
(or something similar)
1000 times
om wall.

46. One PERSON copies or make-up random captions. Another person takes
photos. Match photos to captions.

47. Serial TV works. 25 ways to fold a hat, to comb your hair,
25 different people spitting.

48. Develop a visual code. Give it to another student to crack.

49. Disguize an object to look like another object.

50. Do a film or TV script or scenario. Use TV layout paper.

51. A video tape that is a result of reading a book.. You give a
book report in front of camera. MAYBE E.T. HALL, THE
HIDDEN DIMENSION.

52. Smell pieces.

53. Touch pieces.

54. Art that you see by looking up or down.

55. How do we get eyes off the visual and into experience. Rent a
service rather than an object from Yellow Pages.

56. Take a canvas stretcher, size of your choice, to an upolsterer and have it upolstered with fabric of your choice.

57. A piece that deals with measurement--up, down, right, left, etc. and where spectator is located.

58. Make up list of distractions that often occur to you. Recreate on video tape.

59. Make up art parables.

60. Edmund Scientific Catalog project. What art can you make by ordering from this catalog. Maybe grow plants chemically.

61. Hypnosis. Can art ideas be implanted and removed in a mind?

62. A wall drawing based on numerous persons height--ea. marks his height on wall with line, signs name and date.

63. What art can arise from such phrases as; 1. Entasis, 2. Gestalt *AS CHICANO GRAFFITI* with some left over information, 3. Simple shape, simple experience, 4. Unitary form with reduced relationships, 5. Unitary form with line of fracture. Or, can pure informantion be art?

64. The structural movement of cameras as subject matter.

65. Performance pieces. I.E. Speak thru your hand to your thigh but not with your head. Or talk with your knees to something knee-high. Or what are your dog-like traits without imitating a dog. Or the delivery of a speech to an imaginary person in differente spaces in a room. Do a series of artificial voices. Can the various positions of the hand change the rsonance of the voice? Say "good morning" every morning into a tape recorder for the length of the tape. See Growtowski, Tbwardra Poor Theater.

66. A smapshot album of things to see in Los Angeles with exact locations so that others could locate sights (sites).

67. Document change, decay, metamorphosis, changes occuring in time. Photograph same thing at various times during day.
67. Do good and bad compositions (by photo) of same scene, objects. Frame a photo in viewfinder and move camera a foot to side before shooting.

68. Make up a list by looking at art books, talking to artists on things to avoid in making art. Do them. Ask yourself if results are good or bad art.

69. What art can come from the use of a set of walkie-talkie radios?

70. By using movie camera to follow actions and by your observations into cassete recorder, document the movements of someone secretly for an entire day. Or have someone follow you.

71. Photos are flat. Photograph flat surfaces. Maybe excahnge them.

72. Change, control, alter, arrange light in room environment.

73. Arte Povera. How much and what kind of art can you make from kleenex and masking tape, for instance.

74. A film, video tape, etc. that deals openlyywith a physical flaw of yours (in your estimation). A film called PIMPLE?

75. Information exchange. You wite letters to someone and they to you and so on. Framed letters of Refusal(I am sorry, but...), for instance. Or Thanks(Thank you for your ...blah, blah, etc.).

76. Random photos. End of, beginning of, roll photos. Camera sent up with pidgeon, balloon, given to another persons with shooting instructions, shooting from hip, etc. How do we avoid our good taste?

77. Using of time devices. Time clock(that prints time in and out), random time devices (red dot on cash register tape), a fuse, a candle.

78. Large scale art that can be seen in its entirety. For instance, if you dyed sheets ea. a separate color and arranged them checker board like, say a hundred or more, they could only be experienced by walking thru them, but they could be seen (also photoed) by helicopter or airplane.

79. Photograph backs of things, underneaths of things, extreme foreshortenings, uncharacteristic views. Or trace them.

80. Put labels on things that list their contents.

81. Design an art test.

82. Can one give and take away aesthetic content?

83. Street works, art determined by location. What would you do on top of a 30 story bldg.? What would you do under water?

84. Given $50. could you increase the sum in a period of time?

85. Describe the visual verbally and the verbal visually.

86. Film of, or video of, children's play activities--walking on a ledge, drawing a line in the dirt, etc.

87. Do a work of art by telephone. Or use TBA (John Collins).

88. An all word TV tape. Or a single word.

89. A real time movie or video tape. A steaming cup of coffee.

90. If photos come from reality, what kind of reality comes from photos? Reconstruct a photo three-dimensionally.

*** INTERMISSION ***

(We had just left #90.)

91. Scenarios. Do a movie form an existing, stock scenario. Or 1 person write scenario, another shoot movie. Or GRABBAG scenario-- everyone write 2-3 scenes, drop in box, someone pull out maybe 10 and they are shot in the order drawn out. Or everyone do their version of the grabag scenario.

92. Video tape of making sound effects.

93. Design a secret handshake (for our class members?).

94. Verbally describe a landscape instead of painting one.

95. A disjunctive work that is based on parts and not a whole, that is one see the parts and never the whole.

96. Prove a point as in a science fair diorama, display, tableau, such as, "How quickly does bread mould under certain conditions?", or "Is plant growth hampered by use of conditioned water?", "The effect of colored lights on plants", "Is untreated seaweed useful as fertilizer", "What effect does ultra Sonic vibrations have on plants?", "The effect of asperin on potato plants", "Why is a rainbow round?", "Do race, color, texture affect the strength of hair?", and etc.

97. Take the titles of any amateur art exhibit and illustrate them. For instance such titles as, Ah, Toro!, Autumn Leaves, Mexican Patterns, Xenogenisis #2, Xanadu, Wharf Enchantments, French Restaurant, Boat Patterns, blah, blah.

98. Repaired or patched art. Recyled. Find something broken and discarded. Perhaps in a thrift store. Mend it.

99. Art that requires the rental of a Service rather than an Object.

100. How does one react to a minor stress problem. Perhaps compare what he is thinking to his outward behavior.

101. Put new canvas over old paintings.

102. Composition based on the duration of say, one gal. of paint.

103. A 30 day continuous line on adding machine tape.

104. The shapes of shadows of well known people (or well known artists for a specific example).

105. Reversals. Be black, say things backwards, all while standing upside down. *THINK BACKWARD.*

106. Put make-up on dogs and other animals. On trees and plants.

107. "If each of us were to confess his most secret desire, the one
 that inspires all his plans, all his actions, he would say:
 'I want to be praised.'" (E.M. Cioran). Do a piece that deals
 with Praise as a theme. *BE PRAISED OFF CAMERA*

108. Photograph of umbrella and sewing machine on an operating
 table. That's Surrealism isn't it?

109. Blow powdered color thru staw on drawing made with fat on
 wall underground. That's cave art isn't it?

—OK, LET'S TAKE A FIFTEEN MINUTE BREAK. CRITS WILL START AGAIN WHERE WE LEFT OFF, AFTER YOU GUYS HAVE HAD YOUR ICED COFFEE OR WHATEVER.

This assignment was given in a course on vision and color at SVA in the fall of 2010. The idea came from a reading group on color and discussion with Corin Hewitt.

Take a color walk. Give yourself at least one hour of uninterrupted time. Do not plan your walk in advance or combine it with other activities (commuting, shopping, etc.). Try not to talk or interact with other people during this time. You will not need to bring a cell phone, journal, camera, or iPod. You will not be graded or evaluated on your color walk.

You can begin your color walk anywhere. Let color be your guide. Allow yourself to become sensitized to the color in your surroundings. As you walk try to construct a color story or a narrative based on color you observe. What are the colors that you become aware of first? What are the colors that reveal themselves more slowly? What colors do you observe that you did not expect? What color relationships do you notice? Do colors appear to change over time? We will discuss the color walks in our next class.

My friend and colleague Jim Cambronne told me about this assignment, and since then I have included it in most classes I have taught.

It starts with a group visit to a museum. Each student chooses a work of art from any collection. The only requirement is that the students spend one hour—uninterrupted and alone—with the piece.

During that time, they must keep track of their thoughts. Most students take notes; some have made recordings. The exercise culminates in a presentation given a few weeks later to the rest of the class. This presentation can take any format; it is a way to select, organize, and communicate the thoughts triggered by the piece.

Each time I have given this assignment, a few students take a vaguely art-historical approach and research the origins and context of their piece, presenting the information in didactic form. Most follow a more personal route. Then, the process is one of detailing a visual experience, of describing vision and its aesthetic, affective, speculative, and associative ramifications. The presentations are often guided by the piece, with the student pointing to its physical and material qualities as evidence. Once, a student led the group to a specific spot in a park close by, where the view reminded her of the abstract shapes of a small oil painting by Kandinsky. The students describe meandering thoughts, full of discoveries, doubts, paradoxes, and cul-de-sacs. They also bring up specific memories and experiences. (A beautiful text by Hélène Cixous exemplifies the process well: "Bathsheba or the Interior Bible," in which she contemplates and discusses the painting by Rembrandt. I often have students read it after everyone has completed the project.) These wonderings/wanderings by the students span poetry, experience, and politics. They remind us of the multiple meanings in the "facts" presented to our senses. Art is immersed in the welter of description and the pronouncements of desire.

In a class for advanced students at Cooper Union I've taught a couple of times, I have asked each person to research and then give a presentation on a contemporary artist of their choosing. I got the idea from Miranda Lichtenstein, who does the same thing in some of her classes, but I upped the ante a bit by having the student interview the artist in person. I tell them to make a list of five artists they would like to focus on, starting with the person they admire most and who they think would be the hardest to get in touch with, down to a fellow student whose work they think highly of. Nine times out of ten it's not that hard to connect them with their first or second choice, through one or two degrees of separation, or, failing that, through a simple call to the artist's gallery. And of course, being artists, most of them are generous or egomaniacal or both, and are more than willing to talk about themselves to anyone who is interested. The process tends to be good for everyone involved, and the students generally come away with some of their imagined boundaries broken down. Either that, or they just can' t believe they actually got to go to Roe Ethridge' s studio!

AN ARTIST YOU HATE

In the fall of 2009, I was in Carol Bove and Corey McCorkle's team-taught MFA course at New York University. Our first assignment was to write about "an artist you hate." All of us, including the professors, had to sign confidentiality agreements. It turns out that who and what we hate, or fear, often has some resemblance to our own art or our own backgrounds. I wrote a letter to an artist and read it to the class, then burned the letter afterwards.

DOUGLAS HUEBLER ASSIGNMENT

In a 2006 *Artforum* article, John Miller mentioned a certain work by Douglas Huebler. I couldn't find the images online or in any books, so I decided to assign it to my students in an Introduction to Photography course at NYU and see what they came up with. I wanted the students to think about transubstantiation—from mental state to image.

> Assignment: Create your own version of Douglas Huebler's work *Location Piece #2*. Photograph one or more places that you feel could be characterized as being 1) frightening, 2) erotic, 3) transcendent, 4) passive, 5) fevered, and 6) muffled. Then scramble the resulting images.

THE SORORITY BLACKBALL PARTY

Have everyone write something good and something bad about the person's work. Stick it in a basket. Pull out the slips and read them at random.

People can be as critical as they want.

MY FIRST GREAT ARTWORK

Assign the re-creation of the person's first artwork (not baby scribble—the first one where he or she conceived the idea of being an artist).

This idea is ripped off from Sean Landers.

EXTREMELY SELF-CONSCIOUS VIDEO PRESENTATION

Insist people present their work on camera.

Some people HATE this, usually nonverbal painters. Dana Schutz did a pretentious sock puppet critique. I was a very pompous sock.

SOCK PUPPET SINCERITY

Have everyone present their work on camera as a sock puppet.

Obviously stolen from Dana Schutz.

SILENT TREATMENT

Have one artist present his or her work. Everyone else is silent; no response is permitted. Often the artist coughs up an interesting thought, because he or she isn't on the defensive.

John Szarkowski's idea.

DANA HOEY'S SPECIAL SHTICK

Have one artist stand in for another and present the work. No friends—the person impersonating the artist must not know the work or the person and thus make as many mistakes as possible. Everyone addresses the stand-in as the artist, and asks questions of the stand-in; even the artist addresses the stand in as him- or herself.

Yes, it's from a kind of therapy called "psycho-drama." I was questioned most skeptically by my shrink for using this, but damn it works.

My graduate students got in a fight about capitalism. It was my fault, really; I gave them a reading by an anarchist anthropologist, the complexities of which were eclipsed by the sentiment, shared by graduate students and French theorists alike, that capitalism is a sort of void space capable of swallowing anything, material or otherwise, with which it might come in contact. Frustrated with this monodefeatism, I stayed through the break to continue talking with the most hysterical of my graduate students, telling him, "there are no totalizing systems," while he told me, "there is no outside." When the break ended someone wanted to show a video, but the blinds on the window across from the projector wouldn't shut. The metal chain meant to raise and lower the blinds was wrapped around them at the top of the window. "Is anyone tall enough to reach that?" I asked. We stood on chairs; we stood on stools. The student who had offered the most impassioned argument for her own agency in the face of the void space appeared with a rusty garden rake. "I got this from the woodshop," she said. We wrapped the chain around a prong of the rake and pulled down; we wrapped the chain around a prong of the rake and pulled to the side. Some of us wrapped the chain around a prong of the rake and pulled to the side, while some of us stood on stools and pulled the other half of the blind away from the rake. The blind fell and everyone cheered.

I became an artist to avoid ever having to be told what to do, and while I now understand that coercion comes in many forms, the least direct of which are often the most complete, I have enough sympathy left for this original impulse to be squeamish about ever telling my students what to do in any manner as crass as an assignment. When art, having shed its attachment to any particular form sometime in the 1960s, became ontological, it doomed all work made thereafter to seem always to be making an argument for what all art could, really what all art *should*, be. With this as the political reality of my field, who am I to say, "Make a map of an imaginary place using charcoal?"

Yet as artists, we give ourselves assignments all the time; this is what it is to have a practice. If we are reasonably thoughtful, however, we understand these assignments not as "that which will produce work of value," but as "that which will allow the work to happen, perhaps producing the conditions through which

something of value might take place." If your assignment is to represent the possibility for a social interaction that is not scripted by the economic and political structure of the institution in which it is housed, your assignment is self-defeating. When the blinds need fixing, this social interaction might take place.

In my second year of teaching, my class was given a show in a student gallery. In response to their lack of enthusiasm for showing their work in such a space, I suggested they make a group project of it. They gave themselves an assignment to divide the gallery into two halves, good versus evil, and to divide themselves accordingly, with half of them bringing in objects of evil and the other half good. After two days, the school removed the exhibition and I received an incensed phone call from my Chair. The good side of the gallery contained pictures of puppies and a Christmas tree, the bad side a pentagram made of tape and the movie *The Ring* on loop. It was never discussed in advance, but the students unanimously responded to the premise they themselves had created by bringing in objects they imagined as parodic representations of good and evil. The administration, however, in hastening to reinstate the moral order, inadvertently made their gesture affective. The best assignments I have given have always been accidents.

JULIAN KREIMER
WET-ON-WET LARGE STILL LIFE

Designed for oil painting, this assignment should be administered during the second working week of the semester (usually that means the third week of class). Students bring in:

> three double-primed masonite panels, eighteen by twenty-four inches each.
> lots of medium and solvent
> large tubes of black, white, and three primaries
> lots of cotton rags (paper towels are pretty useless for this)
> at least six medium-to-large brushes (ideally hogshair)

I set up a large still life using the junkiest props I can get my hands on, piling them into a huge pile (about the volume of three standing adults) that can be seen in the round. The props should be placed to minimize, as much as possible, their known or narrative qualities—so a mannequin bust, for example, should be jammed into the pile upside down, and the same goes for bowls, pots and the inevitable water pitchers. Since most prop closets are full of fabrics, rope, fur stoles, woven baskets, tableware, and the occasional shoes, the setting-up is usually straightforward. For a final touch, ropes, netting, and other hard-to-depict things are dangled all around.

A quick demo starts the class: a student is asked to squeeze out about a finger's worth of black or white paint onto one of his masonite panels and use solvent and medium to thin it out to the consistency of ketchup (since this assignment uses tons of thinner, I require that students use only high-quality odorless solvent—Gamsol specifically—since anything else used in these quantities would leave us all with bludgeoning headaches). I point out the blobs and unmixed bits, and usually end up taking over and fixing it. It's pretty important to point out to them that this entire assignment is like walking on a tall balance beam—in that it's incredibly straightforward but really hard at the same time. Let them know it's designed to promote failure, so if it's not going well, they're doing it right.

The students fan out around the room to their easels. Once there, they squeeze out three fingers' worth of white or black paint onto the middle of a

panel that is laid on the floor. They thin it until it is a creamy, even consistency, so that when held perpendicular to the ground, the paint gets as close to dripping without actually dripping as possible. This takes longer than expected, often up to twenty or thirty minutes for everyone to get it right. I wander around checking everyone's panel. No one gets it right the first time. I usually yell at them "more liquid!", "more paint!", or "more both, juicier!" They tend to like being yelled at so long as everyone gets yelled at more or less equally: they feel this is what they thought art school would be like (especially since I'm wearing a big apron that day, for obvious reasons). A few students don't have enough of some material. This is when the short "sharing is caring"/"teamwork" lecture is delivered, and students are invited to help their classmates out. I explain that sharing will make them better artists.

Once the panel is evenly covered with the juicy paint, each student puts it up on the easel, and using the remaining neutral color (i.e. black if the ground layer is white, or vice versa), paints the still life so that it takes up the whole panel, trying to depict as much of it as possible. (This is also the crucial moment to have them fastidiously clean up the negative-space rectangles left all over the floor. If not done at this point, there's little hope of leaving the room clean for a few days). The paint on the panel soaks up the new color, so they have to figure out how to lay down a clean brush stroke onto the wet surface.

About thirty minutes into the painting, I show them how to lay down a clean brush stroke. Using a volunteer's palette, I clear off an area, squeeze some fresh white or black, clean a brush off (or better yet, use a clean one), mix medium with the blob to match its consistency with that of the panel surface, then, using minimal pressure, starting with the brush as parallel to the picture surface as possible, start the stroke (I usually choose to depict a rope or a high-contrast edge, something that's a long line in the actual still life), slowly twirling the brush as I go so the fresher paint goes down, simultaneously lifting the tail of the brush so that the line ends with the clean paint at the tip of the brush. This demo is best ended in silence on my part, ceremoniously returning the brush to its owner, followed with a dismissive fan of both hands, indicating that they should return to their easels to practice it themselves. Questions about this demo are answered with a silent fan of a single hand. Follow-up questions are answered with a silent "I

don't know" lift of the shoulders and inward pursing of the lips, as if someone had just asked for directions to an unknown place.

Once people start to get their compositions down, I begin to comment, focusing on capturing large contrast shifts, the elegance or awkwardness of individual brush strokes (both are useful tools), and how muddy the painting is getting. Frequent pointing out of the light and dark value shifts in the actual still life versus those in the paintings is useful. Warnings go to students trying to depict only one tiny portion of the mess.

The painting itself should take about sixty to ninety minutes. For a five- or six-hour class that means they have time to do two, alternating the ground between black and white. The third panel is for homework: lay down a non-neutral color as the base color, and use both neutrals to paint a wet-on-wet picture using individual passages or even brush strokes in the two in-class paintings as their source.

The still life should be taken down at the end of class.

(For plein-air landscape classes, just have them do the horizontal mixing at their site, and have them choose something in the landscape to depict.)

Note: make sure there's enough storage space at the beginning of class so that each student can lean the three wet panels somewhere where they won't get bumped by other paintings over the week. Since it's an early-in-the-semester assignment, that's usually not a problem.

Also note: try as you might to keep the room clean at the end of this assignment, you are unlikely to succeed. The other teachers who share that classroom will likely complain, so make sure to talk to them beforehand, and apologize in advance for the mess your class will leave.

1. Make your last painting.
2. Make a series of four paintings in which you remake the exact same work.
3. Paint something that made you cry.
4. Make a protest painting.
5. Read an obituary (without a picture) and paint a portrait of the person described.
6. Make a painting that compliments the viewer.
7. Make a painting that serves as a tool.
8. Make a painting of your bedroom from memory.
9. Build a shrine and paint it.

RACHEL FOULLON
A COLLECTION AND A MEANS FOR ITS DISPLAY

The most impenetrable subjects in art school, to both learn and teach, are how to 1. be truly and weirdly yourself, and 2. successfully convey that through objects and/or actions. They are much easier said than done, especially when there are skill building, social forces, insecurities, and immaturities to contend with. However, in an undergraduate sculpture class at NYU, my peers and I were given an assignment by the terrific Jack Risley, which proved to be powerful enough to fast-track many students in the class toward a significantly more fluid way of thinking. It was so revolutionary in terms of raising the bar for all of our budding practices that I was excited to give the assignment to a class I taught ten years later at Columbia. Yield: success again!

It sounds innocent: Create a Collection and a Means for Its Display.

This can be a collection of absolutely anything (made, found, or otherwise) of absolutely any quantity, and any vehicle for the collection's display (however simple or complex), *or* any and all interpretations of the very nature of a "C" and its "D"—two variables with the perfect structural integrity and innate fragility to yield astounding results from blossoming artists from any place and at any age.

Something about this assignment, I swear, is alchemical.

But just like any good assignment being delivered, I will here deny the reader of any anecdotes or examples of how I, my peers, or my students responded to the above prompt (and don't even think of asking the kids in the year above you), so as to keep the reader's imagination open and unencumbered …

So go on, collect! And display.

When I taught photography, briefly, back in the late 90s, the most interesting thing someone said at the bar the night before class would become that day's assignment. If, say, a painter told me about the saint who made the devil kneel and hold the Bible, then my assignment to the class would be: Make the devil kneel before you, so you can read him the word of God.

After a ten-year hiatus, I taught undergraduate photography again. I wasn't going out to the bar enough for the old method to work, or perhaps the bars I went to were less incendiary. For the first class, I asked the students simply to take the camera and make pictures. They returned with images full of ambition, expression, personality. The students asked for the next assignment. I said: you are exceptional individuals and skilled artists, you know what you need to make, and should make it. For the most part those students continued to create fine pictures.

Over the course of the term, I thought often of Ursula K. Le Guin's novel *A Wizard of Earthsea*. Ged, the titular wizard, goes to study with Ogion, a magician who seems more like a Zen monk. Ogion refuses to cast spells. When it rains, they sit in the rain. When they are hungry, Ogion and Ged forage for food. They wander like tramps, picking herbs. Ged, impatient with this humility, sneaks a glance at Ogion's spell books and performs a summoning ritual. Things get way out of control, and Ged gets one glimpse of Ogion actually performing magic with a glowing staff (the simple walking stick of the herb-gathering tours), fending off the demon Ged summoned.

Ged leaves Ogion, and travels to a magic school (uncannily prescient of Hogwarts), and there learns illusions, epic poems, the language of dragons, and all the other trappings of wizardry. It's not until the fourth *Earthsea* volume that Ogion finds a keeper of a student, Tehanu. During Tehanu's tutelage, pretty much nothing happens. The two chat, tell stories, and generally meander about. At one point a dragon does show up, and, after a brief conversation, flies off.

This, of course, is the model of our contemporary art program. We sit around the table, talking about this and that, the uses of herbs and hearsay anecdotes. For passing dragon read "visiting artist," who flits through and perhaps issues a scorching critique. As a teacher, I want to be Ogion of the first *Earthsea* book. The students, called by their talent, are impatient to learn and practice the secrets of Art. But why not refuse to teach the big spells, the big effects, or task them with any quest at all? They should understand the materials at hand, the basic flow of life. Figure out what it is right to do next, especially if you've done something right before.

Teachers are not all great mages. Students should ground themselves in basic practice. Most art students, if lucky, will become basic practitioners, not flashy dragon-lords, and should have a straightforward way of working. If the good artists chafe at this unglamorous regime, all the better.

It is in the doldrums that our talents are most needed. The best training for desperation is to know early the feeling of no guidance. In photography the squeak of intention destroys serendipity. Don't summon the demon of overdetermination. Stand there, present in the world, and make work.

JACKIE GENDEL AND TOM MCGRATH
GOT NO STYLUS

You will need a big piece of paper. Big.

Make a drawing with
— no lines
— no value
— no "shapes"
— no "subject"
— no narrative
— no pictorial content whatsoever
— no symbols
— no color
— no collage
— no "spills," "drips," etc.
— no Xerox transfer
— no design software
— no street art (no using your paper on pedestrians)
— no spray paint
— no A/V equipment

And especially:
— no use of a stylus (pencil, pen, marker, crayon, basically any kind of drawing tool that comes in stick form)
— no direct hand contact with the drawing

BOB NICKAS
FROM ADAM & EVE TO THE THREAT OF A SPANKING

I'm not an artist and I didn't go to art school. But I did go to Sunday school after church services every week when I was around six years old. I hated it, of course, but possibly knowing what a committed heathen I'd turn out to be, my well-meaning, somewhat devout mother sent me off every Sunday. The only class that I remember was the one where we were told the story of Adam and Eve, and asked to make a drawing of them in the Garden of Eden. It was meant to be a little contest, and there would be a prize. Everyone set to work, and there was considerable snickering from the boys seated around me. It turned out that they had all drawn Eve with enormous breasts, stretched out as if she was a centerfold in *Playboy* magazine, and Adam was sporting a rather impressive boner in most of the pictures. There was not a fig leaf in sight. The nun who ran the class was definitely not amused. As she passed my desk, she saw that I had drawn the sinful couple standing rather modestly behind some flowering bushes, carefully covering their nakedness. She held up the drawing and announced that there was a winner. She might as well have invited the kids to beat me up after class, and gotten in a few licks herself. (Catholic nuns can be incredibly cruel, smacking rulers down across a kid's bare knuckles for the slightest offense.) Anyway, I won the contest; the prize, if it can be called such, was a picture of the Virgin Mary. My mom was proud of me, as only moms can be, and displayed my drawing and the picture of the Virgin Mary back at home. I don't know what became of the drawing of Adam and Eve. But today I'd be happy to deface it with the biggest, hardest, longest dick you've ever seen.

—

When I go to art schools I always hand out copies of Paul Thek's "Teaching Notes," which he wrote in 1978 when he was at Cooper Union. He asks his students questions like,

What is an abstraction?
What is the purpose of art?
What is greed?
What is the purpose of happiness?
What does spiritual mean to you?

And he also gets a little too personal, wanting to know,

> What do you do to make yourself more
> attractive sexually?
> Why do you do this?

And then he proposes a number of tasks, some of which are impossible.

> Design a black mass out of any materials
> you can find.
> Redesign the human genitals so that they
> might be more equitable.

Other assignments will inevitably serve as reminders of artists and works which only appeared years later.

> Paint a series of playing balls like planets,
> be accurate."

This could be an early work by Fred Tomaselli.

> Make a spaceship out of a cereal box.

would have to be Tom Friedman.

> Design something to sell to the government.

This, disastrously, could be *Tilted Arc*, and you'd think that Richard Serra would have known better. Even so, it did provide him with the one and only time his work was ever relevant to any wider discussion outside the confines of the art world.

Some of Thek's assignments are simply wonderful, and should be taught until the end of time. My favorite:

> "Make a large folded-paper airplane, paint
> on it a slogan which you think will revolutionize
> your life."

Once, a student in a class I was "teaching" at Columbia actually built a spaceship out of a cereal box, which he brought along on a trip the class made to the Whitney. I dared him to leave it behind in one of the museum's galleries, and he did. I don't know if this counts as the most successful assignment I've ever given, but it's one that I remember, and it's thanks to Paul Thek.

—

This isn't an assignment, and it isn't a best, but here goes. An artist I know went to Skowhegan in the late 70s/early 80s, and Jackie Winsor was one of the teachers at the time. There was a final crit, and all the students had finished up their work and installed it in their studios, waiting for Winsor to come and review what they had done. Like a posse—perhaps from *Lord of the Flies*—the students followed closely along behind her, and when she was especially tough on someone, they ended up being shamed in front of their fellow classmates. Winsor walked into the studio of a young woman who was standing nervously by her work. Winsor looked around, silently and very briefly, then said matter-of-factly: "You're a boring person, and your paintings are boring." With that, she turned and went out of the room. The young woman burst into tears, and buried her face in her trembling hands. The other students were stunned, and left quickly. The artist who told me the story confirmed that the student and her work were, in fact, boring; and he also mentioned that Winsor "playfully" threatened his roommate, saying that if she was his mother, she would lay him across her lap and spank him.

For years, I had a fantasy that I referred to as "the Jackie Winsor piece." The materials needed to perform the piece are: a small handkerchief, a bottle of chloroform, medium gauge rope, gloves, duct tape, and a sleeping bag. The instructor, hopefully a real tyrant who deserves to be taught a lesson, is rendered unconscious, blindfolded, bound and gagged, placed in the trunk of a car, and driven late at night to a sleepy motel in the middle of nowhere. A room is rented, paid in advance for a weekend, in cash, with instructions that the guest is not to be disturbed for any reason whatsoever. The instructor is left on the bed in the motel room. Photographs should be taken to fully document the piece.

Now, anyone who attempts to realize the piece will have done so of their own free will. I am not urging anyone to action. In fact, I advise most strongly against it. Law enforcement will not take kindly to your little art project. Remember, this is pure fantasy, and there's no penalty for something that only happens inside your head. Think of it as conceptual art … in the form of revenge.

ANNA CRAYCROFT
THE ART OF EDUCATION AND THE EDUCATION OF ART

When I was 23 and fresh out of college a woman in her fifties hired me to be her private art tutor. She was making oil paintings and struggling with both the medium and subject matter of her work. Together we searched for solutions to her stumbling blocks. However, after a month or so of regular visits, I was abruptly told that this would be our last. My termination was justified on the grounds of redundancy; she explained that she was currently in psychoanalysis, and therefore already had someone with whom she worked out her "personal troubles." I remember feeling stunned and embarrassed by this proclamation. From my perspective our discussions had been entirely in keeping with the type of discourse I had learned in the previous five years of training in art school.

The intimacy of the one-on-one conversation typical of weekly studio visits in a college art course draws a close parallel to the dynamic between an analyst and their analysand. The cathartic workings of the student-artist are explored through a dialogue that develops over a matter of months or years. There is a strong potential for transference/counter–transference projections due to the age difference—in undergraduate and graduate programs—between professor (parent) and student (child) as well as "mature" artist and "emerging" artist. The half-hour-to-hour durations of the studio visit recall the time limit of an analytical session.

As with the studio visit, many structures within art school appear to have been modeled on—or gradually evolved to resemble—other forms. Classes on art theory are indistinguishable from the seminars of a liberal arts college. Foundation classes teaching basics in technique, or advanced, preprofessional coursework (teaching the skills of writing artist statements and compiling press packets, for example) resemble the how-to workshops of a trade school. The diplomatic assembly of students for group critique can feel like a political caucus. Even with a rich history of pedagogical traditions spanning hundreds of years, the standard of how we design, determine, and evaluate learning in art school remains in question—and thus is prone to imitate other, more resolved, forms. And while this may be a good thing—an

opportunity ripe with the potential for innovation—many efforts to take advantage of this latent stage seem to miss a crucial point.

There is a redundancy in the very conjoining of the terms *art* and *education*. In some respects art and education are near-identical enterprises. Each seeks to develop or manipulate communication systems in order to affect the way its participants see, think, feel, or behave. Artistic and pedagogic practices both assist in the cultivation of citizens and the reinforcement of institutional power. However when the two words are placed side by side it is their differences that become highlighted, not their similarities. This distinction has forced a hiccup in the potential progress of the teaching of art and the cultivation of artists. The only way to avoid noticing this redundancy is to force each word to modify the other—wherein one word represents a method and the other a subject. It is not just art, but art as a teaching tool. We will not learn just anything: we will learn art. These sentences may seem innocuous, but the degree to which they restrict the aspirational depth of both fields is disheartening. When art becomes a "teaching tool" it is at best a prop, an index, or a model. When we "learn art" we can learn a technique or a history but not the process of radical thinking—i.e. being *taught* how to think in order to think differently—with which art is engaged.

There are wonderful examples of efforts to consider the two components of *art education* in one frame. In the experiments of 20th-century artists like Joseph Beuys, Judy Chicago, Luis Camnitzer, Allan Kaprow, Anna Halprin, John Baldessari, or Josef Albers, this unity can be palpably felt. A number of contemporary artists and curators have attempted similar critical innovations through symposia, exhibitions, and alternative schools. However the most exemplary realization of this harmony that I can think of left an impact that has lasted the almost two hundred years since its introduction. Interestingly, this was achieved not in the field of art, but in a renaissance for early education that passed through the hands of three radical thinkers.

Between the late 18th and early 20th centuries, visionary pedagogues Johann Heinrich Pestalozzi, Friedrich Froebel, and Maria Montessori each developed tools and curricula to shape young minds. Not only did they devise philosophies around which their respective curricula were built, they also

designed and constructed complex aesthetic systems that included languages, social games, and physical objects into which their ideas were embedded. Pestalozzi was an innovator in pedagogical drawing. Froebel designed the first objects for hands-on exercises—blocks, weavings, sticks for building— organized according to specific stages of children's development. Montessori constructed teaching tools to translate math and grammar problems into colorful geometric forms and symbols. Each of them designed entirely new ways of communicating— affecting not just how we organize what we communicate, but changing the language with which we do so. The methodologies of Pestalozzi, Froebel, and Montessori engaged the sensorial, the conceptual, the social, and the individual as each part of the same activity. Their curricula interwove the experiences of teaching and discovering, thinking and making, communicating with others or with oneself. Art and education were inseparable.

The definition of art during the lives of these three pedagogues may not have been expansive enough to consider them artists. I make a motion for an historical revision to do so now. In order for art education to stop parroting the social dynamics and organizational frameworks of other institutions, it must recognize that the studio is a classroom, the classroom is an exhibition, the museum is a curriculum, the lesson is a social experiment, the artwork is a teacher, the artist is a student, and so on. By considering pedagogues like Pestallozzi, Froebel, and Montessori as artists, we in turn consider all artistic practices as educational, and pedagogy as an art. Hopefully their example can assist us today in escaping the endless loop of redundancy rooted in the monikers "teaching-artist" and "art school."

MARINA ROSENFELD
MIXTAPE FOR A DAY OF STUDIO VISITS

THE VELVET UNDERGROUND & NICO I'll be your mirror // BLACK SABBATH Take a look at the toys around you / Right before your eyes / The toys are real! // THE SPACEAPE In a state of near paralysis / restriction forms analysis / guided by subliminals ... / givin' answers to questions that never existed // (BRITNEY say it, say it ...) PINK FLOYD Dim the lights / Do you want my blood do you want my tears / What do you want? // (MISSY: Mommy look fresh / in respect me sweats /Mommy Mommy Mommy Mommy) ANTHONY COLEMAN'S SELF HATERS: *The Abysmal Richness Of The Infinite Proximity Of The Same* // (WARRIOR QUEEN: What's wrong? What's the matter?) JOHNNY THUNDERS I'm a boy / I'm a girl / What am I wearing? / I'm a picture / I'm a frame / where am I hanging? // NENEH CHERRY It's sweetness that I'm thinking of ... // (COMMON I'm all in a state of ease, utopia / Holy Molia, it's totally awesome!) R STRAUSS Hands, stop all your work / Brow, stop all your thinking / All my senses now yearn to sink into slumber... // BIG L Flamboyant is the label I'm with, Motherfucker // HENRY PURCELL O heav'ns! what content is mine ... such woes as only death can cure! // CAGE for all we know he may be silently weeping / or silently laughing or both you just can't / tell // J DILLA Donuts //

To get into an art program, I was asked to go about town and write reviews of all the art shows that were up during the summer. I was given this assignment because I wanted to transfer from the sound art department to the fine art department of the university I was attending—I was coming from a scientific background and had never studied fine arts before. So my case was a little peculiar and the faculty had to figure something out for me. The assignment served as a "recruiting" tool; it was a pragmatic way for the examiners/teachers to gauge my perseverance, as well as a good way for them to get to know me better.

In return, it turned out to be a good exercise for me before entering art school: to verbalize what I liked, why, and how. I recall that of all the reviews I ended up writing, my favorite one was of the newly opened Nike Town, with memorabilia Nikes (I remember Frank Zappa's) and a power-tech shoe display that used light boxes and sound effects. I don't care for Nike shoes much, but the grand spectacle multilevel store was more telling in its cheap, inventive, sad, (in)efficient way than most of the actual art shows I had seen during the summer. There was a clear discrepancy in the newly opened store: the make-believe technology, the megalomania of the project (its sheer size and central location), the historicization of the brand and the inevitable lifestyle propaganda on one hand, and on the other hand the poor product selection. The crummy little sporting goods store a few doors down carried more Nike products than the huge Nike Town. Yet the few products on display at Nike Town were displayed over and over, in ridiculously fancy display boxes, accompanied by charts and light shows, giving it a general feeling of artificiality—there was an air of radiant, joyful parody to it all. In the review, I treated Nike Town as an art show, with Nike's marketing executives as artists. Nike Town was the best art show I had gone to all summer. It confirmed for me that a simple transfer of context can produce wonderful results.

ANDREW BERARDINI
FIVE (MOSTLY HIDDEN) COURSES I WITNESSED AT ART SCHOOL

While at the California Institute of the Arts in Valencia, getting my own seemingly useless MFA in writing, I was in close observation of the school's fine arts students, along with their sundry professors, distinguished visitors, and abused adjuncts. The best I could figure what art school and its assignments teach (and with great success!) is not how to be an artist, but how to act like one. The list below does not exactly contain exactly assignments, but like all other tasks obliquely assigned in life, they are likely more consequential than the ones we've explicitly been assigned.

#1 OPENINGS
Every Thursday, the School of Art would host "openings," exhibitions by mostly grad but sometimes undergrad students, accompanied by the exhibiting students purchasing school-subsidized wine, beer, and water, sometimes laying out tables of food to lure faculty, staff, and colleagues into lingering around their exhibition, forcing some kind of consideration through proximity.

Though much of the action still happened, as ever, behind closed doors (studio or otherwise), there was an expectation that you could gauge your own success (at least in conquering the system) by the number of faculty at your opening. And if off-campus curators, dealers, or collectors schlepped the thirty miles north from Los Angeles to attend, you could almost guarantee faculty attendance; they either aspired to get splashed by the slough over of youthful success or were just hankering to feel cosmopolitan.

Attending openings at school gives students a working idea about what a goodly amount of Saturdays over the next ten to fifty years will look like. Training for future professional activities is part-and-parcel of acting like an artist.

#2 PATRONAGE
At other art schools around Los Angeles, professors would hook their students up with dealers and curators (or even nearer the ethical borderline, collectors), but as far as I could tell this act of generosity rarely transpired at CalArts. Though often too happy to take the most technically savvy on as nominally paid assistants, the artist-professors

selfishly ignored the fact that it's quite difficult to get a foothold if somebody older than you doesn't take an active interest.

Failing this, funding can be derived from any number of other sources, and the forms of patronage artists solicit in art school are good indicators of how they will carry out their postgraduate career. Students who were expert at capturing grants, but perhaps untalented at being artists, could almost depend on academic jobs running art departments at second- and third-tier universities, this mastery of bureaucracy preparing them for more administrative careers.

Which is just to say that being able to understand and exploit different kinds of patronage is built into the structure of art school, ensuring different kinds of artistic careers after graduation.

One artist I know who received a full-ride at UCLA aptly called his graduate education "welfare for artists," patronage at its simplest and perhaps best.

#3 CONVERSATION

Words and phrases in the language of contemporary art drift in and out of style depending on the intellectual fashion, but there are a few standbys. Baldessari's *Terms Most Useful in Describing Creative Works of Art* (1966–68), though modestly dated, is still pretty applicable, in my experience.

Mr. Baldessari also handed down the most famous class in language acquisition at CalArts. Michael Asher's "Post-Studio" was a test of conversational endurance rather than a lesson in artmaking. Asher's crits were less a commentary about one's work, and more a hardcore initiation into the rites and rituals of art speak, or "the methodology and language of the discourse surrounding contemporary culture."

After class, the students might be found studying magazines available in the library or in special department-specific lounges, looking to find a chink, an entry point to how it all works. Flipping through periodicals, from the New York classics to the academic fringe, they try to learn the particular patois, the patter.

#4 STUDIO VISITS

Learning how to act like an artist often happens behind closed doors, often in the studio. The studio must therefore be visited. Visiting artists/critics/curators are paid (usually in the low to mid-hundreds, but sometimes higher) to perform one of the famous roles: either being entirely cagey, or asking numerous, invasive questions, or chatting about everything *around* the work, or barking commands at the artist (sometimes of course ignoring the young apprentice entirely and just talking about themselves). The artist, in turn, learns how to respond to these various prompts.

In an ideal sense, the MFA studio is a pristine space unsoiled by the sticky fingers of the art marketeer, but it's almost guaranteed that if a visitor provides opportunities to students then they'll be invited to return with the reiterative honorarium, which might include a plane ticket and hotel to help sweeten the deal. (Most art people need to go to L.A. at some point.) This invitation to trawl for talent in the form of a visiting lecture can easily backfire, as the biggest names aren't always the best connected and tend, by the nature of their bigness, to be fairly self-involved. But fancy names do efficiently burnish the reputation of a program, even if they might otherwise prove useless.

#5 "LISTENING/SEEING"

The only authentic class I witnessed that was actually meant to teach someone how to really behave like an artist, James Benning's "Listening/Looking," provided a space in which simply keeping one's eyes and ears open was important. Arguably a little hippie-ish and poetic, the course description is the kind that makes CalArts so strangely attractive:

> Each week a different location (either urban, rural, or wilderness) will be visited for the purposes of listening and seeing. At the end of the visit the class will meet within the location to discuss what each has individually experienced …. Some of the specific sites are: an oil field, emergency hospital waiting room, Death Valley, the Los Angeles Port in Long Beach, San Fernando Road, and 29 Palms military base.

Applicable of course to filmmakers trying to find a decent location, I think this activity is what's useful to almost everybody: whether the postgrad artist's practice is defined by closed-circuit art references, studio games, or all out craftiness, or even if the student goes on to be something that has nothing to do with art, listening and looking with keenness and clarity seems an important gift, and a rare one.

What is the moment, the assignment, the heuristic, to use the parlance of the education trade, which transforms one from a lump of unstudied, lumpen clay into the completely rigorous and whimsically imaginative contemporary artist?

To see and hear what most people miss, and perhaps even to see what is not yet there, to see what is possible.

Convince your three best friends from art school to start a gallery.

When I started to think about memorable art assignments I'd gotten or heard about, all roads led to California: John Baldessari throwing a dart at a map of L.A. to determine where the class would go that day; my own *Blade Runner*–like guided tour of downtown Los Angeles by Mike Davis, who was my first teacher at CalArts, which ended with drinks and apocalyptic talk at the revolving bar on top of the Bonaventure Hotel. My friend Sharon Lockhart mentioned something about a cookbook she had made with her advanced photo class at USC, together with visiting artist Lisa Anne Auerbach. Sharon has a collaborative spirit, and it didn't surprise me that this spilled over into the classroom and inspired her students to work together. The class ran from six to nine o'clock in the evening, and, as someone who teaches a seminar from seven to ten, I know how much the mind can be preoccupied with food during that particular time slot. The students decided to reach out to artists and writers they admired and ask for a recipe. I'm not sure how many meals from the zine were actually cooked or shared by the class (some of the recipes are more practical than others), but the responses were amazing. One of the students wrote an introduction, and if there was space I would reproduce the whole thing here, but here is an excerpt that describes the evolution of the idea for the *f-stop café* cookbook:

> One evening, as we're all just about to boil over the top of our dialogue-heavy melting pot (I do think this is exactly what a melting pot should be heavy with) we decide there needs to be a collaboration representative of our nourishing process, and of working as a group those many nights through dinner time. We turned to the kitchen, which was no surprise, and looked to other artists to consider the ingredients in their work, as well as their work as an ingredient in our own. Where invariably our own materials are the artists of the past and present, we found that our own inspirations find stimulation from the same obsessively concentrated sources, that contemporary artists as well do indeed feed each other—in many cases feeding each other with a certain piggishness.

—Jessica Witkin, "The Joy of Cooking," f-stop café, November 2004

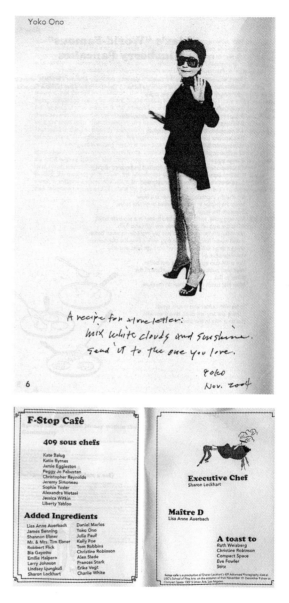

Yoko Ono

A recipe for a love letter:
mix white clouds and sunshine.
Send it to the one you love.

Yoko
Nov. 2004

6

F-Stop Café

409 sous chefs

Kate Balug
Katie Byrnes
Jamie Eggleston
Peggy Jo Pabustan
Christopher Reynolds
Jeremy Simoneau
Sophie Tusler
Alexandra Wetzel
Jessica Witkin
Liberty Yablon

Added Ingredients

Lisa Anne Auerbach Daniel Marlos
James Benning Yoko Ono
Shannon Ebner Julia Paull
Mr. & Mrs. Tim Ebner Kelly Poe
Robbert Flick Tom Robbins
Bia Gayotto Christine Robinson
Emilie Halpern Alex Slade
Larry Johnson Frances Stark
Lindsay Ljungkull Erika Vogt
Sharon Lockhart Charlie White

Executive Chef
Sharon Lockhart

Maître D
Lisa Anne Auerbach

A toast to
Ruth Weisberg
Christine Robinson
Compact Space
Eve Fowler
Stitz

James Benning

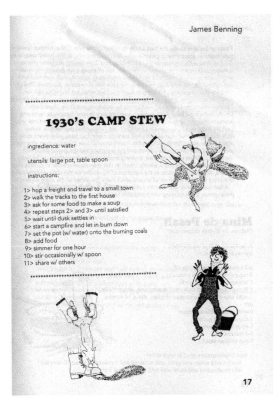

1930's CAMP STEW

ingredients: water

utensils: large pot, table spoon

instructions:

1> hop a freight and travel to a small town
2> walk the tracks to the first house
3> ask for some food to make a soup
4> repeat steps 2> and 3> until satisfied
5> wait until dusk settles in
6> start a campfire and let in burn down
7> set the pot (w/ water) onto the burning coals
8> add food
9> simmer for one hour
10> stir occasionally w/ spoon
11> share w/ others

17

Classes can become private worlds, so when I learned from artist Mario Garcia Torres that Robert Barry once asked a class to "share an idea" and tell no one outside the group about it, including Barry and the teacher, David Askevold, I thought Barry's request sounded redundant. For Barry, the assignment was a piece; for the students, it was one of several works they made for Askevold's 1969 "Project Class" at the Nova Scotia College of Art and Design. According to Barry's instructions, if anyone other than the students found out about the idea, the piece would "cease to exist." The students invented the secret idea and moved on to the next work, possibly based on instructions from Sol LeWitt or Douglas Huebler or Lucy Lippard, all of whom also participated in the class. (Whether or not the secret was discovered is unknown. The work's existence, at least for Barry, is not unlike the famed example of the physicist's cat in the box: both alive and dead until further notice.)

Forty years after the class, and armed with the secret as his MacGuffin, Garcia Torres asked each student about his or her remembrances of the project. Garcia Torres's resulting slide presentation, *What Happens in Halifax Stays in Halifax (in 36 slides)*, does not reveal their shared idea—that wasn't his aim—but he did find many stories that will probably be left out of every art historical account. One student in particular, Garcia Torres learned, refused to participate in Barry's work. She felt that the class was being used to make the work of trendy artists and that the work itself was "pretentious." After all, Barry didn't even show up; he Telexed his assignment in. Garcia Torres was not out to cut down the class, but for me, the discontent is revealing. The Project Class shows many of the pedagogical dangers of an art classroom designed around strict conceptual works. Students become a silent working class, and the school is remembered for its all-star lineup—"Really? They made a LeWitt, too?"—rather than for any pedagogical contribution. But Barry is not naïve. Students have a world separate from the teacher and the school, one that he wanted to highlight, no matter how tepidly. As for who needed this highlighting—the students or the teachers—I'm not sure.

I. AUTOMATIC

We tend to think of Surrealism's primary aim as being the creation of representations of the subconscious. What is almost always underemphasized when speaking of Surrealism is its attempt to harness the powers of the irrational and the subconscious to expanded ends, be they social or political. One of our exercises sought to tap into this underground territory. Visual strategies pioneered by the Surrealists have been championed by almost every movement that followed them, from Abstract Expressionism to Situationism. Starting here, create a project that exists in two places: the sketchbook and another space. This could simply be a set of larger drawings or it could expand into other strategies and solutions.

II. THE SPACE AND TRANSFORMATION

Rem Koolhaas was one of the first modern architects to openly criticize the utopianism of modern city planning. The Situationist International had been attacking these strategies since the 50s. Utopia, derived from Greek, translates literally as "no place." For this project, begin by revising your previous notions of space, taking some of the architectural exercises and readings as a cue. Think about the a priori notions that go into ideas of planning environments for others.

III. POLITICS: STRANGE POWERS

The political landscape of the contemporary moment has seen a confirmation of the critical evaluation of liberal capitalist structures. A simple reorientation of our political views based on the traditional left/right/center distinction has proven ineffective in attempts to address new complexities in contemporary social life. Taking cues from the readings over the semester (I cite the Judith Butler reading in particular), I wonder if we can begin to see if there are other ways of thinking about the political. Additionally, are there other ways of thinking about representing the political? Rather than asking you to make a work about contemporary politics, I am asking you to try to make a work or works that *are* contemporary politics. That said, feel free to use any strategy you see fit, and if this seems overwhelming, think about how these projects this semester have both an historical interconnectedness and a structural interconnectedness.

Painting from observation, students will develop a painting that incorporates decorative patterns (fabric, wallpaper) with found or personal objects of interest. Setting up a traditional still life is not required for this project and is discouraged. However, students should figure out a way of organizing pattern(s) and object(s) in the space of the picture plane so that the characteristics of one in some way affects the characteristics of the other. Eighteen by twenty-four inch stretched canvas.

My first art teacher in college was a painter of gestural, organic abstractions, who taught painting based on formal principles of color and composition. The teaching assistant had a completely opposite approach: cool, reductive, ironic.

One week the T.A. got to give us an assignment, and it was, as I remember, "paint a wall." Or rather, make a painting of a wall. That was it. Being a teenager and an art student, I was, of course, a narcissist. It didn't occur to me that his assignment might stem from his own work, or the limits he was testing in his own painting. I could only see it as a kind of blank, smart-alecky challenge to us. I found it weirdly maddening, like a trick.

I was an A student and a real striver, but for once I didn't try very hard. I sat down with a tray of whites and neutrals, and tried to paint the light on a dorm room wall, from life, in the most literal way possible. The result was awful: a muddy wreck of a canvas, hideous beige fading to a sad eggshell, no luminosity, no complexity, no transformation. I think I missed the class where we all showed our wall paintings and critiqued them—thank God—but I do have a vague memory of handing my assignment in to the T.A. and seeing his expression of mild annoyance, like, *really, that's the best you could do?*

The weird thing is that over a decade later, I started to make paintings of walls, floors, carpets— blanks—in intricate detail. This could be the reason I have such a clear memory of the assignment, but probably not. It's most likely because I found the experience somewhat humiliating, and nothing stays with you like humiliation does.

But art school assignments are inherently humiliating. It's always a trick question: you're never supposed to do it "correctly." You're supposed to somehow interpret the directions in a new way, let your own special point of view shine through, find the key that unlocks the bullshit assignment and reveals the true art within. The ultimate humiliation is, it's not really your work. The assignment forces your "art" to act in service of someone else's art values.

Assignments are supposed to broaden your ideas about what your work can be, and to teach you how to solve problems in art. But they also, possibly, acclimatize you to the idea that failure and humiliation are part of the deal, and that without them you can't be sure you've really exhausted a possibility. Maybe that's the real lesson?

The other lesson is, you might be running into your T.A. at openings for the rest of your working life, so don't phone it in.

KAMROOZ ARAM AND LANE ARTHUR

LANE ARTHUR: *During my senior year at Maryland Institute College of Art, I had the fortunate opportunity to attend a class you taught, "The Studio Practice and Research." As noted in your syllabus for the class, "The course aims to break the myths of artistic 'inspiration' and the romantic/bohemian lifestyle, and focus on the role of the artist as intellectual and researcher, as a means to explore the artist's subject or content." In addition to outlining the course, this description seems to accurately characterize an important transition that takes place in the college experience of all art students. Upon completing their foundation years of college, students are faced with the new responsibility of questioning and analyzing rather than simply fulfilling a studio assignment. As a teacher who's taught at various college levels, how do you value the classroom assignment?*

KAMROOZ ARAM: The transition that you describe is crucial to the development of art students. Clearly, inspiration is not something that can be taught. But at a moment when art students are full of ideas and epiphanies, I think it is helpful for them to have some guidance, to be able to organize their thoughts, slow down and channel their ideas into an appropriate form. The basic approach to this course is present in every class I teach: to open students up to an idea-centered, research-based approach to art-making.

But to answer your question, I have never really focused on assignments much. To my recollection, I only give assignments in introductory courses. These assignments are pretty open: make a painting from found images, which may include photographs, film stills, advertisements, etc. I might give them a little talk on the Pictures Generation, talk about Richter, Tuymans, etc. and then let them go. When working with more advanced students and graduate students I can only recall giving reading and writing assignments. Having attended graduate school at Columbia when the program was very new and experimental, I value an open and steadily shifting model for the classroom studio. No class is taught the same way twice. I only have a syllabus for the administration and maybe to list readings, at most as a vague outline for those who need structure. Do you remember any assignments in the Studio Practice and Research? What do you think were the strengths and weaknesses of this approach?

LA: *While encouraging interdisciplinary modes of production, you resist generalization by narrowing the focus of your curriculum to reflect the needs of the students. In my experience of the Studio Practice and Research, for example, the dialogue was specific to painting, with many reading and writing assignments. In general, I valued writing assignments because they promoted idea-seeking and productivity in the studio. Would you agree that writing is a necessary component to the studio practice, a way to maintain longevity and momentum perhaps?*

KA: Sure. The writing assignments have always come from my own experience with using writing as a tool for research and investigating my work, as well as writing outside of the studio as another way of investigating issues that are, however tangentially, related to my work in the studio. I always keep notes in the studio, as I have ideas or come to conclusions about certain themes in the work, in addition to occasional random musings. I think that writing in the studio can be a very effective tool in contextualizing one's practice and understanding one's own work by concretizing ideas and offering a more logical approach to content which may have been explored in the less rational methods of art-making.

LA: *How do you judge the efficacy of an assignment? Could you offer an example of an assignment that yielded exciting or unexpected results?*

KA: I honestly don't like assignments very much and I'm not very good at giving them. I think some of the most interesting assignments I've seen were on *Project Runway*, and some of the least interesting assignments I've seen were on *Work of Art*. Perhaps this is because *Project Runway* assignments typically give the designers a set of limitations and let them run with it, whereas the *Work of Art* assignments attempted to give the students a vague and often banal idea to work with, such as "make a 'shocking' work of art."

LA: *I'm glad you mentioned these two television shows, as they both exaggerate the urgency of the deadline.* Work of Art *requires the contestants to complete a project within a week,* Project Runway *ranges from five hours to three weeks. This corresponds almost exactly to the classroom model. I've always thought these time limitations parallel the overbearing demand*

of the market without actually acknowledging it in a critical way. Do you find this to be problematic? Is time something you address in response to assigned work?

KA: That's interesting, I had not thought of the urgency of the deadline, but now that you mention it, it is an interesting parallel. I'm not sure, though, that this is something that is necessarily parallel to the demand of the market. Deadlines are always there. Without the market, it might be a deadline for a proposal or a museum exhibition, the framers or fabricator, etc. Sometimes when there are no deadlines, work is never completed. At the same time that I say this, I can be a pushover when it comes to student deadlines. On one hand, I believe it takes as long as it takes to complete a work and it shouldn't be rushed. On the other hand, I see how this attitude can encourage lazy students to be unproductive, and I certainly don't like discussing work with students when half the conversation is "and them I'm going to ...". Anyway, I don't have a problem with the urgency of the deadline, though the weekly model of *Work of Art* is a bit silly.

I do think assignments have been fruitful in my classes when they have come in direct response to what was happening in the class. This happened a couple of times with your class. I noticed that many of the students were making abstract paintings and we were having heated conversations about the problems and possibilities of abstraction in contemporary painting. I asked you and another student to curate an abstract painting show at school. We booked a gallery and you put on a fantastic exhibition. In this case, there certainly was a deadline. Was all of the work in that show already existing or did you ask any students to make work specifically for the show?

LA: *The artists that the co-curator and I invited to exhibit were not making work specifically for the show. However, several of the works were in progress until shortly before the installation date. Although it was a pleasure to work with everyone involved, it was challenging to organize a large group of students while also collaborating with another curator, who counterbalanced my approach and theories regarding painting. Despite the relaxed reputation of the student gallery, we set out to achieve a realistic curatorial scenario, complete with "press 1" and other promotional materials, even at the risk of seeming dorky. Now that*

I think of it, that was a very meaningful assignment—it helped legitimize many of the arguments we made in class regarding painting, while also presenting real obstacles.

KA: The exhibition served as a culmination of many of the discussions we'd had in class. I was noticing a situation in which students were working with older faculty for whom painting was still somewhat attached to a limited and subjective AbEx approach, while I myself had just come from a graduate school where the name Clement Greenberg seemed the art historical equivalent of Saddam Hussein. But there was something else happening with the students. Some had never heard of Greenberg, but were obliviously functioning in a Greenbergian mode, while others in the show might not have thought of their paintings as abstract until they were put in the context of the show. You were one of the few students who had actually read Greenberg, but you weren't painting abstract paintings. I feel like you had a finger on the pulse of what was happening at school, and as a result were able to find a diverse group of works for the show. So the assignment was specifically for you and the co-curator to put the show together. For others in the class, the assignment was to take part in the exhibition. And whoever was left was asked to write a review of the exhibition.

I don't think this assignment would have been as successful under other circumstances. If I were to have my graduate students at Parsons curate a similar show, it wouldn't make any sense because they have a completely different environment and discourse. The assignment was a direct response to a sort of zeitgeist I saw with the students at MICA [Maryland Institute College of Art] at that time. This is why I prefer assignments that are in direct response to the specific group of students.

The worst assignment I ever gave was at the beginning of an advanced studio class at the European College of Liberal Arts. Since the students are undergraduates, there's a fair amount of education in contemporary art going on alongside work in the studio. I wanted the students to think about who their artistic allies are, and, rather than just throwing up their hands because something's "already been done," begin to articulate what they stand for, and how their work—or their intentions—may differ from artists who share their concerns.

So for this first class, I asked the students to go through a recent issue of *Artforum* or *Frieze*, find an artist they liked who they'd never heard of before, and do a presentation on them.

I arrive at class; no presentations. They don't like anybody.

So my intuitive, smart-ass reaction led to the most successful assignment I ever gave. Fine, I said, come in for the next class with a presentation on an artist whose work you really *hate*.

Next class: everyone's ready to go. The winners are:

Jeff Koons
Willem de Kooning
Damien Hirst
John Duncan
Rirkrit Tiravanija
And the grand prize winner... Hermann Nitsch.

The students performed totally engaged, specific, ten-minute critiques, followed by adrenalized argument (well, no argument over Nitsch), which inevitably led back to a *positive* discussion of each student's own practice.

What I found interesting about this turn of events was how much easier it is, as a first step, to define your own position *negatively*, and how the beginnings of articulating taste are almost always through discovering what you *don't* like. Basically, my discovery, which I hereby share, was to harness everyday artistic bitchiness to pedagogy; because utopia is impossible even in school.

The best assignment I ever gave got me a wife, a dog, "a daughter, and a life.

In 1982, I was in the middle of a break-up with a very long-term girlfriend. After moving together from the Bay Area to Houston, we fell apart for the last time that fall in the heat and humidity of south Texas.

I was teaching photography at Rice—my first real job—and I'd also begun continuing studies classes that were open to the community. I'd started to run around the oak-lined boulevards near the Rice campus that September, to stay in shape and to stay sane. I'd feel centered and content but each time I'd pass a small apartment complex, a beautiful, pure white English setter would bounce out onto the street and knock me out of my calm. She'd chase me but was always quickly followed by an equally beautiful dark-haired, long-legged woman. "Callie! Callie!" she would cry. (I learned later that the dog's name was actually Kali, as odd a name for a dog as my cairn terrier, Dileas). After less than half a block Kali would return to her and the two would go back to the little courtyard in the complex. The third or fourth time this happened, the woman looked up at me and waved and smiled. I felt my life shift and turn. Tectonic plates rumbled, lightning flashed, I was Al Pacino in *The Godfather II*. I knew that this woman would play an enormous role in my life, and I also knew not to say a word.

A few weeks later Kali's owner came into the darkroom, where I had been working like mad on an upcoming show, and asked me if I was Peter Brown. Jill—her name was Jill—told me she'd seen my photograph in the paper and now understood why I was in the darkroom so much of the time. Jill had just completed a continuing-studies introductory photography class, learned I was going to start an intermediate workshop in a few weeks, and wanted to know if she should take it.

I should make it clear that this was to be an ungraded class populated by adults. I was on iffy moral ground perhaps, but ethics and destiny were duking it out in my head, and ethics was getting clobbered. Never have I sold anything more carefully or effectively. I left little to chance: the fun of the class, the intellectual challenge, the work the other students would do, the technical advice. Field trips to small towns, no doubt. I was acquainted with the District

Attorney of Lavaca County, was she aware of this? He was a good guy! Maybe a barbecue for the class afterwards? An upcoming show (mine!) to which she would be invited. The bargain of it all—plus twenty-four hour access to the greatest darkroom in Texas. "Think about it," I said. "I'm pretty sure it's going to be a great class." She said she would.

Two weeks later, there she was, wearing a yellow slicker and whispering a bit too intently, I thought, to two guys who turned out to be doctors. The first assignment had to do with light and it was clear that Jill was a good photographer—a natural, in fact. The second had to do with portraiture. And I saw some of her friends and convinced myself that they looked interesting. The third assignment was about sequence: I showed the class Duane Michaels, Minor White, Les Krims, and the Stieglitz clouds, and asked them to put together a narrative within a sequence of images.

This is what Jill came up with: three photographs, all taken in her bedroom with the camera in the same place, showing a box spring and mattress beneath a wide window—a triptych that knocked me out at ten feet. The first was taken at night. The window was dark. On the wall above the bed hung a framed poster: "Women's Resources"—a grid of irises. The bed in this photograph had been turned down in an inviting way, and there was an end table next to it covered with what seemed to be a Victorian shawl. And on the table a candle was burning. The second photograph was taken in daylight, and Jill was in the bed, facing the bright window and lying on her side. Her back and shoulders were exposed to the waist: a beautiful curve, slight square shoulders, a sleeping head on a pillow, all in soft light. It was eye-popping—an innocent yet rivetingly sexual photograph of a beautiful young woman. In the third picture, the room was in disarray. The bed had been stripped, "Women's Resources" remained on the wall, but it was knocked sideways and the end table, cleared of its shawl was shown to be a cardboard box. Jill was nowhere to be seen.

And I had no idea what to say. I gestured, stuttered, stumbled, and turned red—but the class was with me (they too were surprised) and everyone began to laugh, including an embarrassed Jill. I mumbled something about the best art being evoca-tive, or provocative, whatever the hell ... that words don't do art justice? I said I didn't know what this was about, but that I liked it because you could build your own narrative around it. That I didn't want to try to

define it because its open-endedness gave it its power. And then I paused and began silently to put together my own narrative, and this included getting to know Jill as soon as the class was done.

A month later we were in the bed that Jill had photographed and that night Kali chewed up my shoes. We've been together ever since.

In our wedding vows we exchanged our dogs, and a year later our daughter Caitlin was born.

Jill says she has no recollection of me ever running past her on the boulevard. Kali apparently chased everyone.

And the sequence assignment, simple as it was, changed my life.

An assignment is issued.

1. The contentedness with the bounded is a sour contentedness—motivation must come from within. We cannot accord action to "right standards," we can instill proper will.

A. Better to give a ridiculous and absurd instruction than to merely explore the realm of the relevant. Typically passive learners need to be jolted on occasion, made miserable, forced to respond or fail. These are all responses necessitated in the moment of assignation. Assignation can be momentary or over a period of time, but it all requires capturing the student in a moment of necessary response.

B. Can't necessarily tell you how to do it, only that it can be done. Requires materials, time, certain strong aesthetic choices. Strong personalities encouraged. Strongly passive remains one of the strongest of all personalities. This is of course why special attention is worth paying to nearly all categories and methods.

C. It is questionable whether right standards exist or should exist. Each member of a conceptual or formal dispute should desire to reject agreement and accept relativism in both concept and form.

 a. Relativism is mutually beneficial.
 b. Assuming content displaces student initiative, for little benefit.
 c. The assumption that only static and inflexible organizing principles can produce predictable and positive results is false.
 d. 2011 – Systems theory.

D. In the context of instruction one should allow pupils to flounder, to find their own way, to grope frustratedly at the surface of ideas for a good long while. The process of realization is like searching for a trap door: no distinguishing features, and all of a sudden the bottom drops out.

 1. The assignment hides the trap door under shag carpet.
 2. The assignment will bind some to the exact formulas dictated, but some will attempt experimentation. To assign – to dictate – to command – to recommend – to advise – to suggest – to transmit – to share. This is a semi-logical progression of methods from hard to soft.

 a. All methods are useful, but not all methods are useful all the time.

3. We should instruct considering all methods as "assignments" but knowing that within the world of "assignments" not everything merely assigns. It could dictate, command, recommend, advise, suggest, transmit, share, etc. The goal is to nudge the searcher toward the hole in the floor.

2. Consider this progression:

 (1): I give assignments that start from a concept I created
 (2): The assignment is to follow my concept
 (3): If it does not follow my concept, then it is not the assignment
 (4): (3) is a false statement

There seems to be little reason for the conclusion in (4). (3) has reasons, based on the hypothetical (1) and (2). But (4) is correct. The assignment only names what is happening, categorizes some chunk of time and space with a handy label. The concept is irrelevant; it was only a prompt in the first place. We should regard any response to the prompt acceptable, fulfilling, true, real. The prompt necessitates something. Any response is a response. You can't just sever the causal chain when it displeases you. Second is the bottom dropping out.

 Instruction should inspire spontaneity, but there is hope that instruction inevitably inspires spontaneity. Non-responses, kiss-offs, and subversions of all kinds are inevitably responses to the prompt, however far they wander. All an educator can hope for is the sudden feeling of falling, when pupils gain a will toward individual competency and expression. All systems trend toward disorder; there's no need for an isolated perspective. Be assigned to openness, to the acceptance of being subverted.

We all figured it was going to be a bad assignment. The roaches were simply proof. John caught one crawling across his desk and spray-painted it silver, in an unsuccessful attempt to make it aesthetically pleasing. He pinned it to an odd scrap of paper, and for a while it was on display, like a trophy. However, after several hours of stunned quiescence, it wrenched its newly shiny shell free of the cardboard and, still impaled, skittered away to join the others clustering around our baseboards.

Our undergraduate architecture studio, appropriately located in the subterranean dining hall of a long-defunct fraternal society, was currently full of roaches and cake. The cake was sheet cake, yellow or white or chocolate baked several nights ago in the seldom-used ovens of our off-campus friends, who we had roused from sleep with a series of plaintive and increasingly desperate phone calls: "Please! Even though I have not slept in days and yes I know I never bake anything, please, can't I just come over and bake several cakes in your tiny kitchen, and perhaps catch some sleep on the floor right in front of it, if I promise to set a really loud alarm and put the smoke detector under my pillow? Please? It's for a project." These sheet cakes had been taken back to our dorm rooms to become slightly more stale (good for structural stability) and promptly ejected from those same dorm rooms by roommates who had the good and well-rested sense to see exactly where this was going, vermin-wise. Now, on the eve of the deadline, their predictions had proven horribly, grotesquely true.

The previous weeks of the semester had been spent hunched over our desks, hunching being the standard posture of all the architecture students, except for Mimi, who somehow managed to look graceful at all times, and Oscar, who had been recruited for football, and was therefore too large to hunch, being forced instead to hunker. We were designing some unnecessary building without a distinct purpose. That was what architecture students did: you gave them a location or a need, and they worked nonstop on creating some unrelated but beautiful structure, slaving away in seventy-two-hour shifts until they were no longer able to see straight, whereupon you asked them to stand up and talk about their project for forty-five minutes to a group of important people. (This is why architectural theory is so impenetrable; the entire discipline is based on an ultimate goal of self-confident incoherence.)

Following the latest round of dazed critique, our professor had noted that our buildings' facades, while nominally masonry, had little connection to Newtonian physics, and that perhaps we needed to gain a more concrete (I believe he chuckled at that point) understanding of how stone worked.

"You will build," he announced, "one bay of your building out of cake. ¾ inch scale."

No mortar was allowed, which at least spared us the prospect of tubes of icing littering our desks. No pasta rebar or other sort of non-cake structural members could be employed. Windows and doors should be left as raw openings. The entire thing (roughly 20 inches tall) should stand freely on its own. I think he may have invoked the masons of Machu Picchu. We had a week.

After an initial day or two of baking and airing-out, we grabbed whatever implements we thought best (from dining-hall knives to hacksaw blades), and began trying to cut out our "stones." Since we were only building a single bay (roughly defined as one entire vertical section of whatever windows repeated across our facade), we learned our first lesson of stone construction early: no sane mason would try to build a freestanding three-story wall. Also, masons did not generally have to worry about their handiwork being eaten by mice.

To keep our isolated walls from simply slumping off to the side, we framed them with buttresses of cardboard, and as the mice and roaches gradually eroded the lower courses of cake, illegal toothpicks were surreptitiously inserted to hold the remaining blocks together. When some of the cake inevitably failed, due to industrial accident (dropped on the ground and broken) or act of God (sat upon), new cake was produced, meaning that we were working with a mix of soft and hard blocks, stacking virtual granite atop virtual clay.

Modern cake technology was also against us. Betty Crocker's delicious "SuperMoist" cake mix was just never going to dry out, making it dangerously unstable. Cake purchased pre-baked at the super-market had some sort of commercial-grade oil in it which leached into the cardboard supports and caused them to collapse. Experiments with Twinkies proved that the cake portion was extremely durable (while squishy, it wouldn't crumble) but there simply

wasn't enough of it, and the creamy filling was so attractive to ants that it was soon abandoned.

After several days, we were all fairly disgusting, even for college students. Any body part resting on a flat surface in the studio came away with a smear of crumbs. As the deadline approached and we resumed our habit of sleeping at our desks, we would awake with a light dusting of cake, leading to a general fear of roaches crawling across us while we slept. The trash cans, filled with the ruins of collapsed cakes, rustled ominously when we approached them.

By the night before the critique, we had all ceased to care. Exhausted and vaguely nauseated, we engaged in none of our typical last-minute frenzy. Many of us actually went home to sleep, though others stayed behind, afraid that after a shower and nap they would be unable to wade back into the filth for the final presentation. In a fit of pique, I wrote an angry letter about how the assignment had been a waste of time, and pinned it to the studio door.

At 11 AM, we carried our models upstairs (itself a dangerous operation) for crit. The rows of windowless openings and crumbled cake-brick formed a Candy-land Dresden in the center of the room.

Although I've asked around, nobody seems to have any memories of the actual presentations. I vaguely recall being extremely happy that I could throw the model away afterward, and that I imme-diately went out and ate a bunch of salad. One particularly organized student wrote a formal letter of protest to the administration, and the professor was not seen in our studios again.

Looking back, I'm sure it seemed like a funny, low-stress thing to assign. Maybe he was having a rough week. Maybe he was distracted by his own work or by another class he was teaching. Maybe we were just a bunch of arrogant jerks.

Every time I give my students an assignment, I am haunted by the fear that I'm going to be giving them their equivalent of what came to be known in studio as simply "the cake project." Although it was a terrible assignment from the standpoint of learning about architecture, for fifteen years it has served as a stark reminder of what students expect from their teachers. Somewhere out there, my comeuppance is waiting. I just hope it's chocolate.

My most memorable art assignment was given by John Monti in his Sculpture 1 class at Pratt. The assignment itself was straightforward: make a sculpture whose primary subject is tension and balance. What made the assignment memorable was that it dovetailed neatly with my very real need to rid my dorm room of a mouse. I had been locked in a battle of wits with this mouse for a few days and although I doubt he saw it as a competition, I felt like he was taunting me every time he slipped through one of my ad hoc cardboard traps. It was like trying to catch a tiny ghost. But now, armed with the purpose of the tension/balance assignment and some time in the wood shop, I felt like I had a chance. The end result, a catch-and-release-style mousetrap made from wood, chicken wire, and aluminum rods, was the size of a large shoebox and vaguely resembled an Eva Hesse. At the time I was enraptured by Rauschenberg's famous statement about wanting to operate in "the gap between art and life," so I did not try to hide the fact that I had a mouse problem and that my project was intended to help solve it once the critique was over. This went over surprisingly well. Two nights later, with the help of some peanut butter, I caught the mouse and let him go by the KFC on Myrtle Avenue.

My class, titled "Diaries and Journals," attracted the troubled: those who already knew they would not be among the twenty-five percent whose careers would take off the first year out of school. Reading Paul Thek's "Teaching Notes: 4-Dimensional Design," I realized that an artist defines oneself by her questions, and that asking "What are your questions?" was more apt than asking "What is your work?" So the assignment became to write our own sets of "Notes"— an unselfconscious way of producing personal manifestoes. Everyone liked doing this. It was one of those assignments where, providing you follow basic instructions, there's no way to fail. Sometimes the results were surprising. Mostly, the class saw the assignment as a game, a way to produce something great without working too hard, but I remember one time when we read our pieces out loud, an administrator who'd been sent to observe burst into tears, assuming some of the questions—"What makes you fat?"—were directed at *her*.

"Teaching Notes" is a questionnaire created by the American artist Paul Thek to teach the 4-Dimensional Design Class under his charge at Cooper Union between 1978 and 1981. The notes consist of a series of questions that deal with subjects ranging from personal data to philosophical perspectives. They are formulated through compelling writing, and stimulate a playful but in-depth exploration of the interrelated nature of personal and contextual events, as part of artistic production. The piece becomes a useful tool to interrogate the role that these relationships play in cultural production.

This art assignment has been appropriated and referenced by artists of different generations from various places. Below, the "Teaching Notes" is introduced through the experiences of three artists and teachers who expand upon the meaningful events it has generated in their practices[1]: Harrell Fletcher reflects upon his various approaches to the questionnaire as a means of valuing ideas and questions as highly as artworks, and as a way to better know his students. Abraham Cruzvillegas recalls the reaction of his students and his appropriation of the assignment while teaching at La Esmeralda and at the National University in Mexico City. Naomi Rincon-Gallardo analyzes her use of the questionnaire while starting to teach in Mérida, Yucatán.

THREE EXPERIENCES

HARRELL FLECTHER: The "Teaching Notes" begins fairly conventionally as a sort of questionnaire for Thek's students: "Name, age, birthdate, place of birth" etc., but the questions quickly become more personal and strange: "What is the purpose of dating?...On what do you sleep?...What is eternity?" Then the questions

1 These contributions are presented in this text as edited transcriptions from online conversations held by mysef with each of the artists.

start to become little assignments: "Redesign a rainbow...Make a monkey out of clay...Design a new clock face." More intense research-related questions are included as well: "Explain the Zen doctrine in your own words...Who is Savonarola?...How can we humanize Cooper?" Thek ends with a paragraph about his grading system for the class: "Remember, I am going to mark you, it's my great pleasure to reward real effort, it's my great pleasure to punish stupidity, laziness and insincerity." He goes on to say that those marks won't mean much, and that instead the reactions of the other students in class will be more meaningful and important.[2]

Just reading the list of questions was a really powerful experience for me. I was in a library somewhere and I remember being struck by what I thought was a beautiful piece of writing, and by the realization that one person could be interested in so many different things and be able through these 'simple' questions to provoke all these different feelings within me. But then it wasn't just that the list was meant to be read, but that it was actually designed as a pedagogical tool. That was amazing to me. It made me wish I had taken that class, and then it led me to ask myself: Can I as an instructor provide my students with this kind of experience?

There is a prevailing idea about assignments in art: that they are something you do in school but that you're not really supposed to do as a professional artist. I was flirting with that idea somewhere in the mid 90s, so when I encountered that list I was already turning around with the idea of originality: How much does originality matter? Can you follow somebody else's instructions and still do something that is still very personal and significant and valuable and real? Can we somehow get rid of the value that's placed on originality? The "Teaching Notes" appeared in perfect timing, almost as if Paul Thek was saying, "Here, use this." These questions were very important to me, both as an artist making projects and as a teacher in

a classroom scenario, while I was working on ways to merge those two roles.

More recently, I've used the questions with my current graduate students. Thanks to their answers, I learned about their life and things that made me understand them in a different way. It was so exciting to think at that time: "Is this an important question to ask, an important thing to know about your students?" and then realize that everything about them is important to know when determining the best way to function as their teacher.

I think that having actual experiences with and knowledge of your students that go beyond the traditional lecturing format is really important and really effective as a teaching method. When I look back at my own educational career, the moments that stand out often times have to do with breaking down this traditional structure and having a more personal experience with someone.

I think the "Teaching Notes" could be of use to students (and to anyone really) in a number of ways, one of which is by showing them how to value ideas and questions in the same way that they might appreciate a work of art. For me, the notes are like my favorite literature, written almost like a poem that encourages readers to examine their own life, their knowledge, and their relationship to the world.

—

ABRAHAM CRUZVILLEGAS: I heard about Paul Thek's work after seeing a piece of Thek's at MoMA in the early 90s. As I had started teaching in Mexico City (at the National School of Visual Arts, at the National University), I was very interested in his teaching work at Cooper Union. Then, looking for more information, I found a catalogue that included the "Teaching Notes." I used it my classes, and made some changes in order to modify it for dialogue with students, but preserved its original soul and feeling.

It was very important for me, because it helped me to approach students for the first time, asking them very personal questions and measuring their knowledge, critical ability, and openness to dialogue. Some students reacted angrily or with surprise, but this always made a good starting point for my classes.

I've imagined Thek's pedagogical work as a very engaged one. As an artist I've challenged myself to question educational practice, attempting to avoid

2 Fletcher, Harrell; Thek's Teaching Notes; Publication Studio, Portland, 2010. p. 4

authoritarian games and relationships. His notes always offered me a tool for understanding my art practice as an ongoing learning experience.

I've tried to design a similar tool for myself, one that can work both as an educational method and as an artwork.

—

NAOMI RINCÓN GALLARDO: My first encounter with Paul Thek's work happened while looking at the catalogue *Paul Thek: The Wonderful That Almost Was*,[3] at the end of which I found his "Teaching Notes." A few years later, I was handed a Spanish version of them that had been made by Abraham Cruzvillegas, who taught at the National School of Painting, Sculpture and Printmaking La Esmeralda, in Mexico City, where I went to school. I found them very helpful when I myself started teaching at the then-recently inaugurated ESAY (Escuela Superior de Artes de Yucatán), a progressive and pioneering project for the first art school in Mérida, Yucatan.

The "Teaching Notes" were relevant because they gave me a way to start unpacking my students' affective baggage. They helped to start developing a group process. We began by sharing personal experiences and autobiographical issues among peers, seeking to create a space that would promote both openness and exposure, a container for vulnerability. Some of the questions stimulated a mapping exercise that helped situate the subjects within the group, thus allowing the group to recognize its identity, allowing them to collectively conceive an educational experience, an ideal school.

I myself only fully experienced the questionnaire while answering it along with my students. As a teacher, I discovered various differences between my experiences and contexts, and those of my undergraduate students. Simple questions such as "On what do you sleep?" revealed that most of my

students were sleeping in hammocks, while I was not. I realized then that a great number of them came from social contexts that I, as a recently graduated middle-class art student from Mexico City, was not familiar with. Furthermore, I understood that they had no common vocabulary with which to approach the artistic context, which I would have expected from a larger city group used to visiting exhibitions and with an already stimulated relationship with artistic production. These discoveries showed even more clearly and powerfully that the starting point should be based on each student's personal background, which would make everyone an expert on their own lives and their contexts. Before I started teaching I already knew that I was coming to a new context, but this questionnaire allowed me to confront this in a much more productive way.

We answered all the questions in different sessions in which responses were made public and shared within the group. It became very clear that there was a fundamental need to create a sense of community, not only within our group but in the school as a whole. Sharing experiences became an essential practice, one that is not always experienced in an institutional framework. This practice allowed students to learn to look at local phenomena in a new way; to intersect their subjective experience with local celebrations; to establish active exchanges among themselves, with the school, and with the people in Mérida. They really made it theirs.

The assignment did not end with the students' responses. It actually prepared the field for other activities to be made by the group. It resulted in real practices: a bazaar in a public plaza of Mérida, a rally of interventions through the city, and games played by students with local communities, among many others. I believe these were in a way linked to some of the questions Paul Thek raised through his collective installation works with the Artists' Co-op: Why should an exhibition be cool, cold, impersonal? Can it be more like a procession, with music, with noise, with people celebrating?

As an art assignment, the "Teaching Notes" has the real virtue of promoting inventive processes rather than repetition. It's open enough to generate different experiences according to each specific context. When it is applied, varying results will be generated, since in every context the outcome will be different. Thek's exercises open the possibility for each of us

3 Paul Thek: The Wonderful World That Almost Was is a catalogue published in conjunction with the show of same name held at Witte de With, Center for Contemporary Art, Rotterdam, June 3– October 8, 1995.

Includes texts by Paul Thek, Ann Wilson, Anke Bangma, Harald Szeemann, Richard Flood, Marietta Franke, Holland Cotter, Roland Groenenboom, and Rebecca Quaytman. Distributed Art Pub Inc., 1995.

to understand our role as a cultural producers. They show us that our own experience can be an important reference for artistic production, even before we acquire the forms of the academy or the art world.

CLOSING WITH MORE QUESTIONS

The three perspectives, and the "Teaching Notes" itself, emphasize the value of experience as part of the educational process and part of our own personal constitution. They raise apparently simple but essential questions for social relations: How well do we know each other? How important is that as part of a cultural process, or as part of cultural production? How and what do we oversee, assume, interpret? How much do we let ourselves be affected by our surroundings?

On those occasions when I've participated in a show or project that required a specific theme, I've made work I never otherwise would have. As far as my teaching goes, I only give assignments to beginning students. For the most part, I would rather see what they produce when left to their own devices. My daughter, however, reminded me of an assignment I gave every year to my Foundation Painting class: I cut a poster of the Beatles in a flower garden into twenty equal squares. Each student got a piece to paint onto a 12×12 inch canvas. The class was six hours long and at the end we put all the painted squares together. The combined canvases always had an astonishing energy, much more so than the individual paintings. It taught the students about the power of collaboration and potential in combining diverse approaches. It opened them up to the possibility of working in different ways and made them question their assumptions about a unified style.

The best assignment I ever got in art school was to find advice on how to be a successful artist. It wasn't supposed to be advice on becoming a successful artist financially. A real artist isn't supposed to be concerned with money. It was supposed to be deeper than that. We could get advice from friends, family, other artists ... anything from anyone anywhere from anytime. We could present the advice as a written list, a painting or a sculpture, even a performance ...

I memorized this very long Bob Dylan poem called "Advice for Geraldine on Her Miscellaneous Birthday" and recited it as I shaved my head with clippers I bought at the Kmart on Astor Place. I wore nothing exceptional for the performance, just a pair of old black jeans so faded they were more gray than black and a threadbare brown button-down shirt I found at a thrift store. I needed an extension cord for the clippers so I used an orange one you can get at any hardware store. I sat on a metal work stool. I performed the piece in a small white room where most pieces took place. After the performance my long black hair was all over me and the floor. During the crit people said it reminded them of the painting *Self-Portrait with Cropped Hair* by Frida Kahlo.

it is sad to say that i never really gave a shit about art assignments more for the fact that i couldn't fulfill them rather than true disdain. just like when i was taking organ lessons and my parents were concerned that i wasn't getting it. in reality, i learned by ear so i practiced what i remembered not what i was reading. so when it comes to art perhaps i tried to make my professors happy (of course any only child would expect nothing less than unadulterated adulation) but in reality i slugged through with the little shitty things i made that didn't fit the assignments or sort of did.

then the professors went on strike. and the world opened up. all the time (going through a breakup) spent in the studio working on god knows what. that is where i found michael and adrian. a couple of art stars in my mind capable of anything they wanted to do. as i struggled with this bullshit oil paint they directed me to another place where there was no grade and just a friend telling you what you did was good. this was the beginning of the art lodge. this was the beginning of scrap art. we made fake names and wrote a manifesto. we listened to george burns and daniel johnston. we looked at henry darger and james hampton and david hockney and i drank a lot so did adrian. then the profs came back assigned us grades and we all went home. they were good professors but the labor dispute was a lucky break for us art lodge guys.

(if anyone has a more accurate recollection of this i am sorry.)

I spent a fair portion of my undergraduate studies in hot pursuit of an A from a beloved graphic design instructor at the art school I attended. She was radical and she was ruthless. In the earliest classes, I recall being mystified and enchanted by her teaching style, which brought in anecdotes and resources from all over the place, and feeling that this was a sensibility I could understand. For a faculty exhibition, alongside an unfortunate collection of watercolors of boats in the-harbor and ceramic vases, she displayed a three-story-high, brilliant red three-dimensional ampersand in the gallery, to represent the "&" in her eponymous design company's name, and I thought she was a rock star.

As I entered my junior year, feeling wiser and more savvy as each semester passed, I recall especially a class she led based entirely around the film *Repo Man* by the director Alex Cox. Essentially, we were supposed to be synthesizing the meaning of this film into a series of projects. We were instructed to watch the film thoroughly, exactly, and painstakingly. Each assignment we submitted resulted in a rejection, and the advice to "watch the film four or five more times." Every week it was, "I think you need to watch that film again" or, "You've clearly missed something in that film." As the semester carried on, our frustration was mounting, our rejections were piling up, and we were watching *Repo Man* nearly nightly in an attempt to figure out what the hell it was in this film that we were failing to grasp. I was tearing my hair out, scanning the films credits for hidden messages, and rewinding the most innocuous of dialogue looking for double entendres—not to mention generally becoming aware that my cinematic comprehension was clearly undeveloped and infantile. And what this had to do with graphic design was beyond mind-blowing. In the end, I believe I got a B, and I'm not sure how I even managed that, nor with which design solution. I recall feeling victorious, which betrayed my original and typically competitive desire to wrest that A out of her. Perhaps I was just relieved to have it behind me.

I dedicate a significant amount of my time now to teaching my own students. I would be lying to say that, with all of these years having passed, I now "get" the point of that assignment (I'd also be lying if I said that I "get" the film *Repo Man* itself). But I can truthfully say I think about that assignment more than anything else that transpired in my four years at

that school: more than the exhilaration of having been on my own for the first time in my life, the anxiety of the financial burden of juggling full-time school and work, the intrigue of pseudo-adult romantic encounters, the absorption of art history and art mythology, the recognition that I'd found my calling. No, I think about that teacher, about *Repo Man*, about what the hell she expected of me and about what I was supposed to have learned from that assignment.

I suppose I hope to come up with an equivalent experience for my own students—an assignment that frustrates them, irritates them, challenges them, causes them to revile me behind my back, but in the end becomes the thing that they never forget.

DAVID KEARNS
WHY I SWORE OFF ART SCHOOL
FROM 1997–2006

Art school did a number on me.

My favorite teacher spent the better part of class keeping his hand-rolled cigarettes lit, indifferent to NO SMOKING signs hanging every few feet on every wall.

XXXXXXX's opening remarks were primarily addressed to the pinch of tobacco and rolling paper in his hand. Occasionally there would be the punctuating look up. The licking of the paper, etc. He would take a drag, there would be silence, he would exhale, and then he would speak. Inevitably the cigarette would go out. He would pause, and attempt to take a second drag. Light another match. Re-light the cigarette. And repeat.

Considering how much time actually went into the careful rolling, lighting, and subsequent re-lighting of the cigarette, very little (if any) actual smoking went on.

The class was Drawing I and it started out something like this:

Take a sheet of eighteen by twenty-four paper.
 Draw as many straight lines as you can.
Draw a freehand perfect circle. Draw another one
 inside of it. Keep going until you can't.
Make a drawing with a deck of cards ...

Eventually:

Just go out and find something interesting to you
 and make a big drawing.
Stick to your guts—that's the assignment. Stand
 your ground.

I took X.X. seriously, and it's what got me through the next three years of art school:

"Your bad painting still isn't working. For my
 money ..."
"Of course. Mr. Kearns is a conceptual artist ..."
"Well clearly you are one of the most interesting
 people working in the [sculpture]
 department, but ..."

For a number of years I would look back on the note which accompanied the return of my final portfolio:

"You have a way with your eye and with the paint,
 YOU SHOULD CONTINUE."
—XXXXXXX XXXX

It was about five years later when I ran into XXXXXXX XXXX standing under a tarp, by a keg, filling a beer, at a backyard wedding in the rain somewhere in southern Vermont. I managed to convince myself of some vague recollection on his behalf of me by the time I finished praising the class and trying to explain the quasimystical experience he provided. He seemed taken aback, and, if nothing else, sort of amused. He apologized profusely for the "hard time" he had been going through when I was his student.

Mine was the last class he ever taught at XXXX.

The very last class is something I'll always remember. It was a cautionary tale of sorts, starting with his finally revealing to us his work via slide-show. He told us his story, the story of how he "became a painter," wherein an undergraduate semester of straight Fs was "the Red Badge of Courage"—it's not like you want to go to law school or something like that. "I didn't care ... I was painting ..."

Later, maybe my junior year, I got a D minus in Sociology 101: Intro to Human Societies.

Name, age, birth date, place of birth, position in family, nationality, religion, education, hobbies, career plans, parents' education, parents' birthplace, parents' religion.

Where do you now live? With whom? For how long? What income do you have? From what source? What property do you own?

What are your requirements in a friend? Lover? Mate? What kind of art do you like? Painting? Sculpture? Music?
What do you read? How often?
Do you buy books? Records?
What is your favorite color?
What are your politics?
Have you ever been seriously ill? Serious accidents?

What do you do on a date?
What is the purpose of dating?
Do you believe in premarital sex?
What happens after death?

Tell us about other members of your family.
Tell us about a close friend.
Tell us about someone who inspires you.
Tell us about the most exciting thing you ever saw, did.

How many rooms are there in your home?
How many floors? What floor do you live on?
Do you have your own room? Do you share it? With whom?
What does your room look like?
On what do you sleep? In what? In what position?

Do you take baths or showers? Do you use perfumes or deodorants?
What style or look do you prefer?
Are you interested in sports? Which? How often?
Do you believe in abortion? Do your parents?

What is your worst physical feature? Your best?
What is the main source of difficulty between you and your parents? Teachers? Friends?

What annoys you the most in others?
What kind of teacher do you prefer?
If you were a teacher, what would you propose?
How would you grade your students?

What is eternity? What is love? What is art? What is a symbol?
What is religion? What is psychology?

Who are your role models?
Who is the person closest to you at the moment?
Who is the person physically closest to you at the moment?
What in your life is your greatest source of pleasure?

How do you know you like someone?
How do you know that someone is interested in you?
How do you know that you are happy, sad, nervous, bored?
What does this school need? This room? You?
This city?
This country?

What is an abstraction?
What is a mystery religion?
What would it be like if you behaved with absolute power?

Redesign a rainbow.
Make a French-curve rainbow.
Design a labyrinth dedicated to Freud, using his photo and his writings.

Design a torah.
Design a monstrance.

Illustrate the Godhead.
Add a station to the cross.
Design an abstract monument to Uncle Tom.

What is a good temple? A bad temple?
Who is your favorite character in the Bible?
Who is your favorite character in Gone with the Wind?

What is an icon?
Why does an icon have to be human?

What is sacred? Profane?

What is the most beautiful thing in the world?
Make a paperdoll of yourself.

What is theology? What is secular?
Explain the Zen doctrine in your own words. What
does it mean?
What does it mean 'In the beginning was the Word?'

Can you find a book on making sculptures of paper?
Make a spaceship out of a cereal box.
Make a paper chain out of a book.

Redesign the human genitals so that they might be
more equitable.
Design a feminist crucifixion scene.

Design something to sell on the street corner.
Design something to sell to the government.
Design something to put on an altar.
Design something to put over a child's bed.
Design something to put over your bed when you
make love.
Make a monkey out of clay.

Design a flying saucer as if it were The Ark.
Make a large folded-paper airplane, paint on it a
slogan which you think will revolutionize your life.

Make an icon out of popcorn.
Paint a balloon gold, paint a balloon silver.
Make a necklace out of coal.

Paint a series of playing balls like planets, be accurate.

Design a black mass out of any materials you can find.

Design a work of art that fits in a matchbox, a shoebox.
Design a new clock face.

What is the difference between philosophy and
theology?

Who is Hans Küng?
What is liberation theology?

What is mysticism?
Who was Meister Eckhart?

What is the purpose of art?

What does 'spiritual' mean to you?
What is the most difficult thing in life for you?
Can art be useful in dealing with this difficulty? In
what way?

What is 'service'?
What is the purpose of society? Of government?

What is the surest way to happiness?

Who is Savanarola? Augustine?

What is attractive in a woman. A man?
What are the qualities of physique most attractive?
What are the personality problems of being an artist?
What is it like to be an American in the 20th century?
What is our unique role?

Who is Roosevelt?
What is action painting? Pop art? The Louvre?
What languages do you speak? Spoken at home?
What religious articles do you have in your home?
Your family home?
Make a skyscraper out of inappropriate materials.
Make a prisoner's pillbox hat.
Make a scatological object, or use scatological words.

Illustrate your strangeness, act out your most
frightening perversity.

Design a box within a box to illustrate selfishness.
Design a throne.

Why are you here?
What is a shaman? Make a piece of curative art.
Make a piece of psychological art.
What do you think has been the greatest hurt, mental
and physical, that you have suffered?

What do you think are the qualities of a life fully lived?
Can you suggest a project, for yourself or for a
group, or for any number, which might deepen your
sensitivity to time?
What is greed?
What is verbal knowledge?
What does tactile mean?
Can you show me an example of tactile sensitivity in
your personal life?

What do you do to make yourself more attractive
sexually?
Why do you do this?
Do you really like very beautiful people?
Do they have special privileges?
What is polygamy? Explain its function in the society.

Make a design of your favorite literary person. Event.
History. Project for Ellis Island.

How much time should you work on a class project?
How much time should you think about it? Discuss it?

What do you think of money? Make a structure
explaining to me your concept of money, or out of
money.

Should art be useful? Useless?
What is pablum?

What is capitalism? Communism? Socialism?
What is leisure?

Make a structure out of photos of primitive people.
Make a structure illustrating anything from the book
of proverbs.
Can you construct a functioning lamp that illustrates
the concept of freedom? Can you construct a
functioning ashtray that illustrates the passage of
time?

What is waste? Who was Malthus?
How can we humanize the city?
How can we humanize Cooper? How can we redesign
the Cooper triangle?
What should the student lounge look like? Where?

Remember, I'm going to mark you, it's my great
pleasure to reward real effort, it's my great pleasure to
punish stupidity, laziness and insincerity.
These marks won't make much difference in your
later life, but my reaction to you will, but the reactions
of your classmates to what you do will.
Your classmates are your world, your future will be like
this now, as you relate to your present, you will relate
to your future, recognize your weakness and do
something about it.

March 28, 2011
To whom it may concern,

The Hansel and Gretel Theater Workshop was a
ten-week-long project I undertook with the graduate
students of the Department of Visual Art (DOVA) at
the University of Chicago as the second quarter of the
First Year Graduate Seminar triad. Graduate seminar
at DOVA has several loosely articulated goals: group
cohesion, pushing boundaries of studio practice and
exploration of the world of ideas. The second quarter
was mine to teach. I had noticed that many of the
grads, in their studio practice, were involved, in one
way or another, in literature, reading, narrative, writ-
ing, or creating characters. I thought it was only logical
to extend those interests into something larger and
more outside the studio.

So over a period of ten weeks we read fairy tales,
looked at operas of fairy tales, read essays about the
writing, politics and history of fairy tales, discussed the
intersecting layers of human practice and intention
that produce fairy tales and eventually created a live
production of a fairy tale in the tenth week.

It was a lively time and the students did a great job.

Pope.L

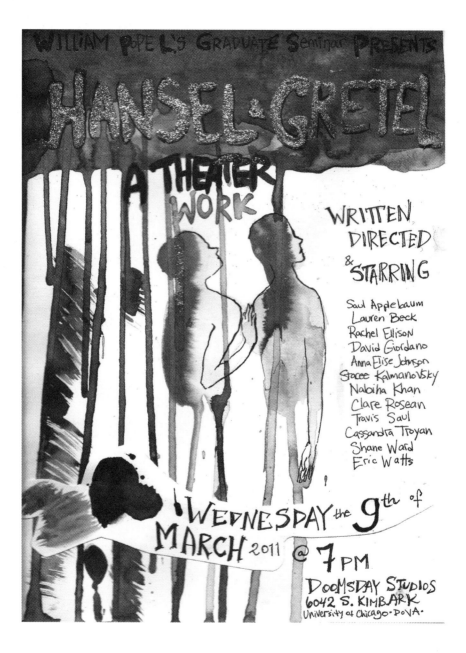

Witch returns to admiring herself in her dustpan, stage right. During this time, Hansel has initiated a game with Gretel—out of nervousness, and a need for touch—wherein they poke one another in turn, at first with trepidation, gradually escalating to an audible hit. This finally draws the Witch's attention and she slams her dustpan to the floor and spins around, furiously, imperiously.

Imbecile!

Slaps Hansel in the back of the head. Witch then stands between Hansel and Gretel, forcing them apart. Slowly, cruelly, she addresses Hansel, prodding and inspecting him at her leisure.

I plan to fatten you, tenderize you, shave you, and baste you. I will boil you in butter, bake you slowly and then eat you...

Witch lunges at Hansel and tackles him, biting ravenously and shoving him into the cage. The attack is sudden and frenzied, yet relatively brief. Witch then closes the door to the cage calmly, assuredly and continues,

...Starting with your feet and working my way up.

(*Witch stands up and then shoves Gretel against the wall*): Gretel you will cook mounds of food for Hansel and feed him constantly.

(*Gathering her dustpan and addressing children shrilly, from the other side of the room*): If I catch you talking to each other I will half drown you and cut out your eyes.

(*Twirling as she exits, abruptly*) Have these chores done daily. Follow them exactly. (*Bangs dustpan on door jamb as she exits, loudly, for effect*).

SCENE FOUR :

(N, *4 beats after scene transition is complete*): Could a candy cane, perhaps, be filed down and used as a weapon? Hansel was, at first, troubled by such thoughts. In time, however—teeth aching, the bars of his cage growing ever closer—he accepted them as natural to his condition.

The electrical storm outside begins to grow and the electricity goes out. Here "Jack Bauer" is analogous to the Pretender; they are one and the same. Hansel eats resignedly from a heaping plate of mashed potatoes throughout the scene. Hansel and Gretel are alone in the Witch's kitchen.

(W, *as she enters*): Damn that wind. Better go check the circuit breaker. Gretel, can you preheat the oven to 450? We're having Hansel tonight!

7

(G): Yes ma'am. (*Witch leaves the room, and Gretel drearily walks to oven. Suddenly she hears a noise and goes to the window.*)

(P): Pssssst- Gretel!

(G): Who is that?

(P): It's the Pretender. There's no time for details- let's just say I'm here to save you, and everyone else in this shantytown. I know you're scared but you're going to have to pay attention to my directions and trust me.

(G): But Jack-

(P): Gretel, I promise you everything will be okay, as long as I have your blind trust and admiration, do I have that?

(G): I guess so.

(P): Good. There's a candy cane behind you and to your left, I need you to pick it up.

(G, *Turns around to face a wall of giant candy canes*): There's more than one.

(P): Goddammit Gretel I don't have time for this! The red and white one!

(G): *Looking from one to another, they are all red and white. She grabs the one closest to her.* Okay, I got it.

(P): Good. Now I need the status on the witch- what are her coordination points?

(G): Coordination points?

(P): Don't play games with me Gretel— there's candy at stake and it needs to be divided for the common good! We can't let the oppressive and bureaucratic powers that be get their greedy hands on a candy monopoly.

(G): What? Hansel is in a cage waiting to be eaten. His life is at stake, and on top of that I think he's been brainwashed.

(P, *Not listening*): I'm outside on the east side of the house. Exit the front door and I'll be on your right. Do NOT forget the candy cane!

Gretel looks around, decides it is safe to leave with the candy cane and edges along the wall to the front door, but decides to go the long way. After about 30 seconds the witch emerges from the other room.

8

H&G
CAST PERSONNEL, SCENE-BY-SCENE

Scene One
Saul as Director

CHARACTERS:
Clare as Hansel
David as Narrator
Lauren as Gretel
Nabiha as Mother
Rachel as Pretender
Shane as Father

Scene Four
Travis as Director

CHARACTERS:
Anna as Hansel
Eric as Jack
Rachel as Gretel
Saul as Witch

Scene Two
Stacee as Director

CHARACTERS:
Anna as Tree
Clare as Gretel
Eric as Hansel
Saul as Witch

Scene Five
Rachel as Director

CHARACTERS:
Cassandra as Gretel
David as Narrator
Nabiha as Ice nymph
Stacee as Hansel

Scene Three
Anna as Director

CHARACTERS:
David as Narrator
Lauren as Witch
Rachel as Gretel
Travis as Hansel

Scene Six
Eric as Director

CHARACTERS:
Cassandra as Hansel
David as Narrator
Shane as Father
Travis as Mother

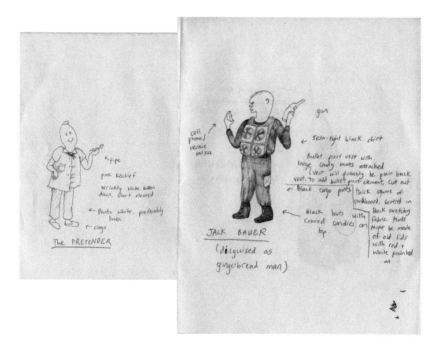

—WE CAN ALL
GO A LITTLE
LONGER, RIGHT?
ANYONE HAVE
A CLASS AFTER
THIS ONE?

In 1991, in need of change and disillusioned with what I perceived to be the art world's shallow relationship to sociopolitical issues, I enrolled at Hunter College. I wanted to go back to school and believed that as a returning student I might get something deeper out of it than I did when I was a teenager. Also, I was beginning to teach on the merits of my art practice, but I lacked a college degree.

I had been working as an artist for over a decade and had no interest in studying art. Instead, I gravitated toward political science, fueled by the fantasy of transitioning into politics proper, where I imagined I would find a more rigorous context of ideas as well as a keener sense of cause and effect than the one I experienced as an artist engaged with social issues. My outlook entering school that year was ridiculously idealistic.

Boy, was I surprised. The political science division at Hunter College was conservative and appeared to be largely a feeder for the State Department. I felt out of place, but that unknown terrain was also strangely exciting. At the time, my personal style was scrappy thrift store: I wore a black leather jacket which stood out in poli-sci, particularly in the course called "National Security," mostly populated by young men with perfect haircuts.

Initially I was confused about how to enter the dialogue and couldn't find my voice. I sensed the paradox of the returning student who at once knows too much and not enough. A greenhorn in live debate, I was more at home articulating politics in the spaces of art and exhibition making. Additionally, I was fed up with the black-and-white, us-versus-them mentalities that typified the Reagan/Bush years and the ongoing culture wars. I was questioning everything, including what I felt a connection with.

Realizing I was a clean slate in the environment, I decided to play with my identity and impulsively assigned myself an experiment: *don't be yourself, adopt another perspective and profess political views you disagree with*. The idea was purely intuitive. I would no doubt learn from advocating something I objected to, though I didn't know what.

My first major paper for the course on security was an in-depth discussion of the overthrow of Chilean president Salvador Allende written from a pro-US government vantage. The paper captured the attention of the professor, who was also an editor of a Washington-based national security journal. He graded it A-plus and invited me to his office for a chat.

"I'm having trouble reconciling your appearance with your ideological views," he began.

I played off his puzzlement. He let me know the unexpected paradox might hold some currency. "Are you interested in going to Washington?"

"Eventually," I replied.

But I wondered for the time being if he could organize an internship for me. Anticipating the need to follow through unconditionally, I switched my voter registration from Democrat to Republican the following day. And sure enough, in our next meeting he inquired about my political affiliation. "Republican," "I answered firmly, looking him in the eye.

"I just want you to be comfortable with the internship placement," he replied.

This professor shepherded me through two internships with local Republican politicians, to which I would not have had access without his support.

In my first internship, working in a New York state senator's office, I was instructed to plow through various media reports and topical literature in search of problems that could be developed into research topics. If an issue seemed promising, the office would publish a report on the matter for the senator to present at a press conference, and he would garner media attention for his role as a community watchdog. Identifying the right type of theme was tricky; it had to be newsworthy and relevant to the senator's constituency, and a touch of controversy didn't hurt. School dysfunction, environmental protection, land-use debates, health care—all fine, us research assistants were told. "But don't look into AIDS, unless it has to do with children. AIDS babies are OK."

My second internship, doing constituent services for a city councilman, was marginally more elevating. Some individuals' problems actually got solved: securing temporary housing for a family or providing someone with a new wheelchair, for example. But this work was primarily an exercise in navigating the intricate maze of city agencies in order to compel accountability. Some problems were extreme, like weeks of no heat in a city-owned apartment in the middle of winter. An individual citizen could complain all she wanted without result, but when the council member's office lodged a grievance, it got

attention. Some issues, however, were impenetrable. For example, toxic emissions from a restaurant affecting the residents of a nearby apartment were surprisingly not the responsibility of *any* agency: the fumes fell into the crack between the purviews of the Department of Environmental Protection and the Department of Buildings.

I kept my utter shock over the cynical attitudes I encountered to myself. In all fairness, strategic thinking is the common core of electoral politics and is not special to the Republican party—although I didn't know this at the time. The experience of the Hunter poli-sci program and the internships deflated my idealism to the point that, ultimately, I concluded mainstream politics were more cynical than anything I'd experienced thus far in the cultural arena. I realized I was unwilling to distort myself enough to fit in, and went running back to art.

And what had my self-assignment brought about? It was eye-opening and enlarging. Thinking beyond my professed set of beliefs and opinions and wrapping my mind around unfamiliar perspectives opened up new avenues of critical reflection. I learned to listen deeply to others as well as to myself, to defer judgment and be less reactive and more analytic. I gained insight into how codes of identification and constituencies are constructed. I learned new rhetorical skills—how to express and advocate and argue from other points of view. It was like learning a new language. I matured. I thought about both politics and art more subtly than I had previously. And in the process, the naive with which idealism I had embarked on this project with transformed into something far more indeterminate and complex, productively informing my artistic practice and how I have thought ever since.

DAVID TRUE
WHITE BOX SET-UP

Every student must bring to class a cardboard box or carton neither too large nor too small.

They are to paint the box white tinted with a color of their choice, so that the chroma is not strongly noticeable. The box should appear essentially white.

The boxes are then placed into an interesting agglomeration. The addition of plain white support structures (sculpture stands) might be useful to lift the tinted boxes off of the floor.

The students then paint the boxes on a medium-sized canvas, as a still life.

They must extend the composition to run off the canvas in all directions, with no negative space surrounding the boxes.

Because the boxes are so close in value and the differing tones are so mild, finding strong contrasts is not possible—forcing students to express differences through texture.

That, then, leads to other methods of differentiation. The spaces in between objects become an organizing principle. The usual modes of still-life thinking must be given up. The paintings become abstract and the students' tendency to arrange a pictorial space around individualized objects is broken.

Naturally a lot of other discoveries present themselves, which make the venture frustratingly engaging.

The teacher finds that circumventing the still-life tradition is necessary, if only to induce a different way of presenting the tinted white boxes as objects. The students make a painting of painting.

The pile of boxes remains over a day or two only as a decoy, and is irrelevant.

I usually give the assignment sometime in November, middle of the first semester. I issue something between a permission and an order: you have my permission to do what you think would be a really bad artwork. I give a limited time frame, usually one week. I give you my permission to fail for one week, or maybe less: I give you the order to experiment for just *two hours*, take two hours out of your life to do what you think is a bad work, to do something out of your habits or comfort zone, without fear of judgment.

You have my permission to fail.

No one has yet followed this advice anywhere near to the letter. Sometimes I get emails during the week asking technical questions about, say, conservatorial concerns, what if I use this material and this happens, in essence asking my permission to do this or to do that experiment. After all, what if the failure should fail?

There are structural/institutional reasons and aesthetic/ideological ones why I give this assignment and why it seems to be nearly impossible for early 21st-century MFA students to fulfill.

Educational institutions (I'm speaking here of the United States at least) are increasingly corporatized in their organization, goals, and language. The utilitarian and public (as well as the declarative and spectacular) are emphasized over the speculative or private. This can affect the kind of creativity that doesn't work on a metronome or a meter.

The corporate atmosphere of educational institutions is usually not fully transparent to the student, yet it is part of the infrastructure for the economic stresses they face: student loans, job and art market pressures. In that geopolitical/economic matrix, it is no surprise that the schedule of the traditional two-year MFA Fine Arts program is as rigidly timed as a military quadrille. Speaking as a participant, I can say that this is necessary in order to pack as much real instruction and experience in as possible, but it also ensures the *appearance* of instruction and of money's worth.

Between the first few weeks of sheer shock when students experience an overwhelming exposure to a bewilderingly vast amount of diverse new artists, ideas, theoretical languages, art styles, aesthetic and political criteria (many of these contradictory), and the pressure in the second year to come up with a streamlined package of thesis work, there are literally only a few weeks in the two years when experimentation can take place with some knowledge and some momentary freedom from expectations.

Students are expected to produce work regularly for critiques and discussion with teachers and visiting artists. This is why they have come to graduate school, but, in this atmosphere, it is unfortunately also the case that doing work whose meaning you might not have a ready explanation for, work that is transitional, even work that is a "failure," is a terrible risk.

This enforces the current dominance of intentionality. Even though many art faculty still express a mid-20th-century rhetoric of experimentation and discovery through studio practice, there has been a radical shift in the past thirty years from the mix of formalism and subjective expressionism that characterized art education in the wake of Abstract Expressionism, to a type of conceptualism that, at least on the surface, seems to reward rationalized concordance between visual appearance and verbal articulation, a to b. An artist today is unlikely to start a work without knowing exactly what it's going to look like and to *mean*. Appropriation and sampling give you the basic elements; a catalogue of tropes and recipes provide methods and styles for their assembly. Students are encouraged to research the subject of their work, consider their audience, and have all elements in place before they proceed to execute the work accordingly.

Here Walter Benjamin's conclusion to his 1928 essay, "Post No Bills: The Writer's Technique in Thirteen Theses"—"The work is the death mask of its conception"—should be a cautionary precept. Benjamin's interest in the "unintentional truth" carried within the dust and debris of early consumer capitalism reminds one that a contemporary artist's intentions cannot determine what mark of its time the work will ultimately carry into the future, intention notwithstanding.

Here the artist's encounter with (an expanded notion of) materiality takes on new importance, transforming the linearity of intentionality. Experimentation with time, chance, language, even research, as well as with traditional media, can bring the artist to an expression that tells the artist something beyond the already previsualized,

audience-tested, executed idea. Some works of course require planning, but even then the task of the artist is to be extremely alert to his or her own reaction to elements that may seem like surplus in terms of the initial intentional program but feel the most alive, however illogical at first glance. Political art is often criticized as didactic, even when it's only meant to be accessible to a targeted audience. Perhaps that's because some (though not all) "political art" works may neglect the unexpected power that can be released by something seemingly peripheral to a political or didactic program: a color, the angle of a shot, the small gesture of a performance that speaks volumes, in an allusive poetic register. Even just for a nearly imperceptible moment, a work must be allowed to become unmoored from its initial premise.

To get around the rigid confines of intentionality and self-commodification, I have another assignment I'll just sneak in here, another path in the same direction as Fail! To help students to access the unknown within themselves, I ask them to write a detailed description of the visual appearance of a work they would never do, to convey through language both the work and the reason they would never do it. I always say, you've already pictured something the minute I said this. What did you picture? The result, often enough, is a description of an interesting work that they obviously should try to do. Here language has been the experimental path to an extremely important realization for an artist: that what you dislike passionately is in part something that is within you.

Finally, writing the present essay, I thought about one other possible assignment. I've never tried it, and in the current system, it would perhaps be radical to the point of insubordination. Since necessity is an ineffable yet crucial factor in what makes a work interesting, this assignment would be to experience the world but NOT make any art, for an hour, a day, a month, a year. You do not have my permission to make art. I forbid you to make art.

What creativity might erupt from this suppression?

ROCHELLE FEINSTEIN
WHO, ME?

I give myself assignments. Many artists do. The "Assignment" comes in many guises: strategy, proposition, correspondence to community, site specificity, budget, to name a few. I designed a graduate course eight years ago called Laboratory in order to open a door, namely, the studio door. It asks students to construct new work based on an introduction to, or a re-examination of, of default-mode historical categories. They learn more about who they are and what might be possible to make.

It's a "Round Robin." First, we read primary documents stemming from specific time frames by artists, critics, fiction and non-fiction authors. Then core groups of students and myself make visual presentations related to the readings, and discussion follows. All presentation materials correspond to the context of the readings—cultural, social, aesthetic, political. Heading home, I gather the major points of discussion culled from the discussion and give an assignment based upon specific parameters. Whether about the mid-20th-century orthodoxy of medium specificity (and why that was), "Specific Objects," etc., the assignment requires a collaboration between a concept, even if stale, and the response of the young artist who brings an entirely different context to a premise.

I'm sending the final assignment of LAB, from November 17, 2010, covering final readings and making a drawing from a specific medium: a #2 pencil and a piece of paper. I'm sending two examples. They are mostly all terrific. The names of all students, each of whom were contributors to the term's intimacy of thought and momentum of discovery, are: Beverly Acha, Julia Bland, Caroline Chandler, Gabriela Collins-Fernandez, Kyle Coniglio, Oscar Cornejo, Kiki Johnson, Doron Landberg, Eric Mack, Evan Nesbit, Tameka Noris, Jen Packer, Amy Rinaldi, Kenny Rivero, Rachel Schmidofer, and Dave Whelan, Jr.

Rochelle Feinstein
Professor, Painting and Printmaking
School of Art
Yale University
January 14, 2011

Date: Nov 17, 2010 10:25 AM EST
From: Rochelle Feinstein <rochelle.feinstein@
	yale.edu>
Subject: FINAL PROJECT, LABoratory

Hello All,
The holiday break is much welcome and needed. I
wish you all a great Thanksgiving, Whether nomadic
for the next 10 days, or near your studios, this final
project should suit your individual situations.
Included in readings included in your packet are:
— Lawrence Alloway. Chronology, "Provisional List of
Events Related to the Politicization of Artists". 1976.
— Primary Information, 2009. Timeline, reprints,
essays documenting the Art Worker's Coalition (AWC),
published in conjunction with P.S. 1 exhibition,
"1969".
— Live/Work, a current exhibition press release. La
Mama Galleria. Nov. 2010. The statement is relevant
to our term-long term exploration. It asks: how do
current conditions effect painters? All of the LAB
readings might be said to propose this question. A
painter might be keen to reflect upon this but not all
painters are (ex: *Artforum*, essay. Sept. 1976: Painting/
Anti-Painting: A Family Quarrel, Painters Reply.)

Our conversations have highlighted the ways that
artists have used their environment as a site of critique,
or intervention; a positionality, or as a "relational"
platform. We inhabit a shared social experience,
yet not all artists feel compelled to make reference
to those conditions. The choices for artists are
complex and demanding; in comparison to 1976, we
are participating in an expanded field of mediums,
a fluctuating art economy of supply and demand,
acceleration of consumption, display, volatile political
conditions, a fragmentary critical discourse, etc...

FINAL PROJECT:
FIRST: Using Alloway's chronology as a template,
produce a two-page Chronology that spans the decade,
2000–2010. Note those public events that have had a
meaningful, memorable impact upon your own lives
—landmark events, visual/screened experiences, your
perception of things around you that have been part
of a larger cultural, social and / political landscape. A
book, picture, an event; public or private: what has
formed the YOU of the present, what has been
significant to the formation of your identity? If you

are now 25, for example, your world has expanded
exponentially since the age of 15. Experiences,
undoubtedly, also widen, deepen and alter your an
awareness as an individual and as a generation.
	"Public" -adj. relating to or involving people in
	general, rather than being limited to a particular
	group of people, (OED)

THEN: Based upon your Chronology - create a work
on paper no smaller than 8.5 × 11 inches and no larger
than 22 × 30 inches. Use a No. 2 pencil ONLY. Make a
drawing that corresponds to who the author of your
Chronology is. What might the work of this artist look
like???

The choices are yours to make. Always.
Email me if you have any questions… .
Make 17 copies of your Chronology to hand out for our
final class.
	Best, Rochelle

(April) AWC demands for gallery reforms
Prince Street Gallery (realist co-op)
(May) Invasion of Cambodia
 Shootings at Kent State
New York Artists Strike Against Racism, Sexism, Repression,
 and War. Galleries and museums to close for one day
Strike lead to formation of the Emergency Cultural Government
 (Robert Morris and Poppy Johnson, co-chairpersons)
ECG organised resistance to the US representation in the Venice
 Biennale
Women's Ad Hoc Committee (Lucy Lippard and others)
(June) Professional and Administrative Association formed at MMA
New Art Association formed within College Art Association
Hans Haacke poll at MMA (Information exhibition) concerning
 Nelson Rockefeller and Indochina policy
WAR, the Ad Committee of Women Artists, and WSABAL (Women
 Students and Artists for Black Art Liberation) demo at
 Whitney Museum for 50 per cent representation of women
 in Whitney annuals
(September) Referendum '70 (fund for peace candidates). 40
 galleries and auction at Parke-Bernet
My Lai 4-magazine cover project (Artforum, Arts agreed; Art
 In America and Art News declined)
Vigil before Guernica: Myy Lai poster distributed

1971
Artists' Reserved Rights Sale Agreement (Robert Projansky,
 Seth Siegelaub)
Attica prison riot
The Attica Book (edited by Rudolf Baranik and Benny Andrews)
Haacke's documentation of slum landlords rejected by Solomon
 R. Guggenheim Museum
(April) Contemporary Black Artists at Whitney Museum; the
 target of protest by Black Emergency Cultural Coalition
(May) Rebuttal to the Whitney Museum at the Acts of Art Gallery
Brooklyn Museum. "Art Museums RElevant to Women?" Panel
 arranged under pressure from women artists
26 Contemporary Women Artists. Aldrich Museum, Ridgefield,
 Conn. (Lippard)
Women In the Arts (WIA) founded
Art Workers News began publication

1872
A.I.R. Gallery (women artists co-op)
Judson Theater: The Flag Show (several artists arrested)
Beginning of Watergate (-1974)
Sex Differentials in Arts Exhibition Reviews: a Statistical
 Study. Tamarind Lithograph Workshop

1973
Women Choose Women. New York Cultural Center. Artist-
 selected exhibition, arranged by WIA
(March) 25 Years of American Painting 1948-1973 at Des Mones
 Art Center. Cat. "American Painting and the Cold War"
 by Max Kozloff (reprinted Artforum May 1973)
(September-November) Strike at MMA
Rothko Estate versus Marlbrough Gallery

PROVISIONAL LIST (2) OF EVENTS RELATED TO THE POLITICIZATION
OF ARTISTS

1964
Student rebellion at Berkeley
Artists and Writers Protest Against the War in Vietnam
 (members included Dore Ashton, Rudolf Baranik, Leon
 Golub, Max Kozloff, Irving Petlin, Jack Sonnenberg,
 George Sugerman)
Tonkin Gulf incident

1965
Defoliation reported in Vietnam
Vietnam protests: first teach-ins
Civil rights marches in the South

1966
Emergence of black power groups

1967
Artists and Writers Protest: New York collection point
 for the Los Angeles Peace Tower
Angry Arts week: artists' contribution, Collage of Indignation
Artists and Writers Protest: Portfolio (Paul Burlin, Baranik,
 Charles Cajori, William Copley, Alan d'Arcangelo, Mark
 di Suvero)
Art for Peace: Sale at Leon Golub's studio

1968
(April) Martin Luther King assasinated
(May) Strike of students, linked to workers in Paris. Artist
 and dealer support
Opening of Venice Biennale delayed by student demos
Columbia students protest university's proposed gym in Harlem

1969
(January) Art Workers Coalition formed (Carl Andre, Hans Haacke,
 Lucy Lippard, Tom Lloyd, Takis, and others). First target
 the Museum of Modern Art
Harlem on my Mind at the Metropolitan Museum. Black protests
(April) Demand for Martin Luther King wing at MMA for third
 world art
(Summer) Boycott by artists of US contribution to Sao Paolo
 Biennal (Haacke, Ashton, and others).
Women Artists in Revolution (WAR) formed out of AWC
(November) My Lai poster (Q: And babies? A: And babies).
(October) Bowery and (November) First Street Galleries founded
 (realist co-ops).
(December, 1970) Robert Rauschenberg: Currents (silkscreens
 referring to "the world condition")

1970
(January) 55 Mercer Street (artists co-op)
(January) Letter to Picasso proposing the removal of Guernica
 from the MMA (Petlin, Golub, Kozloff, Copley). No answer
(February) Free day at MMA won by AWC but demand for 8 community
 art centers ignored

Personal Chronology
Amy Giovanna Rinaldi
2000-2010

Two Thousand
- Vladimir Putin elected President of Russia
- The Tate Modern opens in London
- Ellian Gonzalez returns to Cuba after custody battle
- First major backpacking trip through the Sierra Nevadas
- Kind of Blue: Miles Davis
- Iraq rejects UN Security Council weapons inspection proposals
- After Supreme Court ruling Bush V. Gore, George W. Bush is elected President of the USA
- Sunship: John Coltrane
- Yevtushenko Poems

Two Thousand and One
- George W. Bush announces limited funding for stem cell research
- Joins Jewish Youth for Community Action in Berkeley California
- Three weeks of tests for possible brain tumor or growth yields no conclusive findings
- 9/11
- The USA invades Afghanistan
- The Patriot Act is signed into Law
- Close friend attempts suicide
- Bush signs executive order allowing military tribunals against foreigners
- Beyond Good and Evil :Nietzsche
- Enron files for bankruptcy

Two Thousand and Two
- No Child Left Behind Act is signed into law and debate ensues over California public school issues
- Discovers the copied works of Joseph Cornell, Piet Mondrian, and Alexander Calder made by Jerome A. Fox in the last months of his life
- After discussion with Miriam Fox takes out books on Anselm Keifer at Palo Alto library
- International Criminal Court is established
- Congress passes resolution to authorize Bush to use US forces against Iraq
- Visit to Berkeley Free Health Clinic to support close friend in her abortion
- Bush signs Homeland Security Act into Law
- Starts job at CKT with Kim Friendland, Rebecca Pollack, Andrew Gordon-Kirsh, Rachel Kofslofsky and Jesse Falk Finley.

Two Thousand and Three
- Protests in SF against the War in Iraq last days although barely televised. Is arrested for protesting and quickly released from custody.
- SARS outbreak
- Death of Sheldon Reuben causes a distrust with family members who with held his illness. As a result spends a week cutting class and taking the train into SF to walk around the SF MOMA.
- US Invasion of Iraq
- Grutter v. Bollinger: Supreme Court upholds affirmative action in University Admissions. Debate and protests ensue on UC Berkeley Campus
- Governor Gray Davis is recalled from office in California and replaced by Arnold Schwarzenegger
- Saddam Hussein captured in Tikrit
- California Earthquake
- Mad Cow disease outbreak in Washington State

Two Thousand and Four
- CIA openly admits there was no imminent threat from WMD prior to the 2003 invasion of Iraq
- SF, CA issues marriage licenses to same-sex couples
- Helps close friend with heroin addiction enter into rehabilitation center in Berkeley, CA
- Founds Albany High School Student discussion group for Peace in the Middle East
- Blackwater contractors bodies found mutilated in Iraq

- Abu Ghraib abuse revealed to mass media in United States
- Travels to Havana for reunion of Venceramous Brigade
- Tienanmen Square Massacre demonstrations in Hong Kong
- Saddam Hussein tried for war crimes
- Genner California Mushroom Trip
- Hamas claims responsibility for Beer Sheva suicide bombings
- Colin Powell resigns

Two Thousand and Five
- Kyoto Protocol goes into effect
- Accepted to Oberlin College class of 2009
- Texas City BP explosion
- High school classmate commits suicide
- Meets members of the Black Panther Party at May Day BBQ in Oakland, CA
- Backpacks with Jacob Rinaldi, David Kessler and Daniel Gottleib through Sierra Nevada foothills
- Spends time in isolation on Cloud Mountain
- Elected Head Dinner Chef at Tank Coop
- Death of Agnes Rinaldi
- Begins first serious relationship with will span the next five years with conservatory student

Two Thousand and Six
- First Avian Flu case in Scotland
- Digital Photography courses replace analog ones at Oberlin College. Enrolls in digital photography against strong opposition to the medium
- Israeli troops invade Lebanon
- Moves in with College Boyfriend
- Hezbollah declares war against Israel
- Enrolls in Harlen Wilson's Political Theory course at Oberlin College.
- Saddam Hussein sentenced to Hang
- Begins visual score project with aid from Randy Coleman, John Pearson and Andrei Pohorelsky
- Founds Reinstein Screen Printing Inc. with fellow classmate Eliza Koch
- Travels to China
- Close friend dies of an overdose while enrolled in assisted living home

Two Thousand and Seven
- Starts taking birth control which leads to severe depression and a change in academic schedule. Considers transferring and eventually attending Law School.
- Travels to Mississippi with Matthew Rinaldi to film documentary on Oprah Winfrey's life and discovers the political underpinnings of a town which once fought for integration.
- Leaves photography department after realization medium is no longer conducive to conceptual framework for art making
- Moves to New York City
- Takes Job at Lower East Side Print Shop

Two Thousand and Eight
- Fidel Castro resigns as President of Cuba and Raul Castro takes his position
- Gaza Strip Air Strikes
- Lehman Brothers file for Bankruptcy
- Waits on line for 12 hours to vote in Ohio
- Barak Obama elected 44th President of United States

Two Thousand and Nine
- Travels to Istanbul, Turkey to work at Play Gallery form artists Nanette Yannuzzi-Macias and Sarah Schuster
- Begins printing editions for professors at Oberlin College
- Graduates from Oberlin College
- Constitutional Court of Thailand dissolves
- Israel launches ground invasion of Gaza Strip
- Travels to Bangladesh
- Michael Jackson dies

- Travels through Thailand and Vietnam with Meena Hasan
- Road trip across the country with Ben Neufeld and Jim Rowell
- G-20 Pittsburgh summit held

Two Thousand and Ten
- Earthquake in Haiti
- President of Poland Lech Kaczynski is killed in plane crash
- Takes Trip to the American Academy of Rome where Meena Hasan has residency
- Visits The Madre in Naples with relatives
- Starts School at Yale

-

Kyle Coniglio

2000
-Trip to Disney World
-Triplet cousins were born

2001
-Sister is diagnosed with-
 Obsessive Compulsive Disorder
 Attention Deficit Hyperactive Disorder
 Periventricular leukomalacia
-September 11th attacks
-Iraq war begins

2002
-Graduated middle school
-Got my first computer
-Started my first job as a summer day camp counselor (lasts 4 summers)
-Started high school
-Marched in the Macy's Thanksgiving parade

2003
-My cousin/God son David was born
-Spent a week backpacking and canoeing at Roland's Pond in the upper Saranac
Lakes with my Boy Scout troop
-Marched in the Macy's Thanksgiving parade
-Move into a new house (3 houses down from previous home)

2004
-New house catches on fire, my family and I loose most possessions and
relocate for 6 months.
-My Confirmation
-First Concert (A Perfect Circle)
- Bush is re-elected

2005
-First time using oil paint
-Purchased my first car
-Got my driver's license
-Hurricane Katrina

2006
-Start working at a deli (lasts 1 year)
-Graduate high school
-Got a Facebook
-Start working as a custom framer at Michaels (lasts 3 years)

-My sister is admitted into the Kennedy Krieger Institute for 9 months
-Start Undergraduate at Montclair State University majoring in Art Education
-Went to the Metropolitan Museum of Art and the Chelsea gallery district for the
first time

2007
-My sister comes home
-Economy declines
-Went to MOMA for the first time
-Attempted to transfer schools
-Met Julie Heffernan

2008
-Change my major to BFA in Painting
-Gas prices hit $4 per gallon in NJ
-Earn a painting award and scholarship through MSU
-Work with "at-risk" youths during the summer
-Proposition 8
-Obama is elected (My first time voting)
-Begin 5 month internship at the International Print Center New York
-Lost 60 lbs
-My mother passed away

2009
-Joined an online dating site
-Got my first commission (earned a car for a painting)
-Began being a teaching assistant at MSU for painting and printmaking
-Came out of the closet
-Talent award scholarship through MSU
-Went to Ox-Bow for a week on full scholarship
-Turned 21
-Went to a gay bar for the first time
-Was in my first group show

2010
-Got accepted to Yale
-Haiti earthquake
-Went to the Whitney Biennial for the first time
-Gulf Oil Spill
-Graduate from MSU with honors
-Marched in my first gay pride parade in NYC
-My sister moves into a group home
-Gay suicides in media
-I move to New Haven and start graduate school

The course RECONSTRUCTION has three assignments, to be completed in any order over the course of the semester:

A. Take something apart.
B. Make something out of something else and donate it to a thrift store.
C. Make something and bury it.

As a respite in the middle of the semester, there is a one-day project—Library Roundabout:

Make an autobiography with books from the library. Using the Library of Congress classification system, choose books with call letters which are part of your name. Photocopy the stack of books, showing the full spines, so your name reads across the bottom of the page of the photocopy. If needed, scale the image to fit on a single sheet of paper. The titles of the books form the autobiography.

During the final years of the 20th century in Chicago, home to many imported modernisms—glass skyscrapers presenting their crisp lines and barren structural plazas to airplanes buzzing in over the lake—from Hyde Park to Evanston, graduate students heard whispers of a course in porn.

This was hardly new. Chicago was beyond modern, beyond monetarism, still swaying in the embrace of poststructuralism. From the tilted-glass- ceiling studios at the School of the Art Institute reflecting light from the lake, one could cross Michigan Avenue to the Department of Art History, Theory, and Criticism, and join close readings of Linda Williams, Laura Kipnis, Judith Butler (this was the late 90s, after all), the occasional El train shuddering past. Courses in deconstruction, the transposition of literary theory and cultural studies, queer theory and gender studies were all the rage in MFA programs. Universities at Santa Cruz, Berkeley, and Wellesley had all initiated courses in the study of porn.

But this Art Institute class on pornography about which one heard quiet allusions—sotto voce utterances in school lounges, Ukrainian Village bars, and student apartments—was not entirely concerned with theory. It was offered through the video department (video, film, and media were separate departments then—this was the late 90s, after all). In fact it wasn't connected to the Department of Art History at all.

It was a production class.

A course in making pornography, in making porn films in particular, it wasn't listed in the graduate program's course catalogue, but operated as a kind of "shadow class"—one had to know the right people to have heard about it, much less sign up. Recent grads still hanging around related the rules: students who took the course were required to act in the porn they produced.

I'm not sure I ever met anyone who actually took the course, though it seemed most people knew of it. Or those who had taken the course didn't speak of it, which I fantasized as a sign of the extreme closeness and trust that developed between participants. Whatever exposures of self, desire, and voyeurism were revealed in the class, they remained there, between its participants.The *idea* of the course preoccupied me— the switching roles of director and actor, exploiter

and exploited (in the financial, legal sense), artist and pornographer. The main requirement—that all participants perform in the porn produced—followed the conventional structure of film production classes: students take turns behind the camera and before it; they rotate roles, experience all sides of production.

It seems to me now that this self-reflexive turn of enactment—of agitating boundaries between observer and observed, theorist and practitioner, actor and prostitute, top or bottom, film exposure and self-exposure—is what took root so firmly in my consciousness as a formal mode of artistic production: that the conditions of an artwork's own production could raise complex questions and erase comfortable cultural boundaries.

I knew the class was the conception of Vanalyne Green, who taught in the video program then, after chairing the department. I must have asked her about the course, as she was an adviser in my final year, but I can't recall any specific conversation. I do remember that a few years later, over a bowl of noodles near Canal Street in New York, she recalled how a particular dean had asked her to keep a "low profile" regarding the class, concerned that press and attention of the wrong sort might be directed at the school because of it.

—

In film, traditionally, there are multiple takes of each shot. If the take was good, the director calls out "cut" and then "print it!" instructing the camera assistant to note that take. Film laboratories do not print every take, only those marked in the camera report as "print." Many moments of cinematic drama have been built on the distance between a director's utterances of "cut" and "print!" as actors hold their breath in suspense, praying that another take won't be necessary.

Scurrying down a narrow fluorescent corridor of the Art Institute's film department in Chicago, I hear a voice cry out, "Print it!" then silence. Through an open doorway, a dozen graduate students in variously blocked postures are scattered about a black box classroom under ersatz theatrical lighting. There isn't a film camera in sight. Instead, Yvonne Rainer stands among them, sheath of papers in hand. This is Rainer's "Approaches to Performance" course.

Over drinks at the Rainbo Club on Damen, I ask a friend taking Rainer's course about the exclamation I heard coming from their classroom. It started, she tells me, when a guy in the class arrived early, sat down, and closed his eyes, humming with his headphones on. As students slowly trickled in and grabbed chairs, the guy—eyes still closed and headphones still on—sang to himself a soulful rendition of the lonely, 80s-noirish Phil Collins song "In the Air Tonight." Though he was just singing along to the music he heard through his headphones, to everyone else in the room it was a doleful a cappella rendition of an emblematic rock song, and they sat, riveted, through its duration. When the song was over he opened his eyes, surprised to see everyone looking at him, some laughing, and Rainer called out "print it!"—expressing the desire to render permanent what had been a unique and estranging moment, one that she wished to hold onto, to use even, in the collective work they were developing.

From then on, the class decided that when someone did something spontaneous that was surprising, alienating, or they just liked it, they should call out "Print it!" and the whole endeavor would be noted and broken down as a performance that could be reconstituted and fed back into the body of the larger piece they were developing.

Indeed, in the middle of the public performance the class gave at the end of the semester, a guy in the audience just a few seats away from me suddenly started to sing "In the Air Tonight," a capella. Stripped of his headphones, his bare words rang out in the matte black space. The audience shifted, feelings of discomfort, pleasure, and embarrassment palpable as they tried to reconcile his identity as audience member or performer. Then the performance shifted again and the audience's attention was directed back to the performers before them. He stayed.

In 1979 Phil Collins came to London's Townhouse recording studios to play drums on his former Genesis bandmate Peter Gabriel's third solo album. In Studio 2's Stone Room, a live room with walls of soft Oxfordshire sandstone, built to emulate the timbre of recording in a castle, Collins started messing about on the drums while the mixing board's reverse-talkback circuit was activated (talkback is a button on the mixing console the engineer presses to speak to the musicians in the recording studio; reverse-talkback allows the engineer to listen to the musicians' responses). Engineer Hugh Padgham and Gabriel were amazed at the heavily compressed

sound from Collins's drumming, and overnight rewired the mixing board so that the reverse-talkback circuit could be recorded. Padgham and Collins used this reverse-talkback microphone recording method when they recorded Phil Collins's single "In the Air Tonight" for his 1981 album, and the gated reverb, or fedback sound, became a Collins signature.

—

In 1981, Mathew Hale told me a few years ago, he was in a "foundation course" at Winchester Art School in Hampshire, England. In those days in the UK, you could attend your local art school for one year for free, and then you could transfer and complete your degree elsewhere.

The purpose of the foundation course was to let students spend a preliminary year trying things out—fine art, fashion, textiles, music—before deciding what to focus on later. It was an open context.

Susan Hiller came as a guest artist to Mathew's course one day, taking the train southwest from London. No one in the class had met her before. They didn't really know about her work. "She was funky, very groovy, but not at all flaky," Mathew reflected, "smart. A sharp hippie."

Hiller said she was going to do something with them that came from Gestalt therapy. The class was in a seminar room. She asked everyone to lie down on their backs on the floor, and she turned out the lights. I'm going to tell you a story, she said, I'm going to tell it up to a certain point, and then you will all finish it for yourselves.

She was quite charismatic, and Mathew recalled that they all took it very seriously, lying on the floor, listening to her voice in the dark. She described you walking though a landscape, she made up a terrain and described you moving through it and that you came to a wood, and at the edge of the wood there is a fence, and a house on the far side of the field opposite. And you all know what this house looks like, she said, now I want you to go into this house. And that's the moment when Hiller stopped, and everything split, and each student continued the story in his or her own mind, in the dark of the room. You could hear everyone breathing. It was isolated but also collective.

It went on for about twenty minutes, quite a long time, Mathew reflected, and then we were to each make a record of our part. I don't remember if we shared them. I don't think so. Most people wrote. I think I wrote but I also made sketches. But that wasn't the interesting thing—it was the experience. It's very striking how well I remember it, and the house that I invented without trying. It had the quality of knowing something in a fundamental way without being too conscious of it. A genuine impulse, which is half desire and half something serious, the thing you learn to trust or you're nowhere when you're making something. It had that strange quality. I think what she did was create that experience for us. Recognizing a feeling in yourself that you can trust—and it's very real at that moment—it seems like that was what she was doing and everybody was having a very absorbed experience in the dark. It was like being a glider up in the air and then being released.

I mention this story to Susan a few years later in London. She listens to me and then cocks her head to one side. "Yes," she says airily, "that sounds like something I would do."

I think about the works Susan did at the Freud Museum in London, and how Mathew had described the atmosphere at Goldsmiths where he continued on after his foundation year—"there were no specific disciplines"—and how his teachers, Michael Craig-Martin, Mary Kelley, Jon Thompson—handed him books by British psychoanalysts of the "Middle Group": Marion Milner and D.W. Winnicott. The input of psychoanalysis was strong, and people were interested in the idea of doing something for a reason that is unknown or unconscious, rather than being entirely driven by the preconceived.

I ask Mathew about whether he felt what Susan had undertaken with them in Winchester was similar to her "group investigation" works in the 70s. In particular I recall a documentation image from *Dream Mapping*, of people sleeping in a field, in fairy rings—naturally reccurring circles of mushrooms or stimulated grass growth whose folklore suggests those who trespass into them are in danger of being in permanent enthrallment to their dreams, rather like the protagonists of that Wim Wenders film who end up in the Australian outback, staggering about, addicted to a device that allows them to record and review their dreams, so much so that it takes over their waking life. Hiller's group event had participants recording and diagramming their dreams over three days, blurring distinctions between shared and individual experience, dream and reality. Mathew said

he was well aware of that work now, and often thinks of that experience on the seminar-room floor when he sees the documentation image of *Dream Mapping*, but didn't come across the work until fifteen years after he left Hampshire for London.

A few weeks later, back in New York, I look for that documentation picture and when I find it, I am struck by several things. The first is that the image was taken during daytime—or perhaps day-for-night—and though the figures sleep in random positions in the field, the sky, grasses, farm, and animals are all clearly visible. In this Magritte-like juxtaposition of day and night, bodies take on a tinge of the performative, and the image a wave of the surreal. The second thing is that the face of the person closest to the camera is obscured by a baby crawling out of a sleeping bag. The infant lends a kind of folksy, communal charm to this particular group investigation, but also resituates the image on a psychosurrealist plane; the baby's presence among slumbering adults is estranging, metaphoric. Dropping off into sleep is a dropping off into the unconscious.

The last thing that gives me pause is the caption below the photograph, *Dream Mapping* 1974: site specific group event, Hampshire, England." This group investigation happened in the Hampshire countryside, at Purdies Farm, just a half-hour from where, seven years later, Susan would conduct the group exercise with Mathew's class. And 1974, that's the year I was born—do I see myself as the infant in the picture?

—

On New Year's Eve, 2010, I was at Holly Zausner's home on 10th Avenue in Chelsea—a much-loved loft that she plumbed and renovated in 1979, carving living and studio space out of the top floor of a former tire factory whose name can still be read faintly on the side of the building: Congo Tire. A faded black-and-white picture of the building sits in the window of La Luncheonette, the restaurant on the corner. In the late 70s, a train would transit the highline outside their window just once a week out their windows—from 34th Street down to the meatpacking district it slowly rumbled along, and back again. Now Holly's building is flanked by new condos that "recall the finest aspects of the artists' studio spaces of the early 20th century" with "oil-rubbed bronze hardware, Noguchi-designed

Akari light sculpture in double-height living room, individual climate control including multi-zoned central air-conditioning." Her loft's view of the river is now partially obscured by Frank Gehry's monumental glacier, the IAC building, and Jean Nouvel's "total design" condo, a sleek high-rise featuring on-site lifestyle manager and luxury attaché, situated adjacent to a city jail. Across from Holly's front windows is the now-manicured High Line park, which looked fantastic that evening as it sat empty, pools of lit-up drifts of snow and reeds fading into dark.

A woman in a white mini-dress with a sunburst of silver sequins at the neckline sat next to me. She told me that before she attended art school in New York—and deviated into fashion and interior design—she was an undergraduate at Kent State University. I perked up— when was this? ("1979.") Had she seen Robert Smithson's *Partially Buried Woodshed*? (Blank stare). I described the work's planned entropy, so closely synced with the history that, four months after Smithson's work was realized, brought the National Guard to the campus in a violent suppression of student protest against US invasion of Cambodia, and how the two breakdowns—of the woodshed and of the state—merged when someone painted *May 4 1970* on the woodshed's broken roof beam.

The woman mentioned that during her time at Kent State she took a course called "Kent State," which was dedicated to the study and critical examination of those events of May 1–4, 1970 on campus. In the class, she said, they read books and articles on the period, including James Michener's *Kent State: What Happened and Why*.

After the fashion people, including my neighbor at dinner, left for other parties and likely countless hours trying to hail cabs on cold street corners, my friends and I stayed to ring in the New Year together and talk into the early morning hours. I curled up on the couch and, the High Line and considering the train that rumbled up and down the same limited stretch of track each week, I fantasized about this in situ class where history and location doubled back upon themselves, re-enervating the debates, misunderstandings, and misinformation that still characterize much literature and scholarship on both Kent State in 1970 and Smithson's work (a group lesson plan for an art course listed on KSU's website misrepresents the work as having been made in 1971 "to memorialize the events of May 1970").

Shuttling back and forth along this path, I recall that Holly, like me, went to Bard as an undergraduate. Though our experiences there were two decades apart, we shared an art history professor who taught a survey course which Holly recalled with some skepticism—"it was very linear." Holly left Bard in the early 70s for Paris, where she went around to all the Brancusi collections—public, private, his atelier, gardens—by day, and the Cinematheque Française at night. She lived in Paris, together with an American draft dodger, until 1974.

—

These untaken courses and class assignments I never experienced remind me of an exercise that John Baldessari once arranged for his students. I've heard it told variously but remember basically this: one day Baldessari arranged for a police-sketch artist to come to his class. He left instructions for the students to give a description of their teacher—Baldessari—to the sketch artist so he could mock up a drawing of him.

In recounting the story to myself, I felt my memory was so vague that I phoned Helen Mirra in Cambridge to tell me what she remembers of the exercise, and she immediately asks me if I've "seen the video."

A: Oh it's a video? I guess I knew that.

H: Yeah, I'm pretty sure there is a video—which I saw at some point, probably from the Video Data Bank or EAI.

A: That's interesting, it's only been told to me as a story, not as an artwork.

H: You know my memory might be a bit fuzzy as I'm on a post-op narcotic, Percocet.

A: Percocet? Well you seem OK, so let's just go ahead.

H: Instead of Baldessari coming in at the beginning of class the sketch artist came in and asked the students to describe Baldessari to him. He's not in it at first, the camera is on the students. And I remember I can't hear very well what they are saying. It's very two-camera.

A: Really? Two cameras? One on the sketch artist, and one on the students?

H: What? It's 1979—*tube camera*, not two cameras. *(laughter)*

A: Well it would have been a crime to have two cameras, that's for sure. (*more laughter*) The thing I don't understand is, did he get in touch with the sketch artist by phone and arrange for him to come to his classroom and just start?

H: I think he had him meet him at his office, then directed him to the classroom without going in?

A: Yeah, but then he would have seen him. The sketch artist would have seen Baldessari and known what he looked like.

H: That's true. I don't remember how it was set up. That's the thing about getting it wrong on purpose.

A week later I go to the Metropolitan Museum of Art to view the Baldessari retrospective. I round a corner and there, looped on a monitor, is the sketch-artist piece. I'm immediately struck by how haphazardly it is filmed, rather like an afterthought, and how the image the sketch-artist produces remains for a long time mostly a cartoonlike evil character rendering of Baldessari's face—his eyes look particularly beady, not warm or jovial, and his beard menacing, like a bad guy from long-forgotten 70s chase films.

Phil Collins's own mug, staring out from an ominous black background, is the cover image for the 1981 record on which "In the Air Tonight" appears. The album title is *Face Value*.

—

A few days later I ring up Vanalyne Green, now living and teaching in Leeds, England. I call her online. When I recount my memory of the rules of her porn class, she squints and shakes her head on my computer screen, whose image projects this motion in a stutter. "No, " she says, "I don't think so."

The course was listed in the course catalogue under the title "Body Language," paired with a vague description about "the Kantian sublime or whatever bullshit I had to write about it," Vanalyne says. Together she and the students watched a lot of porn, viewed *The Secret History of Civilization*, read articles by producers of pornography, about the industry and labor and the transition from film to video in the production of pornography. She invited an actor

who worked in the industry to visit the class, "walking down the hall at the Art Institute—he was just *bionic*. Such a different physicality than art students," she recalls. And of course, they made their own work, which was to be a piece of pornography, "whatever that is."

I ask her again about the rule concerning the students needing to switch roles, the exchange of voyeur and viewed, framer and object. Well, Vanalyne said, a lot of people who took the class wanted "to be tops, you know the butch, to be dominant and all that, but they had difficulty finding actors, so they then used one another."

JAY BATLLE
SPIDERMAN'S DICK

In the early 1970s, UCLA had the idea to create a "progressive-thinking" art program. It would be called New Genres, and its students would be required to study performance-based work, installation art, and the very new medium of video. It was the first of its kind: not a decade after performance and video had been accepted as art forms, they were being taught and studied in the academy.

The artist that UCLA recruited to head the program was Chris Burden, who had recently made the cover of *Time* magazine by having somebody shoot him in the arm for a performance piece. Burden in turn recruited Paul McCarthy, another performance artist, who was at that point living in Denver with his family. With fifty cents in his pocket, McCarthy recalls, he happily took the job.

Twenty-five years later, when I came to UCLA to study art, New Genres functioned just like painting, sculpture, or any other subdivision of the fine arts major. My first assignment for Paul's Beginning New Genres class was to record a performance in front of a Hi-8 video camera. The work was to be a maximum of ten minutes in duration, but could be "whatever you want." But before I tell the story of my ten minutes of fame, I want to describe some of the other performances that Paul told me he had experienced during his tenure as UCLA professor, in response to this and other assignments he gave in New Genres classes.

1. A student whom I picture with curly hair and a slightly chubby build decided she would use paint to cover her entire body, and then just dance. About halfway through the jig, she started to gag and vomit. Eventually she fell over. Paul, for the sake of art, wasn't sure whether to intervene or not—but he finally decided to ask her if she was okay, and, what type of body paint had she used? "Body paint?" she replied, "I used floor stain. My dad's a carpenter."

2. A tall young man was interested in Yves Klein and his famous leap into the void. His plan was to jump out the second-story window of the arts building, grab the strong horizontal branch of the tree there and swing in the air, landing on the ground. "Simple gestures make great art," he would repeat in his head to inspire his leap of faith. He had practiced this feat

alone, successfully, multiple times. The day the class was gathered to bear witness was no different—except the tree branch had been blocking someone's view, and this person had complained to the landscapers, who had just cut it down. So, this time there was no branch to break his fall, and the only thing that broke were both his legs, in front of an astonished audience.

3. A very skinny, butch girl with short blond hair gathered the class for her ten-minute performance. She began to strip amid awkward smiles and snickers. Slowly she undressed down to her last two undergarments, then abruptly produced a razor blade she had been hiding in her mouth. Removing the item quickly from her gullet, she drew a line down her delicate inner arm with the silver blade, and walked to the wall to make a mark of blood, ending the performance. Unfortunately she had cut much deeper than intended (it was a brand new razor) and hit an artery. The mark turned into a spurt and the audience became part of the painting.

4. There is a close-up video shot of curly white fur and the sound of saliva. The image is hard to make out, but it could be the back of a poodle's head, licking something. The "performance" goes on for a while and a soft female voice is saying something to the poodle. Finally the camera angle widens to reveal the mise-en-scène. The very quiet art student who always sat next to you smiling and saying nothing has put peanut butter between her legs and allowed her white poodle named Tiger to clean up the mess.

5. In my class there was a very angry girl. She hated everything and everyone, she was not happy with Paul and thought New Genres was stupid, but none of the class suspected this. She took the camera with her out into the sculpture garden to film her ten-minute work. She pushed the red button on the camera, did her performance, and then pushed the button again when she was done. But actually, she had pressed the button twice and recorded nothing. So the camera was recording on her walk back to Beginning New Genres class, swinging in her hand. She went through the entire class of ten students, person by person, the T.A., and finally Paul. She revealed her true thoughts about us in the most explicit manner. I can't remember what she said about me. I'm not sure if I was even in this class, but I remember it that way.

Just like I remember seeing Spiderman's dick. When I was a very young boy I was forced to meet Spiderman at a car show in Arizona. My father thought I would be happy because Spiderman was my favorite superhero. The thing is, you should never meet your idols. The actor that the car show had hired to play Spiderman was seven feet tall and going commando in his costume. So at the time a picture was snapped of me shaking Spidey's hand, I was staring at his crotch. I was transfixed by the enormous baby arm bulging out of the red and blue suit. Spiderman had a huge dick.

But by the time I was an art student in college, I had completely buried this memory. But for my ten-minute video assignment, I got this image in my head of Spiderman making and eating grilled cheese sandwiches in front of the camera. I'm not sure why; it just seemed like a good way to interpret the assignment and to stand out from the other students.

So I went down to a giant costume shop on Hollywood Boulevard, looking for an adult-sized Spiderman outfit. But after about twenty minutes of wandering the aisles I only found it in children's sizes. I saw every other major superhero in stock, but no adult Spidey. I asked a woman behind the counter; she told to me that the copyright on Spiderman by Marvel comics had banned the production of adult costumes. (There would be no adult suits until the following year, when the movie with Tobey Maguire came out.)

I bought the toddler-sized suit anyways and dropped the grilled cheese sandwiches from the bit. I had an assignment to complete and I thought the fat-guy-in-little-suit routine would work just fine.

The very attractive teaching assistant in Paul's class was in charge of running the camera. I stripped down to my white briefs (unfortunately I had not switched over to boxers yet) and the T.A. smiled at my nervousness and underwear. Quickly, I donned my child's Spiderman costume, pulling the stretchy blue and red material over my shins, putting the mask on my head with the eyeholes at my cheeks. I'm not a little guy: I'm six foot nine and weigh around 190 pounds; unbelievably, the costume stretched up and over my entire body.

Then I went for the zipper up the back, squirming to force it closed. (Imagine a fish dangling on a hook, just freshly pulled from the lake: this was my choreography.) Just as I pulled the zipper all the way to the top, every seam in the costume ripped at the same time. The noise was really loud, as was the roar

of laughter from the T.A. There I stood motionless. Picture a full-frame shot of a large young man in a ripped eleven-year-old's Halloween costume, blind. I looked like a hobo transvestite trick-or-treating in front of a hot graduate student. That's when I remembered the car show, meeting my hero, and the lost childhood I was trying to regain. I guess the assignment was a success.

I was just telling Joan that my idea would be for an art school film directed by Clint Eastwood, and like I was telling Miaka at Jim's last night, the idea is that as a battered poet/critic I come in and spar with these nubile MFAs. But they should be like on their way, big contenders, built up on theory and refs. Not like sometimes where they don't even know who Judd is. The teacher should have to wrap me up in thick pads before I go into the ring with these kids, knowing how much they have. So that at least I get some protection. Ya know the thick red headgear and like even a chest pad. They should be strong and young and throwing serious blows, while I'm a fragile old critic nursing a kind of permanent hangover like Walker Evans near the end up at Yale. Just there for sparring a bit and getting twisted up in the sexiest kids. Right. Eastwood could bring this out. Sort of Yale sculpture meets *El Dorado*. *El Camino* I mean. It's ridiculous. I used to tell people I'm working at the New Haven Institute of Technology. Then I switched it to just Jessica Haven. Even when asked I thought I can't write about this shit. Like the girl who push-pinned a cum-filled rubber from the night before on the wall for the crit. I enjoyed that one. I think some of the students thought the rubber belonged to me. But things would get out of hand. James and Rashan having a fist fight as this sort of Basquiat-Schnabel thing down in a ring of car headlights. And another violent work made by a girl who asked to have herself punched in the face hard by her boyfriend in front of the camera. Neither fight-work used boxing gloves. And then there was the kid who made a jello mold from finger nail clippings collected from all his friends, and the boy who claimed with his shaven scalp to have had a part of his brain surgically removed. And Brock, who just never spoke. Not a word. He had sworn to be mute the entire year. It was like *Titicut Follies*. Me in a loony bin talent show. Barry, my chair, came to me once and asked if maybe I wouldn't mind backing off a bit because the school can't take legal responsibility for my students jumping out of airplanes and making skydiving formations for my conceptual art class. Or all going to get the same tattooed birthmarks. But it was really just one prick of dark brown ink near the armpit. Harmless. Not that I would have gotten one. Or giving up art to play competitive Scrabble. I loved teaching kids to be disobedient while I was training dogs the exact

opposite. I remember how Adrienne's Portuguese Water Dog, Dakota, would perform in the park off leash up on the Upper West Side, with her very nice heel, and piss on command at the curb by the doorman to my sweet melodic "You can do it" while the students were like getting that Dada manifesto by Maciunas that urges artists to Flux, or shit it out essentially on the Buñuelian living room floor. All art should kind of assault the domestic interior. Think of *Teorema*. The only movie with an entire art book in it. The two boys sit there on the side of the bed flipping gay pages of Francis Bacon. It is clear. Art is the muse. Art is the perverter. This will be my next class: The Perverter. A kind of workshop in the penetration past the threshold of domesticity. Like the two demonic blond boys in white museum gloves—white everything—checking out the golf clubs standing at the door in *Funny Games*. But teaching at MICA, for example, was a sort of pedagogy trial and error. Error and Trial essentially. Erroneous artworks being tried like criminals in crit after crit—Theater of the Crit I call it, and Joan and I are well underway to developing an actual stage set. I'll ask Alan and Linda to design something maybe, that can be a sort of Grahmian interrogation room for the open-spaced studio where the MFA senior crits will happen. At Yale I think it was once called the Pit. Known for its abusers and perverters. God, Richard, de Kooning's specs on a string dangling, was sure out of control that summer up at Norfolk. He was like the barflies staggering across Bedford at 8 AM back when the Charleston was the only bar in Williamsburg. Other than I guess Teddy's. But up in Norfolk, Blake dove down like a bowling ball in the gutter and shattered about fifty glasses and off we went to the emergency room. And at UCLA, the time Charlie just grabbed his hair and lower back and just paced the room for a while and then just took off swearing that my art was Bad! It's all been pretty strange and like performative theater in and out of the crit. I like the idea though that kids will stand behind the glass and talk about the critics as we carry on with all our grotesque pontifications. Talk about us as we spar I guess. Make fun of us and the defenseless little artwork lightweights. I should leave after a day's critique feeling like I need about three beers quick. Amtrak back to NY has always been a place to recover. The bar car. A great bar on track to pass out in or get stalled out in on the dark tracks. In Philly when Charles Bernstein would get on and join me and William Downs for microwaved hot dogs and a round of beers. The train would just pick up all the teachers and artists and poets on the North Coast and bring us back to to our safe beds and cozy families in NYC. Like the yellow school bus stop after stop, till the whole group is back together. Fun talks. The fighters back in their studios preparing for the win, while we elders have realized that there is only the slow exhaustion, the losing of energy and life. At MICA when I came I had tons of energy—true they were undermining me, exploiting me and every other adjunct—but I always knew I was on track with the kiddies ready to exhaust no matter how. I was a glorified camp counselor, like Bill Murray in *Meatballs* chanting "it just doesn't matter," the teacher that kept the wayward students from dropping out purely by being liberating and being, like, in a way one of them. Joan says back in the day she had to learn karate-type arm blocks to shield the gropers, the professors who would come in to paw her knee. I don't think I even did this, but I guess I could be a pretty bad flirt. Flirting with the eyes though isn't flirting, it's just perverting. Like Stamp in *Teorema*. He just looks. As does Gene Wilder. That's it. They are art because they look. I guess I wanted to just get off that train and enter that classroom and soak it up and breathe their aspiration and turn it on. I learned how to be responsible for being fucking inspiring. It's no joke. I taught freshman even at first. I was lit up like Kinski at times just by arriving in Baltimore. They would come back from Christmas vacation as new kids. First semester still unsure, then going home and deciding to leave it behind, and then they'd come back ready to play. Many kids stuck with me for years. Took the old fogies a while to realize where all the kids had gone from their classes, why they had so many available easels. Then they realized I had like fifty sophomores piled in my room. They started capping my class at like fourteen then down to nine and penalizing students for working with me. That prick said I gave A-pluses for boogers smeared on walls. Meanwhile he was in a Sunday Civil War dress-up game where grown men would play Battle of Antietam. I'd say a booger on a wall is fine and the war game is fine too, even if it's kind of a Dick Cheney-like thing to do. All funny games. All crit-able in the theater of interrogation of art students. The game I didn't want to play was the one with a girl who had the eyebrows of Sontag and was after me, for more one on one and I was so fucking scared of her because she

was such an intense narcissist and I was a democrat. But she wanted to catch me and when she did she pounced on me with like a ten-pound dildo made from an old monster truck wheel. I made that boy giggle in class discussion that day when I said that the baseball stadium was filled with ghosts who had all died of AIDS and were dancing to the YMCA anthem having a kind posthumous hoorah, and then I was like getting called in to fight for my job for my supposed gay bashing. But in retrospect I should have been flattered to have been victimized by the same Kosher Frank that tried to bring down David Byrne and then ran off to join the Taliban. But my real hope from the beginning was to find the lost Velvet Underground. So I just asked them all to line up and gather around, and I started pairing them off into groups of three or four, whoever looked good together. Body language usually told the story. It was fun to form bands that I thought might look like rock bands if they were to be photographed for an Elektra album cover. Like OK I have a group of twenty-five kids, can I get a Kinks-looking band, a Raincoats-looking band, a Beach Boys out of the like six or however many cute blond boys in short-sleeve pinstripe oxfords, and have like one left over to be a Scott, or a Linda Ronstadt. But I was also thinking that any art school kid can make great music because they will have instinct and style even if they had no musical experience. I found every class would have at least eighteen very stylish kids, even the geeks looked exceptionally geekish, plus one drummer, a few guitarists … NO TALENT—all you need to put on a punk rock show. Plus the P.A., mic, mic stand. But they stopped letting me use the P.A. when they heard that the Parapalooza was a drunken scene off-campus loft with crowds of local Baltimore skate kids trying to climb up fire escapes and find the action. The shows would get pretty edgy and pretty much shoulder to shoulder. But I was the only teacher—strike that—the only teacher taking a hit off some kids joint. What was I thinking? Getting fat all semester at the bar between classes, hardly even mentioning Lawrence Weiner by name in what was supposedly a "conceptual art" class. There were many one night bands and some other longer running acts like Hunter and the Gatherers and Shaun and Brian's very trippy Cutter Hammer. Mike Heleta's noise stuff. Once even a four-person marching band. This all led to Ponytail. I decided to just put Jeremy, Ken, and Dustin together even though I knew I'd have all three of my top musicians in one group rather than evenly distributed. See Molly was like dressing up like a little cute Hasid with a small felt pin-on yarmulke with a gold Star of David and everything, and I just thought it would be a challenge to see if the other guys could back her on stage. Not exactly Mark E. Smith, but she was a rock star, an instant cult dyke. Papich was also a star and he had his own band, Ecstatic Sunshine. Jeremy actually played like Keith Moon so it was clear these kids were gonna put it all together. But I had no idea that was gonna happen, that they'd actually go on to headline festivals and appear all over the world. And that people would ask me if I am the Jeremy Sigler that started Ponytail. And Devon really must have been the instigator. She even shot a Baltimore band picture for my class as a project mimicking that famous Harlem Jazz moment. I kept getting pissed every time I heard the name Dan Deacon cause he wasn't a student! He was like not one of mine. No idea anymore who was actually in the class or enrolled. Never once looked at the roster. "A" meant "F." "A+++" was the average grade. Grade inflation I guess. But how can you give a kid a grade for smashing a guitar? My daughter was being born that semester, and Geoff Grace subbed for me a few times. I'd sort of lost control of that class. But the rock show was only one night at the end of the semester so what was I gonna do the rest of the time? Movies! This is the only way to eat up a five-hour studio class for like sixteen weeks. Adjunct means movies. So had a handy little music curriculum: *Don't Look Back*, *Gimme Shelter*, *Ziggy Stardust*, *The Harder They Come*, *Topsy-Turvy*, *Company*—all my faves. *NASHVILLE*. I think I showed that Townes Van Zandt doc one year near the end, the Ramones doc, and Devo videos, as well as *Ladies and Gentlemen, Introducing the Fabulous Stains* by Lou Adler. Still want to interview Lou Adler. Love the guy. He did *Up in Smoke* and I think produced one of Cole's favorite Care Bears movies. When someone once suggested that I was like *School of Rock* I knew I had to quit. Even if I was like more Anti-School of Rock or School of Punk. Or School of Rock my Religion! It had run its course. So I tried a new idea out. *Being There*. I decided to teach the movie as a play. I cast it, directed it, rewrote it. I was like brutal. Trying to get into them all. Like Cassavettes into Gina Rowlands. Pure psycho directing. I convinced Vish to learn to play piano at the nearby Peabody Conservatory to get the Satie song down. So he was enrolled in two colleges at once—for me. And Kenny learned

Basketball Jones by Cheech and Chong so that we could do that crazy street gang scene. My Chauncey the Gardener was perfect. Lotfy in bowler and pinstripe double breasted suit. In the dress rehearsal I caught him wearing tighty whities instead of boxers and told him to get into character. He was also supposed to be in sock garters. But I miscast my female lead even though Lauren warned me, because I just didn't know that a theater director needs to base his decisions on vocal projection, not ass-cheek projection. It was amazing, me the bearded Zack-looking teacher tearing tickets and raking in like two hundred bucks for beers at the Tav while my conceptual art class was killin' em onstage. I did almost break a broomstick on one kid's face during one rehearsal, but aside from that, everything was cool. We even did the outtakes, the famous Hal Ashby outtakes that roll behind the credits, as the audience was gathering their stuff and clearing the makeshift theater down in the atrium of the neoclassical Mt. Royal Building. After *Being There,* I did a stand-up comedy class for a few semesters, just to really use up the last of my energy, and to once and for all get them to mercy-fire me. It had become like the Island of Dr. Moreau down there so close to the Mason-Dixon line. I was sort of nearing that point of mutiny where my own furry cyborgs were beginning to turn on me. Two years of teaching stand-up to pathetic under-grads, trying to get them to transform their traumas and shame into crafted self-deprecation. Not that I knew how this was done. I just had a feeling about it. Bruce, Kaufman, Sellers, Allen, Cleese, Joan Rivers, Pryor! Prior! Kaufman! Kaufman! Kaufman! These guys weren't being studied anywhere. And the night of the big comedy show I had them all in tears. They were so scared, breaking one by one. It was like we were a bunch of paratroopers preparing to invade the audience, pissing our pants. But after comedy night we all hugged. Really hugged. It was like the end of SNL, where they all take the stage. Really visual camaraderie between us, and respect for what we'd accomplished. In art it's all phony cheek kisses and petrified little pats on the back while peering over shoulders at whatever image of success walks in. In music it's a solid trustworthy soul shake that eases off in a snap. In comedy, it's a solid long hug. If I did anything in art school that was worth doing it was that. I hugged those kids, and gave them a reason to hug ... Clint.

JULIAN MYERS AND DOMINIC WILLSDON ON "EDUCATING ARTISTS:" A LETTER TO CHARLES HARRISON

San Francisco, February 2011
Dear Charles,

We are reading "Educating Artists," pulled from a 1972 edition of *Studio International* that has seen better days, and very much enjoying your pungent criticisms of the art school mindset. The piece is a broadside in a debate we can only grasp part-way— and you might react with bemusement, if not horror, at the prospect of its disinterment forty years on. Still, it spoke to us and we thought we might respond. In many ways, it is surprising how little has changed. The idea that art school (merely) encourages and assesses students' self-expression still exists—this self-absorbed notion of art school as a pseudothera-peutic situation, shaped by Skinnerian techniques of "reinforcement" and "reward." It might even be the dominant notion of what art school is, today, and we have as little patience for it as you did. You also elaborate, critically, on the idea of art school as a kind of nebulous "free space," deliberately left undefined so as to allow for maximum creativity and free play— as you describe it, "something close to a primary (or elementary) school open plan." It is a terrible fate, isn't it? One must believe in something like "educa-tional osmosis," where "the central generative process of art education [is] one of perambulation in and around the art school by staff and students alike, punctuated by chance encounters."

In other ways, though, we feel somehow detached from your concerns, and the context you were addressing: the circumstances of art education in Britain in the early 1970s. It is long ago and (for one of us more than the other) far away. It is not easy for us even to reassemble what those circumstances were, exactly. We grasp that the old independent art schools were being incorporated into the polytechnics. Art *schools* were becoming art *departments*. We know too how issues of art education mattered to your Art & Language circle, at that time, and on through projects such as *Posters for 'School'* (1975–76) and *School Book* (1979); and you have written elsewhere (in "The Conditions of Problems") about how that circle suffered professionally from these transitions (though this trauma is well coded in "Educating Artists").

We understand, too, that just as the partisans of the independent art schools felt these administrative changes to be a threat to their sense of the value of art, you saw grounds for optimism, for the very same reasons. You surmised that ending the isolation of art schools held out the potential of ending the isolation of art, thought it could mean that a body of theory might be articulated to justify art practice, as with other disciplines in the polytechnic, and argued that art education might borrow protocols from those disciplines—and thereby gain some possibility of "order" and "priority."

You argued for a new kind of research-based art practice, on par with other academic activities. This might enable something you describe, perhaps mischievously, as "social realism." (You meant to evoke someone like Courbet, we might guess, or Rivera, and not the Association of Artists of Revolutionary Russia.) This seems to be the key passage, for you:

> In so far as art does indeed offer opportunities for access to and expression of some non-materialist systems of evaluation, its practices and priori-ties [would you say, its "methods"?] are of wide concern. [...] The potential in terms of art educa-tion now seems to lie in the direction of finding a means to explicate, rather than to decorate the world. [...] Social Realism in art might come to mean something very different ... if it could only serve to describe an intellectual accomplishment rather than an ideological stance.

This is where we find ourselves estranged from your account of things, as it was then. Not that we don't feel the appeal of this agenda—we do. We would like to be able to argue for the explication and evaluation of the world as the method of art. But what could that look like now, as a program for the education of artists? More concretely, what would one *do* in the classroom? What new kinds of questions must be posed, and with which sort of result in mind? More to your point, we might ask, from which polytechnic field might art education extrapolate its idea of research? Instinctively we assumed you meant the social sciences—and we've seen where a version of this has led, to something like art-as-ethnography, with its attendant ambiguities and pitfalls—but the example you call up glancingly in your essay is physics.

Well. Here the limits of our situation may constrain our imaginations, and our appetite for the model offered by science. We do wonder if your idea, that art school might borrow forms of assessment from other disciplines in the polytechnic, seems to lay the grounds for—or, keeping your qualified optimism in mind, to dialectically invert the values of—the reorganizing of the school system according to the dictates of finance, as it was happening in the 1970s. In hindsight this looks rather more ominous: a grim episode of higher education's "legitimation through performativity," this being Jean-François Lyotard's jargonistic description, in *The Postmodern Condition*, of the remaking of the project of education according to the demands of science and the market. Pedagogy will still exist, Lyotard allows, in these new conditions: "The students would still have to be taught *something*," he writes. "Not contents, but how to use the terminals."

This is a sickening diagnosis, compared to yours, incipient in the moment you were writing—but one that squares ever more precisely with the reformatting of more and more classrooms to the priorities of iConomy and e-education, in the art school system and the Bologna Accords alike. The new legitimation you picture as possible in the polytechnic is so easily reimagined by administrators as the transfer of marketable and assessable "skills" for a new breed of knowledge workers. No matter if that promise is often made by the art school with a certain amount of cynical reason. Perhaps we might respond with one of Art & Language's own exhortations for the art school context: "Those paying lip-service to the nostrums of cultural bureaucracy are vocationally depoliticized!" We would march to that.

And where do your suggestions lead us, as teachers, with a group of students? What *would* one do in the classroom? What would one assign students to do? We've been thinking about an experience one of us had, teaching at an Open University residential school around 1998 (you were there, Charles, being the quiet, benevolent doyen of OU art history, playing the french horn in the evenings). A particular group visit to the Tate Gallery included an ad hoc assignment, which may or may not speak to your imaginings in 1972. The students were in a room full of Cy Twombly paintings, and a colleague, who had been approximately part of Art & Language, asked them which Twombly they thought was best. The

students refused to answer. They thought they were all junk. So—this is the assignment, of sorts—he asked them which was worst, and then the group suddenly had many suggestions, and could argue, vividly, why one was worse than another. As a result this colleague was able then to point out that they could make and discuss aesthetic judgements about Twombly.

To know which Twombly in the room is the worst—or the best!—is not to know very much, we'd contend. But the assignment does open the question of judgement, as well as the crucial matter of criteria: ordered and prioritized, according to what? Perhaps answering that question will reveal nothing more (nothing less) than the "class character" of the students themselves. Whether this is a useful revelation would depend on what was done with that knowledge. By the way—and here is something you would be able to confirm or deny—the OU colleague claimed that this assignment originated in the turn of Art & Language away from strict conceptualism to questions of aesthetics, around the time, 1980, of the *Portraits of V.I. Lenin in the Style of Jackson Pollock*. Was that turn motivated by what was happening to higher education in the 1970s? Did you begin to suspect that if art was remade as a cognitive discipline, it would be handed over to accountants?

We surprise ourselves by having more confidence, more hope, for art as research than, we suspect, you have had for decades. It is not that we would want educating artists to be *like* an education in science. But what would happen if we all viewed practice in art schools *as if* it was research? What transformations or shifts in register might result? A few things come to mind, in tune with your suggestions from 1972. First, research is a collective endeavor. It adds something to what others have done and will do; and in this, it opposes the terrible individualism on which the art school still seems to insist. Research, too, is meant to be arguable, contestable, as the assignment of deciding the worst Twombly points up. It is opposed to a kind of art, so prevalent in art school, that is validated by its self-expression, sincerity of effort, or worse, sheer quantity (indeed your Art Theory courses were marked, by contrast, by the careful, "glacial" pace of their production).

We also have in mind your reference, in *A Provisional History of Art & Language*, 1982, to art students' "heuristic activity"—that is, learning through experience, trial and error, and

experimentation. What would a truly heuristic research look like? It might produce something quite distinct from those pseudo-objective, ultraprofessionalized, overadministered, essentially unquestioning investigations that prevail elsewhere in the academy. And certainly some such shift in register would be necessary, should we want art schools to do something other than "reflect the system which they serve so well, whose highest values they enshrine, whose noblest aspirations they foster and whose most liberal principles they exemplify." For us this remains a worthwhile prospect.

All our best,
Julian Myers and Dominic Willsdon

ANGELA DUFRESNE

The best assignment I ever got
Dona Nelson said paint a portrait of your parents, there's no way to gain emotional distance. Just to see what that would feel like.

The best one I ever gave
Four paintings: the most disgusting painting you can possibly make. The most gorgeous painting you can possibly make. A celebratory portrait of someone. A critical portrait of that same someone.

The best one I ever heard of
Kevin Zucker's Five Obstructions, where students pair off and give each other obstacles that challenge and destroy habits and style-crutches. Loosely in reference to von Trier's film.

I have, perhaps, an overstimulated gregarious impulse. This has led me into countless episodes with people who were my teachers, people who have been my students, and people from whom I have learned. These are largely interchangeable groups, a kind of good fortune which has blessed my life beyond my confused days as a schoolboy.

I remember all sorts of instructive moments, times when information was being supplied or a process demonstrated. It's the strangeness of the consultative space which most intrigues me, the to-and-fro of speculative exchange, although I recognize that the most mundane problem-solving moment may carry with it a marvelous corona. A student texted me today saying "No tangents!" and I texted back "No tangents, no centers." There are indeed great instructive moments which double as artworks. Bruce Nauman's *Setting a Good Corner (Allegory & Metaphor)* employs his own do-ishness, but plays with the pioneer "can-do" of all-American purposefulness. The videoed result, demonstrating a fencing method, teases all our cultures of spatial organization and geometrical decisiveness, instructing as it goes. The Studio of the Great Outdoors.

What needs to be taught—when, why, where, and how—is a question of tiring insistence, especially among groups of young people who are seeking atten-tion and, simultaneously, learning how to attract it. I see a complexity now which I never foresaw, which asks demanding questions about cultural values and how they are shared. I am writing this in a school in provincial France on an overcast winter's day. In the workshop this morning a young woman asked me for something. When I explained that I was from London, she switched to perfect English, with a strong American accent, so I asked if she was from the States. "No," she said, "I am Moroccan Japanese." She went on to say that she learned her English from films.

Shortly after, a second confident young woman arrived to use some hand tools, and I was again asked for something. That she was from Beijing was quickly revealed, as was how she had acquired excellent lan-guage skills in English and French. She was eloquent about the language wars raging in her head and talked of the sympathy that her teacher in Beijing had shown her in her struggle. Now things were improving, she said, and mentioned that her teacher in Bourges was

actually a Russian. It is like this now, and the young will invent what they invent from their undoubted con-fidence, locating and relocating themselves as they go.

In the last century I had a class at the Architectural Association in London with a truly international group of students. "How did we get here?" I asked, intending not only the biggest human question, but also to expose the comedy of the daily narrative of big cities, and how we move through them, and how they move through us. The expectation was that they had a whole morning to create a drawing of their morning transactions between home and Bedford Square.

The young Londoner set to work drawing every building on the street where he lived, expanding and adding sheets of paper according to the immense powers of observation, moving like a 19th-century speculative builder backwards towards his 18th-century target on the edge of the West End. You could feel the intensity of his immersion and distraction within the city. At the other extreme, an international student (from the Far East, as we say), drew the tube line from his apartment in west London to the stop nearest the AA, accurately marking off the stops along the way. He also drew accurately the small amount of road map at each end that he used as a pedestrian. You will be able to imagine the range of narratives which sat between these two approaches. How do humans get from the schematic to the spatially and materially rich city fabric, and back again?

The modesty of the common task that morning released energies and attitudes which stood as common ground for the whole group, but also as a palimpsest of the unaccountable behavior of the whole city. Maybe those students went on to analyze or design public space as a professional pursuit? Their responses have stayed with me. Their vigilance and the sieving of one encounter from another stand for all human sorting and valuing. They affect the way I walk through cities, and how I think of others who pass me by.

Bourges, France, January 26, 2011

from Ethiopia. Three died on the journey, but eight survived. It wasn't until almost a year later that he heard from one of them.

What did he say that could inspire these children to walk hundreds of miles, often in the dark of night and for more than a month, in order to possibly have a chance to come to New Jersey? That was the question that haunted me as I sat in the back of the auditorium listening to him talk. He was not imposing as a speaker. A slight man, he stood at the lectern, showing slides of a refugee camp for Ethiopians fleeing the famine and civil war.

That summer he had volunteered at the camp—his summer camp, he said. He taught them English and math, and as they were just beginning with English, they often communicated by drawing pictures. They drew their remembrances of their families, now no longer intact, their villages, now destroyed, and things that they remembered, but could not speak about, even to one another. These things they had seen, the things they had done. He said the drawing calmed them. The drawing helped them, more than the English and math they were learning. It gave them a sense of control, even if it was only a remembered space and not a real place.

Life in the camp was hard. Medical care was sporadic. While there was some food now, it was never enough, and by winter it would be scarce. It became clear to him that few of the children would survive winter in the camp.

He gave them a new assignment. He began to teach them a primitive form of cartography and geography. How to draw maps, how to use the sun and stars for direction. He gave them a compass. He had learned of a pilot program to resettle Ethiopian refugees in New Jersey. But there was a hitch. They would have to walk more than 300 miles to cross the border in order to take the test to enter this program. It would not be offered here.

They were already very good at surviving. After all, they had already made it to this camp.

Eleven of his children left the camp at the end of the summer. He did not know what would happen to them. He did not know if he would ever see them again. He was not sure that he had done the right thing in giving them this assignment, but he didn't know what else to do.

Two of the oldest boys took charge. Walking by night and sleeping during the day. They had learned how to find water and food on their walk

Of course we know artists have a kind of congenital allergy to rules, especially somebody else's rules. We like to make our own rules. Very freeing, right? Well, that's not the whole story. Let's take a look at the rules you are following, especially ones living below the threshold of consciousness. Make a list of these rules, right now. Which of them that you think are your rules, are really rules you've inherited, been taught, learned are the cool rules? Are they serving you, or trapping you?

WEEK 1

1. As you work throughout this next week, try to hear the rules whispering to you.
Keep a running list, and add to it every time you hear another one.
Don't read any further until you've done #1.

WEEK 2

2. OK, you cheated, because it was my rule. Now, what kind of rules did you come up with? Are they the easy formal ones about choices of materials, how long or short the piece should be, or what to wear? Try again, and listen for the harder ones: the conceptual limits you put on your work, the kind of work you let yourself do, or not do. Are there whole parts of your being you put in a separate compartment and don't even consider bringing into your work? Whole enthusiasms you haven't let yourself imagine as part of your work? Embarrassments, naiveties, intelligences you leave out?

3. Now, this week do whatever you have to do to break your own rules. The hardest ones first.

The last few years, I have spent my summers in a house in the Mojave Desert. Summers there are periods of extreme temperatures, reaching 100 degrees or more. Locals try to retreat to other places and visitors are rare. Despite the harsh conditions, I find this environment conducive to working and enjoy that I am forced to adjust my daily routines to the climate as well as the solitude. I have noticed that strictly regulating my schedule increases my focus and accomplishments; it has made it easier to manage the isolation; fixed time frames for particular tasks become companions during the flow of the day. Upon arriving at the house I usually write out a schedule that includes work tasks as well as daily routines. I think of the entries as instructors that have the power to order me around; drill sergeants of my own making. (The distant view from the house includes the U.S. Marine base in 29 Palms.)

I have generally kept the written schedule on the kitchen table. Here is a typical plan:

Get up around sunrise
Outdoor exercise
Breakfast and outdoor reading period
8:00 Communication
9:00 Work indoors on projects (5 minute break
 every hour)
1:00 Lunch
1:30 Reading and short nap
2:30 Reading and note taking
5:00 Outdoor projects and home improvements
7:00 Dinner and puttering
8:30 Communication and reading
10:30 Go to bed

Once or twice a week I strayed from the schedule in order to stock up on supplies or hear a band at the local bar. While I enjoyed diversions of my own making—going to the supermarket was an exciting pleasure—I experienced external interruptions as intruders I would have preferred to avoid. Over the course of the summer I mostly stayed with the rhythm, but occasionally felt I had to do something unscripted and simply "waste" a day. Sometimes, despite its productiveness, I regarded my regimen as a laughable mission unworthy of a self-sufficient adult who is neither in the military nor in a mental institution.

These desert periods lasted about six to eight weeks, after which I returned to New York, where my routine changed into a less rigid schedule determined by urban rhythms and social exchanges. Although noise, media offerings, and social obligations sometimes make it difficult to maintain focus, I never felt the desire to replicate the desert regime in the city. The firm structuring of my daily activities seems to be at home in the desert.

ANONYMOUS

Go into your studio. Using all of the clothes you are wearing, make a work of art. Leave the studio naked.

MICHELLE GRABNER
NO ASSIGNMENT: THE MEDIUM OF INDIRECT TEACHING

Only dead fish follow the stream.
—Finnish expression

The most effective and trustworthy "assignment" I have honed over my twenty years of teaching studio arts is simply: NO ASSIGNMENT as a form of indirect teaching.

A "no assignment" method does not guarantee a Socratic debate, yet it does cultivate critical thinking while eschewing the authority of the teacher and rebuffing the pedagogical misadventure of assessment outcomes.

Critically, indirect teaching emphasizes the weight of work, supporting self-directed knowledge that is shaped by the limits and freedoms of the student and the institution. *Work* and *assessment* are the responsibility of the student.

LIAM GILLICK

Assignments are homework. They remove the responsibility from the cultural producer to devise their own context, and create an artificial power relationship to replace the real power relationship between student-artist and older ex-student-teacher-artist. The assignment replaces the potential for real work and real recognition of power dynamics. The assignment allows the student to avoid taking responsibility for his or her own critical awareness and replaces that with a set of directed "potentials" that are actually rehearsals for future instructions from various powers, i.e. galleries, institutions, and various "clients," all of which are in direct conflict with the potential of art. Therefore I do not give assignments, I don't acknowledge work done as an assignment, and I don't find them funny.

I never give assignments. Well, that's a lie, but probably more true than false. I used to teach a course called "Looking and Listening." I'd take ten or twelve students some place (an oil field in the Central Valley, the homeless area near downtown Los Angeles, a kilometer-long hand-dug tunnel in the Mojave foothills, etc.) where they would head out on their own and practice paying attention. I never required a paper, or a work of art, or led a discussion. If there was an assignment, it was to become better observers. And that they did: afterwards their art grew in a far more subtle direction.

I think it was the best course I ever taught. But I no longer teach it, not because I don't want to, but because of my school's fear of lawsuits. There certainly have been great changes in America since I began teaching in 1970, but maybe the change I am feeling is due to the fact that institutions get increasingly more bureaucratic as they grow older (mine's nearing forty)—or perhaps it is both. About two years ago my school began to require a syllabus along with a statement of purpose—just what are you going to teach? For me this seems condescending; I just don't teach that way. My classes are about providing a creative environment that questions convention, where ideas can form spontaneously and play off one another. I am to the point of believing I can no longer exist teaching in an institution. So why don't I quit?

I also teach "Math as Art." In that class I demonstrate how mathematics is structured and then ask my students to make a work of art that is imagined from their experience with the class. Yes, in this class I do have an assignment, but it is purposely open-ended. Last year a young boy knitted a scarf. He took his favorite love poem and typed it into his computer. Then he hacked into the memory and found where the poem was stored as hexadecimal code (base 16). (Note: A computer really stores all of its memory in base 2, but reveals it in base 16 for more friendly human consumption.) Using the mathematics he learned in my class, he then converted the poem, one letter at a time (including the punctuation and spaces) to base 2, recreating the poem as a series of zeros and ones, the way it actually resided. Then using the zeros and ones as architecture, and because knitting is a binary function, he simply equated a knit to a zero and a purl to a one, and knitted the love poem into a scarf. When he was finished he gave it to a friend in celebration of the winter solstice. This is why I don't quit.

Perhaps I can end with an assignment. The next time you teach a class, just sit there. Don't say a word and see what happens. I guarantee it won't be nothing.

After reviewing all the assignments from the semester,
locate and gather all your finished and incomplete
projects in the classroom, place them in a compact
pile, and carefully consider it. Using drawings, collage,
and/or various computer programs, design and
build a container that corresponds to the form of the
projects pile, making sure it holds everything and is
structurally sound. When finished with construction,
place all your projects in your specially designed
form and take it away from the classroom. Please do
not leave any of these forms/containers outside the
classroom, in the halls, or in your locker.

We were in a museum bookstore in L.A. a few years ago when our various feelings about the booming field of art pedagogy studies finally came to a head. In the midst of inspecting several thick and informative tomes on the rich history of the art school, the intricate assumptions that underpin its existence, and the myriad directions it could theoretically take in the future, we ended up feeling, once again, like the proverbial birds consulting the proverbial ornithology book.

What disoriented us was how little attention was paid to the nuts and bolts of art teaching: the effectiveness and applicablity of certain classroom strategies, coping mechanisms for the psychological toll of being a diligent instructor, ways to teach a subject that resists straightforward explication. Of course, these things tend to remain off the written record, but we couldn't help feeling that this new wave of books would speak candidly and efficiently to the everyday experience of the artist-teacher. But would such a book be possible? Wouldn't its pages be infinite and ever changing? Or excruciatingly mundane?

As we groped and complained our way towards a solution, we thought about what you actually do in class. In class, when you're faced with a multifaceted, perhaps insoluble situation that is manifesting itself in uncountable ways, you either just go straight out for a drink, or you try to come up with a killer assignment. And we realized what we wanted: a book of assignments.

So we began asking people we knew, and people who knew people we knew, to tell us about art assignments: remarkable ones they had given, received, or just heard about. In lieu of any ingenious system of solicitation, we tried to cast a wide net. We asked people who teach, people who study, people who teach but didn't study, people who studied but don't teach, and people who never set foot in an art school. The response was overwhelming: this raft of documents gave us a whole new set of questions. We couldn't answer them in any definitive or scientific way, but we do feel obliged to lay out some conclusions here, now that you've had a chance to make your own observations about the material.

1. Assignments crowd the early days of art school, and they disperse dramatically as students advance. Each semester, each year, each degree program begins in a heightened state of organizational precision: every aspect of a student's work is specified, from dimension to medium to quantity to duration. As things progress, these specifications are removed. You start out drawing three 18 × 24 inch pictures of your roommate in charcoal for Monday, and you end up doing whatever the hell you want, whenever and however you want. In fact, we customarily consider the transition from student to artist as the movement from assignment-directed to self-directed activity. While things are opening up in the studio, assignments shift to the realm of professional development: write an artist's statement, assemble a CV, build a website.

The underlying wisdom of the current system seems to be that the combination of studio autonomy and career counseling in late-stage art school prepares students for the life of an artist, which is allegedly about doing "whatever you want"—and then putting that on your résumé. But everyone knows the real strictures of artistic life are far more complex, and require a creative response to an ever-changing set of external demands. Some of the assignments collected here directly address such problems and solutions; we would argue that all of them do this implicitly.

2. Assignments play a central role in what is still largely an oral system of education. Most artists, when they begin to teach, will pass along—consciously or not—the assignments they themselves were once given. Inevitably, revisions emerge, either from careless misremembering or careful tinkering, with the aim of making a modest update, or in a spirit of full-scale critical détournement. The authorship of an assignment is therefore almost always ambiguous. It is generally understood that assignments are things to be adapted, shared, and reworked. There can be legendary assignments, attributed to legendary teachers, but few people would consider it improper to re-use them. Just like the jokes that assignments sometimes resemble, a lot depends on the telling. Likewise, if assignments are like prescriptions or recipes, it's crucial to know what the ailment is, or who is coming for dinner.

In creating a written archive, however incomplete, we aim to enlarge and improve—rather than spoil, replace, or downplay—this tradition. At the same time, in publishing a book we also wanted to address some of its limitations. The most obvious fact is that

art education is often a costly and exclusive endeavor, available to relatively few people at any given point in time—ideally, this archive will reach a wider audience while preserving its material for future use. So while we are guilty of taking these assignments out of context, we hope the condition is temporary, and that they will soon re-enter different studios and classrooms, and thrive in their new surroundings.

3. Despite the well-established tradition of artist-teachers, we discovered that some artists who teach would rather not be publicly identified as such. This attitude initially surprised us, but it makes sense: the implication that one isn't selling enough work, the diminished cred that comes with shouldering an academic title, the psychic strain of associating yourself with any institution—all of these would be reason to take a paycheck (and maybe health insurance) and keep quiet about your day job. We wondered whether this attitude correlated with geography, generation, or gender. Unfortunately, our sample size wasn't big enough for a definitive insight, and in any case, sociological speculation is well beyond our pay scale.

We do know that the figure of the devoted artist-teacher who excels in the classroom is often stigmatized—even as this stigma is wrapped in layers of reverence and nostalgia. On the other hand, the figure of the star artist who acquiesces to teach is in some ways respected, or even mythologized, for not doing a very good job. With a student body that is similarly too cool for school, there is a constant tension between the cool part and the school part. This is why good assignments are sought and traded with such relish: they can restore a sense of risky social experimentation or cigarette-smoking outlaw status to people who, often as not, regard academia as a gilded cage.

4. Indeed, assignments put the idea of authority into play in all sorts of contradictory ways. As one might expect, we received (and included) numerous objections to the form of the art assignment, made on political, ethical, aesthetic, and even spiritual grounds. Many of the traditional assignment's underlying premises (that art can be administered, that it's a matter of skill acquisition, that it should have anything to do with the successful completion of a task) have been thoroughly dispatched by recent thinking. Beyond these, its basic structure seems

to contravene contemporary mores about hierarchy within the creative wing of the academy: giving an assignment means telling someone what to do; this, in turn, means you know something that that person doesn't, or want to foster the bad habit of subservience.

If an assignment is to go beyond the mundane goal of crowd control, or the less forgivable agenda of shoring up a teacher's power and influence, it has to hold its authority loosely, even disdainfully, without totally relinquishing it. In order to helpfully engage the pressures and ambiguities of contemporary art making, assignments must structure questions in such a way that students and teachers can experience them together. It's no surprise that many of the anti-assignments collected in this book use the slippery logic of "I command you to disobey me" and other infamous tricks of the oracle.

It turns out that these more extreme examples have even come to characterize the genre as a whole. Once you get beyond the basic exercises in foundation-level classes, art school assignments seldom anticipate their perfect fulfillment by the student—that would run counter to what we understand as art: a creative misunderstanding of the rules of a particular game. If we look for the conventional skill-building exercises inherited from the French Academy, or the more phenomenological experiments passed down from the Bauhaus, it seems that a certain kind of straightforward directive is now passing over the horizon of the 20th century. The form itself, however, is flourishing.

—The Editors

SAUL AARON APPELBAUM (p. 81) has formal education in plastic art, architecture, and music, puts immense stock in arts management, and currently holds an unpaid position as Founding Partner of the non-profit studio Vera Maurina Press.

KAMROOZ ARAM (p. 64) is an Iranian-born, Brooklyn-based artist who received his BFA from Maryland Institute, College of Art and his MFA from Columbia University. Since 2009, he has been working with BFA and MFA students at Parsons, the New School for Design.

LANE ARTHUR (p. 64) is an artist currently living and working in Brooklyn, NY.

COLLEEN ASPER (p. 48) has taught at ten schools in the last five years; her adjunct nomadism currently has her dividing her academic hours between the Cooper Union and Yale University.

JULIE AULT (p. 88) is an artist and writer who has taught widely on a visiting basis. She recently completed her doctorate in fine art at Malmö Art Academy, Lund University, Sweden.

Born in National City, California, **JOHN BALDESSARI** (p. 38) attended San Diego State University and did post-graduate work at Otis Art Institute, Chouinard Art Institute, and the University of California at Berkeley. He taught at the California Institute of the Arts in Valencia from 1970 to 1988 and the University of California at Los Angeles from 1996 to 2007.

JUDITH BARRY (p. 116) is an artist/writer whose project ...Cairo Stories premiered recently at the Sharjah Biennial.

JAY BATLLE (p. 105) took a weekend class of Chinese cookery with Ken Hom in Phoenix, Arizona at age 11; he graduated from UCLA with a BA in 1998; he received a full scholarship from the Dutch Ministry of Culture to attend the prestigious postgraduate studio program, De ateliers, from which he was expelled in 2000.

LAUREN BECK (p. 81) is creating a multiplicity of genres through video and drawing. She keeps bees on the side.

MARTIN BECK (p. 117) is a New York-based artist who currently teaches at the Academy of Fine Arts in Vienna.

JAMES BENNING (p. 120) has been making films since 1970. He currently teaches at the California Institute of the Arts.

ANDREW BERARDINI (p. 57) is a writer in Los Angeles. He has published essays and reviews in Artforum, Rolling Stone, and the LA Weekly.

MARY WALLING BLACKBURN (p. 13), a visiting artist at the Cooper Union and the founder of Anhoek School, was a child-student at Public School 130, P.S. 154, P.S. 321, Donner Trail Elementary, Truckee Elementary, Sierra Mountain Intermediate, Jaffrey Rindge Middle School, and Northfield-Mount Hermon School, and was also schooled each night at different camp-grounds as her family wandered across the country in the Fall of 1980.

JESSE BRANSFORD (p. 62) is a Brooklyn-based artist who received his MFA from Columbia University. He is an Assistant Professor of Art and Art Education at New York University, and his work is represented by Feature Inc. in New York.

TOM BRAUER (p. 75) received a BA/BFA from the New School, and his MFA from Yale. He is currently very unemployed.

JACKIE BROOKNER (p. 117), mostly self-educated as an artist, has been teaching at Parsons The New School for Design since the late 70s, and has also taught at Harvard, the University of Pennsylvania, and The New York Studio School.

PETER BROWN (p. 66) attended Stanford University, has taught photography at Rice University, and has published three books: Seasons of Light, On the Plains, and West of Last Chance.

GRAHAM CAMPBELL (p. 17) is Associate Professor of Fine Art at Brandeis University.

NATHAN CARTER (p. 20) lives and works in Brooklyn. He received his MFA from Yale, teaches at Princeton, and is represented by Casey Kaplan Gallery in New York and Esther Schipper in Berlin.

ANTOINE CATALA (p. 57) studied mathematics in Toulouse, France, and sound art and fine arts in London.

ANNA CRAYCROFT (p. 55) is an artist (and teacher) based in New York City.

ABRAHAM CRUZVILLEGAS (p. 72) is a Mexican-born artist currently based in Berlin as a DAAD artist in residence.

SEAN DOWNEY (p. 19) received his BFA from the Kansas City Art Institute and an MFA in Painting from Boston University. He currently lives and works in Boston, and teaches at Brandeis University.

ANGELA DUFRESNE (p. 114) is a Brooklyn-based painter. She teaches at Sarah Lawrence College.

RACHEL ELLISON (p.81) (513) 310–4605

BRAD FARWELL (p. 69) is the proud possessor of a BA in Architecture from Yale University, the indifferent owner of an MFA in Photography from the School of the Art Institute of Chicago, and the nearly broke instructor of a number of undergraduate photo-graphy courses at the Fashion Institute of Technology.

After working in the video games industry for eight years, **IRA FAY** (p. 28) is now an assistant professor of game design at Quinnipiac University.

ROCHELLE FEINSTEIN (p. 91) received her BFA from the Pratt Institute, spent one term in Columbia University's MFA program, and completed her MFA at the University of Minnesota. She has been teaching at Yale since 1995, where she is currently Director of Graduate Studies in Painting and Printmaking.

HARRELL FLETCHER (p. 71) is an artist based in Portland, Oregon, where he founded and runs the Art and Social Practice MFA Concentration at Portland State University.

RACHEL FOULLON (p. 51) received a BS in Studio Art from NYU where she has since served as a Visiting Artist, and received her MFA from Columbia University where she has since taught sculpture.

RACHEL FRANK (p. 18) received her BFA from The Kansas City Art Institute and her MFA from the University of Pennsylvania.

LAURA FRANTZ (p. 12) has taught art and English in the US, Greece, and Turkey. She currently attends Hunter College's MFA program in painting.

KENJI FUJITA (p. 28) went to Bennington, took classes at the Art Student's League, participated in the Whitney Program, had a job at Artists Space, and got an MFA from Queens. He lives and works in upstate New York and teaches at Bard and SVA.

NAOMI RINCÓN GALLARDO (p. 73) was born in Raleigh, North Carolina, and is now based in Mexico City, where she teaches undergraduate-level courses. She is currently working on a punk-opera with anarchist youth organizations.

MUNRO GALLOWAY (p. 46) teaches in the Art Writing and Criticism program and the Visual and Critical Studies department at the School of Visual Arts in New York.

FIONA GARDNER (p. 34) has a BFA in painting from Rhode Island School of Design and an MFA in photography from Columbia University. She lives and works in Brooklyn.

JACKIE GENDEL (p.53) has recently taught at Boston University, SUNY Purchase, RISD, and University of Tennessee Knoxville. She received an MFA from Yale University and a BFA from Washington University, St. Louis.

LIAM GILLICK (p. 119) has taught at Columbia University since 1997, and at the Bard College Curatorial Studies Program since 2008.

DAVID GIORDANO (p. 81) is a reader, tout court.

ALFREDO GISHOLT (p. 25) received his MFA from Boston University and teaches at Brandeis.

WAYNE GONZALES (p. 26) earned a BA from the University of New Orleans in 1985 and has taught at the Cooper Union and in the graduate program at Hunter College.

MICHELLE GRABNER (p. 119) earned a BFA and an MA in Art History at The University of Wisconsin-Milwaukee, and an MFA from Northwestern University. She is currently Chair of Painting and Drawing at The School of the Art Institute of Chicago.

Born in Seattle, **HEATHER HART** (p. 08) studied at Princeton and received her MFA from Rutgers. She was an artist in residence at Skowhegan, Santa Fe Art Institute, Robert Blackburn Printmaking Workshop, and at the Whitney ISP.

CORIN HEWITT (p. 12) went to school at Burlington, Vermont's The School House, Edmunds Elementary and Middle School, Burlington High School, Oberlin College, the Staatliche Akademie der Bildenden Kunste, Karlsruhe (Germany), and Bard College; he has taught at Tyler School of Art, the School of Visual Arts in New York, and the School of Experimental Geometry in East Corinth, Vermont. He currently teaches at Virginia Commonwealth University.

CHRISTINE HILL (p. 76) works in Berlin as an artist and as proprietor of Volksboutique. She has a BFA from the Maryland Institute College of Art and chairs the department of Media, Trend & Public Appearance at the Bauhaus University, Weimar.

DANA HOEY (p. 48) went to Wesleyan for aesthetics and Yale for photography, so she can give all sorts of opinions when she teaches at Columbia and the Cooper Union.

SHIRLEY IRONS (p. 22) is a New York-based artist who graduated from Parsons School of Design / The New School and teaches painting at the School of Visual Arts.

ANNA ELISE JOHNSON (p. 81) received her BFA in painting from Washington University in St. Louis in 2005. She spent years living around the United States and in Berlin, Germany before returning for her MFA at The University of Chicago.

RYAN JOHNSON (p. 70) was born in Karachi, Pakistan and grew up primarily in Jakarta, Indonesia. Currently based in Gowanus, Brooklyn, he holds a BFA from Pratt Institute and an MFA from Columbia University.

STACEE KALMANOVSKY (p. 81) is possessively attached to the catharsis of the material world. She is in search of the secret intelligence of the Dumb Object. What can it do if it is deaf, mute, or still?

DAVID KEARNS (p. 77) is a painter who studied sculpture at Yale from 1994-1997 and promptly swore off art school for close to a decade. He has been drawing for as long as he can remember and now lives and works in Queens.

NABIHA P. KHAN (p. 81): An awkward detour. Valid one day. Must be four feet to ride and a hero within.

BILL KOMODORE (p. 23) attended the Hans Hoffman School in Provincetown, Massachusetts and Tulane University. He teaches at SMU in Dallas, Texas, where he currently lives.

CHRIS KRAUS (p. 71) is a writer and art critic based in Los Angeles.

Since finishing his MFA at RISD in 2003, **JULIAN KREIMER** (p. 49) has taught at Pratt, Tyler School of Art, RISD, NYU SCPS, and SUNY Purchase College, where he's currently an Assistant Professor in Painting and Drawing.

FABIENNE LASSERRE (p. 46) lives and works in Brooklyn. She teaches in the Painting Department at MICA.

MARGARET LEE (p. 20) is an artist, curator, and gallerist.

DAVID LEVINE (p. 66) teaches studio art and never went to art school, for which he can both thank and blame the legacy of Conceptualism.

MIRANDA LICHTENSTEIN (p. 60) is a New York-based artist, who completed her MFA at the California Institute of the Arts. She is Assistant Professor at the Mason Gross School of the Arts, Rutgers University.

JUSTIN LIEBERMAN (p. 29) is a well-connected New York jew. Last year, his house in upstate New York was foreclosed on by Bank of America.

PAM LINS (p. 07) received her MFA from Hunter College, CUNY. She is on the faculty of the Cooper Union School of Art and Princeton University.

CAMERON MARTIN (p. 47) graduated from Brown University and the Whitney Independent Study Program, and currently teaches at the Cooper Union and the Bard MFA program.

JILLIAN MAYER (p. 17) is a Miami artist who is currently continuing her artistic research through the Internet and Twin Peaks, Season 2.

TOM MCGRATH (p. 53) received an MFA from Columbia University and a BFA from Cooper Union. He's recently taught at the School of the Museum of Fine Arts in Boston, RISD, the University of Tennessee, Knoxville, and Columbia University.

JOHN MENICK (p. 61) is an artist and writer living in New York. He occasionally teaches film and video at his alma mater, Cooper Union.

HELEN MIRRA (p. 100) attended Montessori and public schools in Rochester, New York, including an experimental high school where she received gym credit for riding a skateboard to school. She holds a BA from Bennington College and an MFA from the University of Illinois at Chicago.

CARRIE MOYER (p. 08) attended Pratt Institute (BFA), Skowhegan School of Painting and Sculpture, and Bard College (MFA). She is currently an associate professor at Hunter College, where she teaches painting.

JULIAN MYERS (p. 112) is an associate professor at California College of the Arts, where he teaches art history and theory. He received his doctorate in the History of Art from the University of California, Berkeley, in 2007.

The son of a teacher, **BOB NICKAS** (p. 53) was an indifferent student, and has taught at Columbia, RISD and, most recently, at New York University.

SOFÍA OLASCOAGA (p. 71) initiated studies in Art History, Psychology, Sociology, and International Relations at Palazzo Spinelli (Florence), UNAM, and Universidad Iberoamericana in Mexico City, but she actually obtained a BFA from La Esmeralda National Fine Arts School and completed Curatorial Studies at the Whitney Museum's Independent Study Program.

DEMETRIUS OLIVER (p. 33) received his BFA from the Rhode Island School of Design and his MFA from the University of Pennsylvania. He teaches photography at Princeton.

MATT PHILLIPS (p. 51) is a painter currently teaching at Mt. Holyoke College.

WILLIAM POPE.L (p. 81) lives on the banks of a very large lake in a straw house with all the lights on.

JESSICA POWERS (p. 68) is an educator living in the Pacific Northwest who produces programs for marginalized adults at Path with Art, and exhibitions for college students at Seattle University's Hedreen Gallery.

JON PYLYPCHUK (p. 95) was educated at UCLA and the University of Manitoba.

SARA GREENBERGER RAFFERTY (p. 31) is currently Assistant Professor of Visual Arts at Suffolk County Community College, State University of New York.

Artist and composer **KURT RALSKE** (p. 23) teaches in the MFA Digital + Media department at the Rhode Island School of Design, and in the MFA Computer Art department at the School of Visual Arts, in New York.

DAVID ROBBINS (p. 11) is a writer and an artist whose most recent book is Concrete Comedy: An Alternative History of Twentieth-Century Comedy.

CLARE ROSEAN (p. 81) received her BFA from the School of the Art Institute of Chicago in 2010. She is currently pursuing an MFA at the University of Chicago.

HARRY ROSEMAN (p. 21) was born in Brooklyn and now lives in the Hudson Valley where he teaches at Vassar College. He is represented by the Davis and Langdale Gallery and recently had an exhibition at the Nancy Margolis Gallery; his public installations include one at John F. Kennedy Airport and another in the New York City Subway.

AURA ROSENBERG (p. 74) is an artist who lives in Berlin and New York City, where she teaches at The School of Visual Arts and Pratt Institute. She received a BA from Sarah Lawrence and an MA from Hunter College; she also attended the Whitney Independent Study Program.

MARINA ROSENFELD (p. 56) is a composer who lives in New York. She received her undergraduate degree from Harvard and an MFA from CalArts; she co-chairs the MFA program in Music/Sound at Bard College.

GEORGE RUSH (p. 09) is a painter and Assistant Professor of Painting and Drawing at The Ohio State University.

TRAVIS SAUL (p. 81) is an artist, father, teacher, and student.

MIRA SCHOR (p. 90) was an art history major at NYU then got her MFA at CalArts, where she was in the Feminist Art Program. At the age of twenty-four, she became the only woman on a faculty of twelve men at NSCAD, and has gone on to teach as an adjunct at many art programs, including part-time for the past twenty-two years at Parsons The New School for Design.

AMIE SIEGEL (p. 100) attended Bard College (BA 1996) and The School of the Art Institute of Chicago (MFA 1999). She teaches in the Department of Visual and Environmental Studies at Harvard University.

Poet **JEREMY SIGLER** (p. 107) has published several full-length collections of poetry, including To and To is For (1998), Mallet Eyes Fracture Perception (2000), Math (2008), Crackpot Poet Jerzy Ziglarski (2010), and Sorry, I Am Your Mind (forthcoming). He is the Senior New York Editor of Parkett. Sigler has taught in Yale University's Sculpture Department and has received degrees from the University of Pennsylvania, and University of California, Los Angeles.

AMY SILLMAN (p. 111) is a painter who lives in Brooklyn. She teaches in the MFA program at Bard College.

MICHAEL SMITH (p. 121) holds a Bachelor of Arts from the Colorado College and is a Professor in the Department of Art and Art History at the University of Texas at Austin.

MOLLY SMITH (p. 11) earned a BFA at Rhode Island School of Design and an MFA at Columbia University. She has been an adjunct professor at both institutions and has taught art in elementary, middle, and high schools for the past seven years.

KEN TAKASHI HORII (p. 34) Horii is a professor teaching Spatial Dynamics and the current Program Director in the Division of Foundation Studies at RISD. His sculpture, paintings and works on paper are in private and corporate collections nationally and internationally, and have been exhibited in New York, Chicago, Boston and in galleries and museums across New England.

JO-EY TANG (p. 47) attended York Kindergarten in Hong Kong at the age of two.

PAUL THEK (1933–88) (p. 78) was born in Brooklyn and studied at the Art Students League, the Pratt Institute, and the Cooper Union. He composed "Teaching Notes: 4-Dimensional Design" for a course he taught at the Cooper Union between 1978 and 1981.

MAMIE TINKLER (p. 63) moved from Tennessee to New York in 1996; she studied art and many other things at Columbia University where she received her BA in 2000, and at Hunter College, where she received an MFA in 2005.

DAN TOROP (p. 52) is a photographer, digital artist, and teacher thereof.

PATRICIA TREIB (p. 10) received her MFA from Columbia University and her BFA from The School of the Art Institute of Chicago; she currently teaches painting at Brooklyn College.

CASSANDRA TROYAN (p. 81) was born in the USSA in 1986. The insatiable has product the glitch is proscribed and this fucking entitlement like a line slant, the lever cancel and I can see that what you really want to make is pasta. To be a real person is not to be alive.

DAVID TRUE (p. 89) graduated from Ohio University with both a BFA and an MFA. He has taught at Columbia University in the undergraduate and graduate programs, and is presently Professor of Arts at The Cooper Union, where he has been for twenty-one years.

WILLIAM VILLALONGO (p. 62) received his BFA from Cooper Union and his MFA from the Tyler School of Art. He currently teaches at Yale.

SHANE WARD (p. 81) is a sculptor born and raised in Kentucky. He lives and works in Chicago.

OLIVER WASOW (p. 09) is a photographer currently teaching in an adjunct capacity at The School of Visual Arts, Bard College, The Art Institute of Boston, Rutgers, and pretty much anywhere else that he is wanted.

ERIC WATTS (p. 81) is a video artist living in Chicago.

London-based artist **RICHARD WENTWORTH** (p. 115) has enjoyed numerous teaching episodes—at Goldsmiths in the 1970s and 80s, at the Architectural Association in the 1990s, and at the Ruskin at the University of Oxford in the early 21st century, amongst others. He is currently involved with the new Fine Art faculty at the Royal College of Art.

DOMINIC WILLSDON (p. 112) is Leanne and George Roberts Curator of Education and Public Programs at the San Francisco Museum of Modern Art, and an adjunct professor at California College of the Arts. He received his doctorate in Philosophy from the University of Essex in 2000.

TOMMY WHITE (p. 24) only works with students who think he is a genius and believe in everything he says.

KEVIN ZUCKER (p. 14) is an artist who lives in New York and teaches at RISD.

PAPER MONUMENT
n+1 Foundation, Inc.
68 Jay St #405
Brooklyn, NY 11201
www.papermonument.com
www.drawitwithyoureyesclosed.com

EDITORS
Dushko Petrovich
Roger White

ASSOCIATE EDITOR
Prem Krishnamurthy

CONTRIBUTING EDITORS
Naomi Fry
Jessica Slaven

COPY EDITOR
Damian Da Costa

PROJECT MANAGER
Holly Veselka

EDITORIAL ASSISTANT
Noah Dillon

INTERN
Madeleine Schwartz

DESIGN
Project Projects

Paul Thek's *Teaching Notes: 4-Dimensional Design*
(1978–81) is reprinted here courtesy of Alexander and
Bonin, New York. © Estate of George Paul Thek

John Baldessari's seven pages of typewritten
CalArts class assignments are courtesy of the artist
and Marian Goodman Gallery.

Paper Monument would like to thank all of our
contributors for their time and effort. We would also
like to thank the New York State Council on the Arts,
Anna Rieger, Kim Sutherland, Sarah Hromack,
Dayna Tortorici, Priya Lal, Maggie Clinton, and our
friends at *n+1*.

Copyright 2012
Printed in USA
ISBN 978-0-9797575-4-9
Eighth printing